Celebrate
PEOPLE'S
HISTORY

Celebrate

PEOPLE'S HISTORY

THE POSTER BOOK OF RESISTANCE AND REVOLUTION

SECOND EDITION | EDITED BY JOSH MACPHEE

FOREWORDS BY CHARLENE CARRUTHERS AND REBECCA SOLNIT

THE FEMINIST PRESS
AT THE CITY UNIVERSITY OF NEW YORK
NEW YORK CITY

Published in 2020 by the Feminist Press
at the City University of New York
The Graduate Center
365 Fifth Avenue, Suite 5406
New York, NY 10016

feministpress.org

Second edition
First Feminist Press edition 2010

This book was made possible thanks to a grant from New York State Council
on the Arts with the support of Governor Andrew M. Cuomo and the New York
State Legislature.

First printing August 2020

Cover design and text design by Drew Stevens

Library of Congress Cataloging-in-Publication Data is available for this title.
ISBN 9781936932870

PRINTED IN THE UNITED STATES OF AMERICA

Contents

Foreword to the Second Edition

Celebrate People's History transports me back to when I was a little girl growing up on the South Side of Chicago. It was then that I fell in love with the idea that I could peek into the lives of people who lived long before I did. I made up movies in my mind while reading. I imagined myself inside of stories whenever images were available. I lost myself in stories about the decisions people made, the inventions human minds created, and the struggles every generation of my own people have had to wage in this country and across the globe.

I often attempted to see and feel whatever the moment in history happened to be. Sometimes those images hurt, traumatized me, and left me in a puddle of tears. Other times, I found joy in the resilience and resistance of marginalized and oppressed people against those who yield violence and control in pursuit of absolute power. I still sing the words to the songs in *Eyes on the Prize* to this day.

I knew then, even before I had learned the language of social justice movements, that some people kept their control by offering up their versions of history while dismissing the rest as irrelevant or simply too dangerous. Whenever I read a book from the library or the shelf of an adult in my life, I felt like I was being let in on a secret, something that was absent from the news and even from many of my classrooms.

What I did not know at the time was that my love was really just a love for storytelling, even if the stories were painful. People love stories; that's often how we connect with one another. I would learn much later about the details left out and just how much of what I learned in public school was shaped by patriarchal, anti-Black, white supremacist, and capitalist interests. Each poster in this book fills in the details every person in the world should learn. Each poster, its craft and reach, reflects how an individual can contribute to the collective in accessible and affordable ways. At the risk of sounding cliché, these artists are showing us what democracy could look like through work that has reached tens of thousands of spaces across the world.

My teenage self had no idea that I would go on to be a part of local, national, and global struggles for collective liberation. I just knew that I always had to ask questions about everything I was taught. I always wanted to know what was missing. Many of my teachers encouraged us to do so. Their encouragement made me a sharper thinker, educator, and community organizer.

Unfortunately learning history was not always fun or welcoming to me. In high school, my Latin American history teacher once told me that she was "surprised that I was going to college." She felt that I was too immature to continue my education. Hearing that from a young white woman left an impression on me about the gatekeepers to learning history and how they shut young people out of the joys of discovery every day. The good news then, and now, is that I had already fallen in love with learning about humans who lived in the past. By the time I entered her class, I had already been admitted into college and planned to become a history major. I still laugh at the fact that my very first class in college was also a Latin American history course. The irony.

Since then, I've witnessed the value of seeing oneself in movements for resistance and revolution across time. The reality

for far too many people—those who are Black, Brown, Asian, Indigenous, disabled, LGBTQIA+, im/migrant, incarcerated, poor, working class, and many more—is that our histories are quarantined and often surface when beneficial for corporate and state benefit. This dynamic prevents everyday people who organize together for collective liberation from forming complete stories about our past and present. The less frequently told stories moved me as a child and they continue to move me into action to this day.

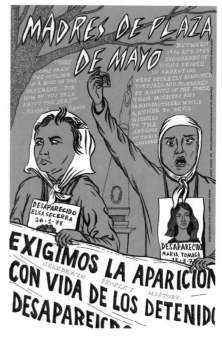

There are far too many gatekeepers in our schools, governments, media outlets, and even our homes who only open the doors for the stories they are comfortable with telling. Fear of losing power drives much of this dynamic. Art has the ability to shatter the barriers to knowledge created by the people who wield their power with repression, violence, and misinformation. The images inside of this poster book, which reach well across communities, weaken the stronghold that gatekeepers to history hold over our lives. Through colors, words, and a wide array of artistic approaches, all viewers and readers are invited to engage with humanity's contradictions.

This poster book also illustrates a history of humanity in which no single person is the savior. The tapestry laid across each page shows how everyday people have always been at the helm of efforts for collective liberation. I want every person to be able to experience and connect with the histories of their people, be they on any side of the oppressed or the oppressors. There is value in facing the past and understanding the role our ancestors played in creating the world as it is today.

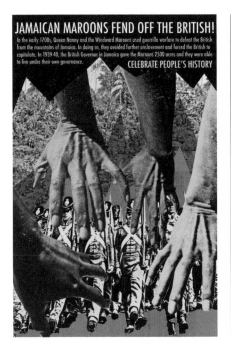

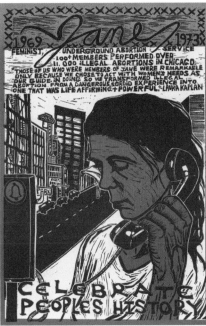

LEFT TO RIGHT: *Madres de Plaza de Mayo* by John Isaacson; *Jamaican Maroons Fend Off the British* by Damon Locks; *Jane* by Meredith Stern.

Black feminist playwright and filmmaker Toni Cade Bambara said that the work of a cultural worker is to "make revolution irresistible." I now imagine how my path as an organizer, and my commitment to revolution in my own lifetime, would have shifted if my classroom had been covered with posters from this book. What if I had seen Damon Locks's *Jamaican Maroons Fend Off the British* poster while learning about the US Civil War? I might have understood that Black liberation is indeed a global struggle. What if John Isaacson's *Madres de Plaza de Mayo* or Meredith Stern's *Jane* posters were in the room when I first learned about reproductive health and justice? I might have understood my options more clearly as a young woman and centered bodily autonomy in my work much earlier. I wish I had had these on hand in campaign-organizing meetings and while

marching on streets during the Black youth–led rebellions I joined and helped lead across this country. I will continue to revisit this book and ask myself how my appetite for revolution, as well as the appetites of oppressed people across the world, can become exponentially insatiable through the cultural work offered here.

We can all have a role in democratizing and liberating knowledge. There is not an issue that is too complex for people across communities to understand. Sharing information is one measure. Knowledge is liberated when information is placed in context and engaged with critical thinking. How could people not grasp complex issues when we all live complex lives? Like building up a muscle, this work takes time, energy, and resources, both human and financial.

Successful liberation movements have always reckoned with the pain and the joy of the past, leading them to form demands reflective of not just a few people but as many as possible. Be it graffiti on the apartheid wall in Palestine or the peace walls in Northern Ireland, people make visual art to tell stories everywhere, especially in times of entrenched violence and systemic oppression.

Incomplete stories lead to incomplete solutions. Each artist included in this book provides us with the building blocks we all need to develop a more complete story of collective struggles toward freedom, across many roads, bodies of water, and times in history. This is an invitation to craft more complete solutions that will remain open for as long as our collective memories exist. I urge anyone who holds this book to take in what resonates most and commit to a lifelong pursuit of knowledge and action. In doing so, I'm confident that collective liberation will be actualized in our lifetimes.

—Charlene Carruthers
March 2020

Foreword

In times of revolution and social turbulence even the walls speak up and shout out: George Orwell wrote of Barcelona during the Spanish Civil War, "The revolutionary posters were everywhere, flaming from the walls in clean reds and blues that made the few remaining advertisements look like daubs of mud." In Oaxaca after the extraordinary commune of 2006 was overthrown, the city was everywhere smeared with the gray paint that covered over the revolutionary slogans. Repressing the revolution necessarily included repressing the voices of the streets and the words on the walls.

A revolution is a moment of waking up to hope and power, and the state of mind can be entered into from many directions. If revolutions often prompt posters to appear, the appearance of posters, murals, and graffiti may foster revolution or at least breath on the cinders, keeping the sparks alive until next time—which is why gentrification and repression often seek to create silence as a texture. In one case memorialized by an early work of Angeleno painter Sandow Birk, a property-owner in the San Fernando Valley shot two Latino teenagers in the back while they were spray-painting; he claimed self-defense. He was clearly a vigilante, but what he was defending was not his own safety but his own reality against theirs. Billboard defacement by groups such as the Billboard Liberation Front takes back the public sphere from corporations and gives it to the radical imagination.

When the walls wake up, they remind us of who we are, where we are, whose shoulders we stand on; they make the world a place that speaks to us as we travel through it, that tells us we are not alone, others have gone before, and hope remains ahead. This is the vitality that street posters serve, now as much as ever. If graffiti at its most basic is tagging—"I exist, I am here," a subversive statement for the young who are hardly allowed to exist—then the posters Josh MacPhee has organized tag the city for Emma Goldman, for Grace and Jimmy Boggs, for the Zapatistas, the Oaxaca Commune, the Highlander Folk School. They say: we existed, we exist, you are not alone, the past is alive and breathes life into possible futures.

For the past decade the romance of the internet has made many—too many—think that it is itself a public space, one that can and has and will replace the public space of cities, of streets, boulevards, squares. But what we learned from the Seattle uprising of 1999 or the Zapatistas is that virtual space is only an auxiliary to the place that matters, which is still public space, the space in which we coexist, bodily, with strangers, the democratic space in which revolution has always unfolded, the spaces of our actual bodies. Revolutions are geographical in part; they liberate the actual space in which we live our lives, as well as our spirits; you can live differently first, but the space in which it is possible to do so matters. The streets still matter.

The demonstrations against the World Trade Organization in Seattle in 1999 were among the early global actions organized by email and internet postings, but they mattered because people showed up from Korea and France and the West Coast, they put their bodies in the way of the meeting to sell the world, they risked and hoped and stood up and sat down together. Democracy must be embodied, which is why it always has a geography. This is why street posters matter today as much as ever.

More than a decade ago I wrote:

Only citizens familiar with their city as both symbolic and
practical territory, able to come together on foot and
accustomed to walking about their city, can revolt. Few
remember that "the right of the people freely to assemble" is
listed in the First Amendment of the US Constitution, along
with freedom of the press, of speech, and of religion, as critical
to a democracy. While the other rights are easily recognized,
the elimination of the possibility of such assemblies through
urban design, automotive dependence and other factors
is hard to trace and seldom framed as a civil-rights issue.
But when public spaces are eliminated, so ultimately is the
public; the individual has ceased to be a citizen capable of
experiencing and acting in common with fellow citizens.
Citizenship is predicated on the sense of having something
in common with strangers, just as democracy is built upon
trust in strangers. And public space is the space we share with
strangers, the unsegregated zone. In these communal events,
that abstraction the public becomes real and tangible.

Such events require the actual space and a public that can and
does exist in it, and the gestures that cultivate such places and
sensibilities keep alive something profoundly necessary.

We are in an era of eroded public space, eroded for at least
three reasons. One is that an increasingly large number of people,
at least in the United States, live in zones where public space was
never part of the design: they live in suburbs, car-based spaces
where you can step in your car, punch the garage-door opener,
and then drive straight to the parking garage of your office and
mall, avoiding being outdoors altogether. Another is that more

and more people even in the old public space of cities are hurried and harried and move through such spaces obliviously. They have forgotten what these places have been and how to live in them. Just as foods that are considered delicacies in one culture are deemed disgusting and offal in others, so it is with public space: occupied as an act of gracious well-being in many parts of Europe, consigned to the homeless in many American cities. When we neither recognize nor prize what these places have been or can be, they lie dormant—though like seeds that germinate after a rain, any great social deluge can reawaken them. Finally such spaces are more policed and controlled in this era when the First Amendment is often consigned to a protest pen at political conventions and other key moments in the history of democracy, surveillance cameras proliferate, and new technologies of repression develop. Yet civil society and by extension democracy depend on public life—a life that is being throttled by these things, reawakened by others, from farmers markets to the Latinoization of many neighborhoods.

These are all reasons why Josh MacPhee's long campaign of putting his series of radical history posters up around the country matter. They are a small gesture, perhaps, but small gestures accrue, and democracies and revolutions are made up of the myriad gestures of the small. I have long thought of pedestrians, of people who walk their cities and know them, as keeping alive a confidence and familiarity that has great potential in crisis and revolution. These posters do for the walls what those walkers do for the streets: keep alive some power and some hope in the public sphere. Just as individuals accrue into civil society, so these individual commemorations of bygone heroines and moments cohere into the radical past on which a radical future can be built.

—Rebecca Solnit
June 2010

Introduction

Around midnight, a half dozen of us walked surreptitiously down Madison Street. In 1998 Chicago's West Side, once a thriving African American district in the 1950s and early '60s, looked like a ghost town. Malt liquor ads were the only images on the streets. We slowly made our way, lugging buckets of gooey wallpaper paste, rolls of printed posters, and big brushes on poles, covering boarded-up storefronts and abandoned advertisement hoardings with images of Malcolm X. After ten minutes of pasting these Celebrate People's History (CPH) posters, we had attracted a small crowd. People came up to us asking for posters for their walls and to give to their kids and friends. A number of passersby actually grabbed the paste buckets out of our hands, eager to help put the posters up.

The experience was an epiphany for me. It taught me that if we make art that speaks to people's interests, history, and desires, and bring it into the spaces we share, people will actually engage with it. The streets aren't dead to political dialogue. They are a place where powerful conversations can begin, and art can play an important role in making that happen.

The decision to make the first CPH poster of Malcolm X came out of a series of conversations with my friend Liz Goss, then a Chicago public school teacher, now a school principal. We chose Malcolm as a subject not only because he is an important political figure but also because of this quote that Liz discovered: "Armed with the knowledge of our past, we can charter a course for our future. Only by knowing where we've been, can we know where

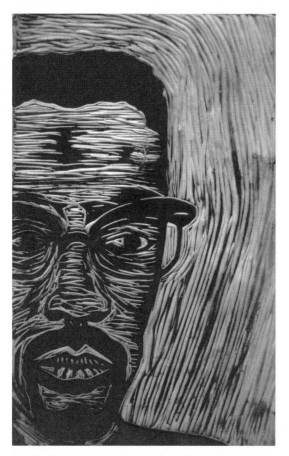

The linoleum block cut for the first CPH poster.

we are, and look to where we want to go."* In many ways this idea—to make history present in our everyday lives—perfectly encapsulates my mission for this project.

The first edition of this book was sparked in 2008 by a conversation I had with Amy Scholder, then editor at the Feminist Press. At the time, the poster series was about a decade old and about fifty poster designs had been printed. I commissioned sixty more designs, and the book was released in 2010 with 110 posters. In the following decade, most of these additional designs have been made into posters, with another ninety-two designs collected for this second edition. The project has expanded in breadth, with designs from another eighty artists, hailing from a dozen different countries. The goal of this book and poster series is not to tell a definitive history but to suggest a new relationship to the past. If we can see that things have changed, then we can imagine that they can change again, and that we can be part of making change happen.

■

The contemporary Left political poster was developed in the 1960s by a Cuban internationalist group, the Organization of Solidarity of the People of Asia, Africa, and Latin

*After some research, it turns out this quotation is most likely a paraphrase from the political statement of Malcolm X's Organization of Afro-American Unity: "Armed with the knowledge of our past, we can with confidence charter a course for our future. Culture is an indispensable weapon in the freedom struggle. We must take hold of it and forge the future with the past."

America (OSPAAAL). OSPAAAL hit on the brilliant idea of folding posters up and stuffing them into their publication, *Tricontinental*, which at its height was distributed to over eighty countries in four languages. These posters graced the walls of student dorm rooms in West Berlin, huts in Guinea-Bissau, and everywhere in between. By the late 1960s, political movements in dozens of countries had developed scrappy but effective community- and student-run print workshops of their own, churning out an explosion of new visual ideas. The most influential examples are the Ateliers Populaire (People's Workshops), which started across France in May 1968 when striking students took over their art schools and converted them into printshops.

The Celebrate People's History posters are rooted in this DIY tradition of mass-produced and mass-distributed political propaganda. From the beginning, CPH posters have been created with limited resources, which inform their aesthetics. The posters are almost all two-color (as opposed to a more lavish four-color process), printed on inexpensive uncoated paper, and produced on analog offset printing equipment. Unlike slick digital images run off on glossy photo paper, the posters have a tactile feel, giving the sense that they were crafted by hand. In this way they hold great aesthetic affinity with the rushed screenprints of striking students, or the off-register, poorly trapped, and hastily made posters printed on underground presses by Latin American and African revolutionaries.

There is a long tradition of posters from the Left that represent disasters or failures,

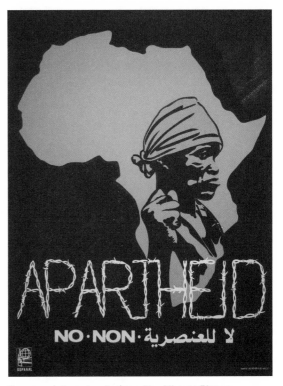

Screenprint poster designed by Alberto Blanco González for OSPAAAL in 1982.

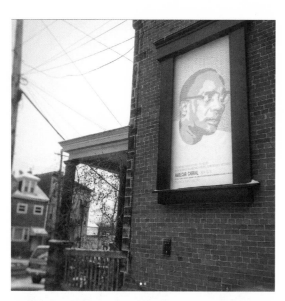

Installation view of the *Amilcar Cabral* poster installed as part of the Sidewalls Project, a 4 x 8 ft. public panel on rotating art in Pittsburgh. Photo courtesy of Sidewalls.

either imaging or imagining the fallout from bad decisions made by politicians, or serving as a reminder of some previous or current atrocity. The best examples of these are the outpouring of anti–George W. Bush posters created between 2000 and 2008, and the tradition of antinuclear posters illustrated with ominous mushroom clouds, created by anti-war activists since the 1970s. Today this genre is best represented by the thousands of Donald Trump images (as a baby, a monster, a fool, etc.) generated in the wake of the 2016 presidential election. In short, they are depressing yet important symbols of the problems of the world today.

Another type of poster is one that serves as an immediate call to arms against a direct foe, rallying for a cause or protest. Recent examples of this are the multitude of posters created to support the campaign against the Dakota Access Pipeline (No DAPL), as well as those generated by the Black Lives Matter movement against police brutality. These posters generally document an immediate moment and are created with the intent to be used in that moment. As we adjust to seeing more and more political graphics exclusively in an online context, it has been these direct campaign- and event-related graphics that have kept the physical poster alive, and are what continue to inspire me to print the CPH posters.

It has generally been rare that a political poster is celebratory. When it is, it almost always falls into one of two categories. First are posters that encourage self-care and positive self-image. These are important, but all too often eclipse

the social and instead pinpoint the individual as the locus of change. Second are the myriad posters that commemorate a very small canon of individuals, almost exclusively male: Martin Luther King Jr., Mahatma Gandhi, Che Guevara, or Nelson Mandela. This canon has recently been expanded some, to include figures such as Angela Davis and Audre Lorde, but is still an extremely narrow view of the people who have fought for justice.

With the CPH project, rather than create another exclusive collection of "heroes," I decided I'd rather generate a diverse collection of posters that bring to life successful moments in the history of social justice struggles. To that end, I've asked artists and designers to find events, groups, and people throughout history who were inspiring in some way, who moved forward the collective struggle of humanity to create a more equitable and just world.

Although I've long considered myself an anarchist, CPH has always been a nonsectarian, ecumenical project, pulling together diverse historical moments and activities coming out of multiple political traditions, from communist to national liberationist, liberal to libertarian. The posters tell stories from the subjective position of the artists, who themselves come from a diverse swath of political sensibilities. They are very often the stories of the underdogs, those marginalized or written out of mainstream

CPH posters on the streets of Chicago.

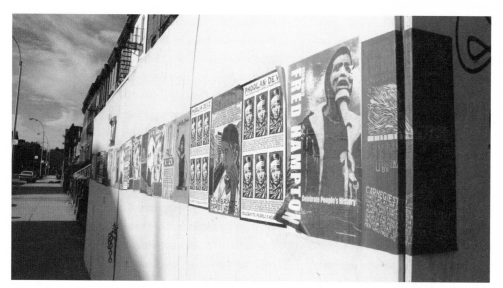

CPH posters on the streets of Brooklyn.

histories. Some of the artists did an immense amount of research, tracking down all they could find, while I'm sure others might not have even picked up a book, but instead had a conversation that sparked their interest or got to work after some quick online research. The goal is to engage people with history and generously share information and imagery, not lock in a single, "correct," historical narrative.

Some of the stories told by these posters are well-known. Many people have heard of Emma Goldman, Frederick Douglass, and Harriet Tubman. But how many know that Tubman carried out the only woman-led US military attack ever with the Combahee River Action? How many know about the activities of Las Gorras Blancas, or that in the 1970s a group of incarcerated men in Walpole, Massachusetts, functionally ran the prison they were confined in? Many have heard of John Brown and his armed attack on Harper's Ferry. But how many know of his political relationship to Henry David Thoreau, a figure presented to school children across the United States as the progenitor of liberal nonviolence? In fact, Thoreau had a much more complicated relationship to violence, and believed there were evils much greater than individual aggression, particularly slavery. By putting Brown and Thoreau back in dialogue with each other, not only can the posters correct historical inaccuracies, they can show that how we understand history affects how we understand politics, both in the past and in the present. History is not simply a collection of great protagonists. It is a social fabric, a chronological quilt of actions and reactions, people moving in concert and in conflict.

■

On the streets, we're inundated with an endless barrage of brightly colored advertisements, street signs, and commercial window displays that evolve and change daily. So much of what we see are directives of some kind: "Buy this!" or "Be this!" Living in this ever-transforming and saturated visual landscape, how do we understand the past of the spaces we move through? Physical spaces where important events happened are abandoned, bought, sold, torn down, or made into monolithic historical monuments. The creation of these monuments, whether statues of men on horses or the preserved homes of Founding Fathers, is intended to acknowledge history, but more often than not it ensures that history is ossified. It becomes lifeless, a thing of the past, and easy to ignore.

The CPH project has clarified for me a series of questions about history and public space: Can our streets become active galleries of ideas and information we can use to understand who we are and where we come from? Can these galleries evolve and change and make room for new ideas, images, and conversations? Since that first night over twenty years ago in Chicago, CPH posters have been pasted up in Philadelphia, Nashville, San Francisco, Brooklyn, Portland, and over a dozen other cities. I know people are interested in the posters because I've received many emails from those who have stumbled upon them. Some want to know more; others want to argue with the posters' interpretation of the past. Either way, folks are engaging with history in new and exciting ways. Our streets can be a venue for asking questions, and these posters can play a role in helping to answer them.

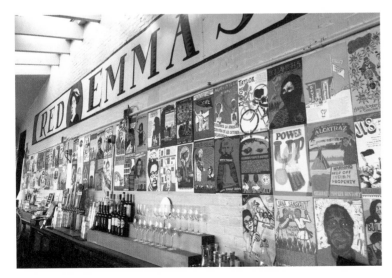

CPH posters on display at Red Emma's Bookstore and Coffeehouse in Baltimore.

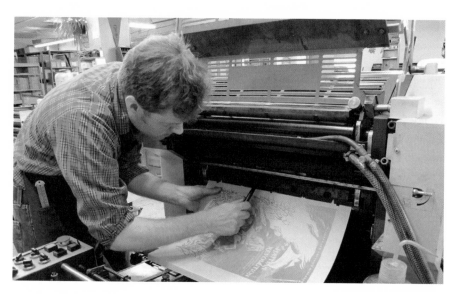

Printing CPH posters
at Stumptown Printers.

The streets are not the only public place the posters have shown up. Over a hundred exhibitions have been held, from showings at local history museums to professionally installed displays at university galleries. They've featured in the background of multiple photographs illustrating stories in major newspapers. They've also been used as set dressing in multiple television shows and movies, helping to popularize them and the histories they contain. From museums to mass culture, every venue is another opportunity for the posters to access diverse and unique audiences.

■

At the same time that my friend Liz was helping me develop this project, she was studying to become a teacher. She told me about the serious lack of engaging political materials for educators.

Indeed, soon after the first posters were printed, teachers began asking me for copies for their classrooms. The reasons they are interested in the posters generally fall into two categories: "I need these in my classroom as direct teaching tools" or "I want to hang these in my class in order to piss off my principal." The former seems the more important of the two, but I have to admit that as a person who has always struggled with school, I also love the latter. There are clearly ideological battles that need to happen in schools, and it's nice to know that the posters play a role in those struggles.

Since then the posters have become part of curricula, and lessons have been built around them. I've gone into many schools and presented CPH as a kick start for kids to make their own posters. The Pittsburgh Creative and Performing Arts School (CAPA) has had high school students

make posters as part of a printmaking class, with impressive results. Undergraduate art, design, and printmaking classes at institutions as diverse as Emily Carr University of Art and Design in Vancouver, Mt. Holyoke College in Massachusetts, the University of Delaware, and Milwaukee Institute of Art and Design have all used the CPH posters for encouraging students to explore color theory, learn the use of duotones, and most importantly think about how to include social justice concepts in their work.

While giving a talk about the poster series a couple years back, I was approached by a graduate student training to become a teacher. It turned out that she was first introduced to the posters almost a decade earlier, when they were hung in one of her grade school classrooms. She kept encountering them throughout her life, and now she intends to use them in her future classes. I hope that these posters can

continue to act as some small corrective to the dominant narratives told in schools, sadly still one where our collective history is presented as an aggregate of the actions of a small number of leaders, with everyone else relegated to the margins—or completely off the page. I firmly believe that if more teachers engage students in alternative ways of understanding the past, it will have profound impacts on our future.

■

To fund this project initially, I saved up money from my day jobs to pay for printing. Offset printing is relatively inexpensive—about two thousand posters can be printed for seven hundred dollars. Twenty years on, they more or less pay for themselves. The idea has always been to make the posters inexpensive and accessible to most people: they sell from two to five dollars each, and you can get them online at

Workshop with students at St. Lawrence University in Canton, NY, within an exhibition of CPH posters.

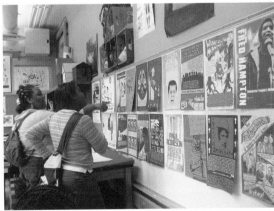

CPH posters in use at the Young Women's Leadership Charter School of Chicago.

justseeds.org, at one of the dozens of bookstores that carry them, or at the events, conferences, festivals, and fairs that I and other members of the Justseeds Artists' Cooperative attend every year. Today CPH posters continue to grace the walls of dorm rooms, apartments, community centers, classrooms, and city streets. Over 125 different designs have been printed in the past twenty-two years, adding up to over 350,000 total posters. Almost two hundred artists have designed posters. Multiple printshops have run the presses they have been printed on.* Dozens of people have run around at night pasting them on city electrical boxes and on the walls of construction sites, and hundreds have helped distribute them around the world.

As individual works, these posters pay tribute to each artist, each poster subject, and to the

idea of a people's history. With the posters collected in one place in this book, we can assess how they function in an entirely new way. It is important, for example, that as a whole they don't simply speak to individual moments, but to broader sweeps of the past. They attest to the evolution and movement of thousands of years of struggle for social justice, and speak to how much more there is to tell. Sometimes the gaps here speak as much as the posters, and are an invitation to artists out there to design posters and fill them.

History is not simply something that has passed. It is the culmination of all that has come before us—something that is still alive, moving, evolving, and changing. It affects the way we see and interpret the present. I hope this book, and all the posters within it, will reinvigorate our collective desire not only to learn from yesterday but to keep history alive today. We live in dark times, with our climate collapsing and the rise of fascism across the globe. Under this looming shadow, it can feel like a handful of posters aren't enough. And they aren't. These graphics are not an end in themselves but a loose guide of roads traveled. We must clutch this map tightly, and use it to plot thousands of paths forward.

—Josh MacPhee
March 2020

*The initial dozen posters were printed at a small left-wing print shop in Chicago called C&D. The two owners, Don Hammerquist and Janeen Porter, trained me in the basics of offset printing, an initial education that has been instrumental in building the knowledge necessary to bring a poster from initial idea to finished page. The shop itself was a product of political struggle, functioning in the 1980s as the propaganda arm of the communist group the Sojourner Truth Organization. Posters have been printed at other "movement" printshops as well, including Inkworks Press in the Bay Area (which sadly closed in 2016) and Community Printers in Santa Cruz. The vast majority of the posters have been printed at the worker-owned and operated Stumptown Printers in Portland, itself a victim of gentrification in 2018.

ANARCHISM | COMMUNISM | SOCIALISM
ANTI-WAR | ANTI-IMPERIALISM | SOLIDARITY
ENVIRONMENTALISM
FEMINISM | QUEER LIBERATION
HEALTH | HOUSING | EDUCATION | CULTURE
LABOR | ANTI-CAPITALISM
SLAVERY | POLICE | PRISONS | ANTI-FASCISM
RACIAL JUSTICE | NATIONAL LIBERATION | INDIGENOUS STRUGGLE

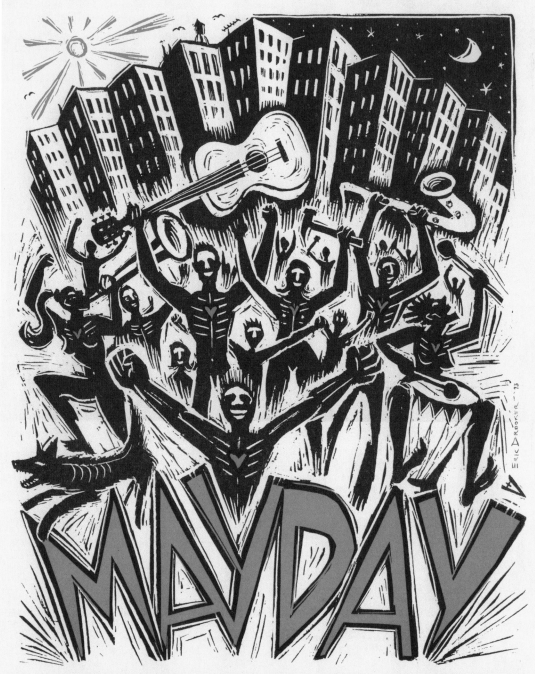

May Day is International Workers' Day, a time of celebration and opposition throughout the world, except in the United States where it began. May Day commemorates the May 1st, 1886 nationwide protest for the eight hour day and the following "Haymarket Affair," a pivotal event in the history of workers' and anarchist movements in which four labor organizers were hanged by the State in Chicago. May Day is also the ancient celebration of Spring and rebirth—the traditional time for planting new seeds in old ground.

CELEBRATE PEOPLE'S HISTORY

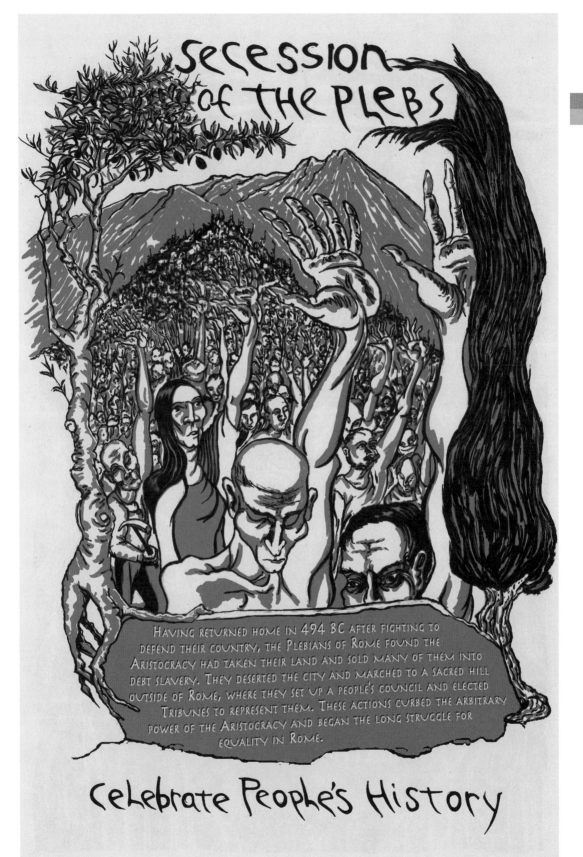

secession of the plebs

HAVING RETURNED HOME IN 494 BC AFTER FIGHTING TO DEFEND THEIR COUNTRY, THE PLEBIANS OF ROME FOUND THE ARISTOCRACY HAD TAKEN THEIR LAND AND SOLD MANY OF THEM INTO DEBT SLAVERY. THEY DESERTED THE CITY AND MARCHED TO A SACRED HILL OUTSIDE OF ROME, WHERE THEY SET UP A PEOPLE'S COUNCIL AND ELECTED TRIBUNES TO REPRESENT THEM. THESE ACTIONS CURBED THE ARBITRARY POWER OF THE ARISTOCRACY AND BEGAN THE LONG STRUGGLE FOR EQUALITY IN ROME.

Celebrate People's History

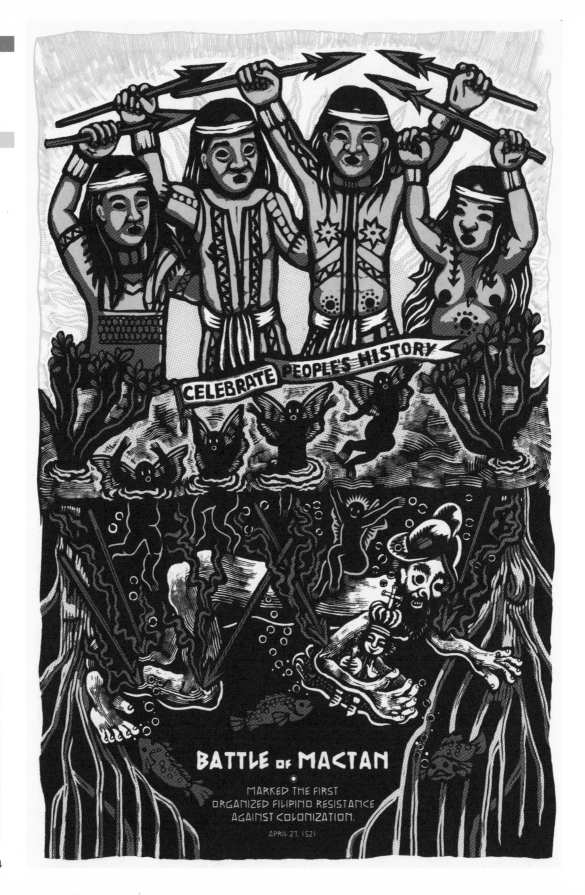

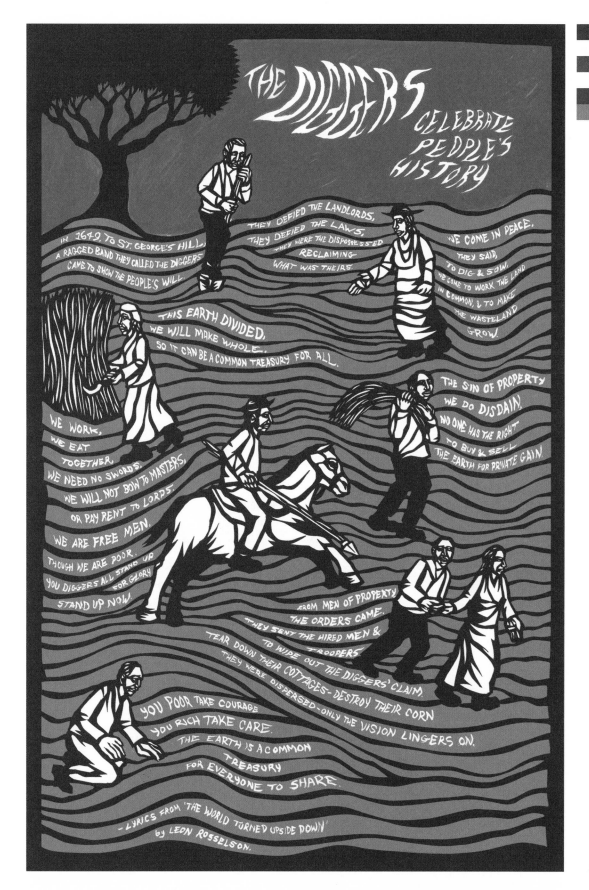

The Pueblo Revolt

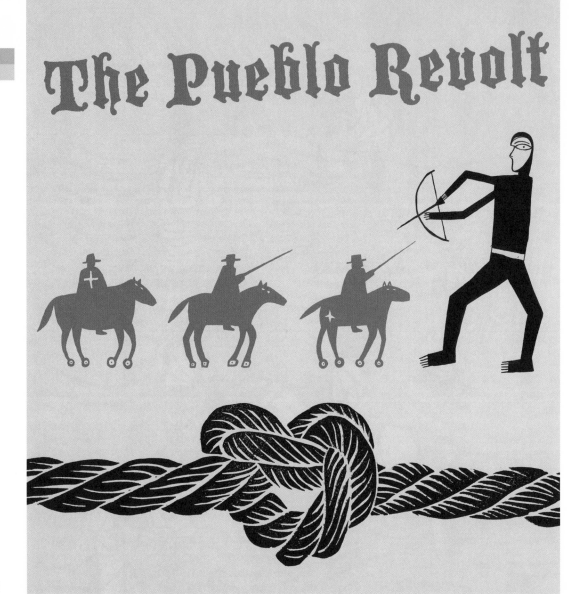

Po'pay was a Tewa spiritual leader who led the 1680 Pueblo Revolt, an anti-colonial movement to remove the Spanish colonial presence in what is now known as the upper Rio Grande Valley. Born with the name Popyn, meaning "ripe squash," Po'pay was convicted alongside dozens of Indigenous leaders for practicing "sorcery." Following the public and violent punishment of these "criminals," the Spanish authorities released the prisoners following the direct action of local communities. Upon his release from jail, Po'pay relocated to Taos, where in 1680 he organized a successful and well-planned assault on the colonial administration in Santa Fe. Carrying knotted deerskins to announce the day of the attack, Pueblo runners informed local communities about a scheduled August 11 uprising. Although commencing a day prematurely, thousands of Indigenous warriors engaged in a ten day offensive that forced the settler community (including Tlaxcala servants, mestizo residents, detribalized Natives known as genizaros, and Pueblo allies) to relocate hundreds of miles south to El Paso del Norte. The anti-colonial struggles of Po'pay and his contemporaries remain a specter of the potential and possibility of Indigenous resistance to settler colonialism.

Celebrate People's History

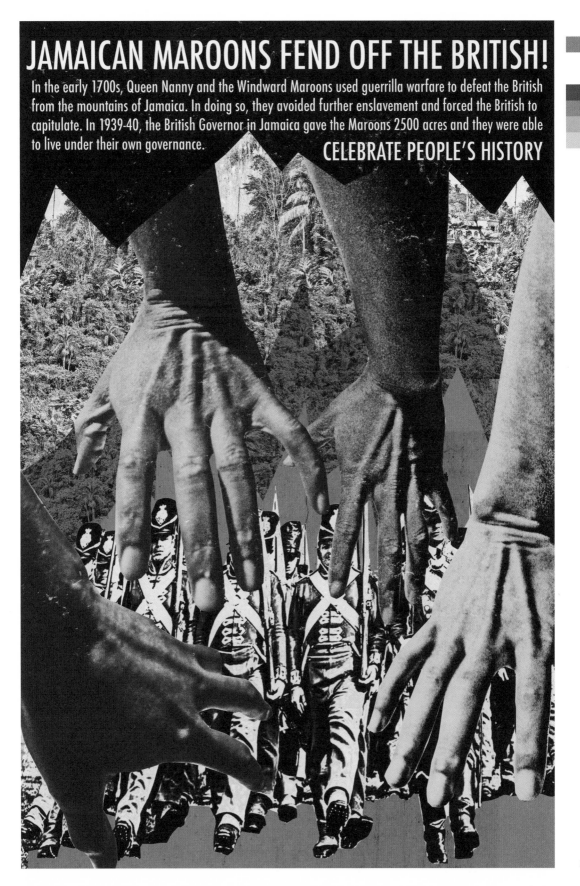

JAMAICAN MAROONS FEND OFF THE BRITISH!

In the early 1700s, Queen Nanny and the Windward Maroons used guerrilla warfare to defeat the British from the mountains of Jamaica. In doing so, they avoided further enslavement and forced the British to capitulate. In 1939-40, the British Governor in Jamaica gave the Maroons 2500 acres and they were able to live under their own governance.

CELEBRATE PEOPLE'S HISTORY

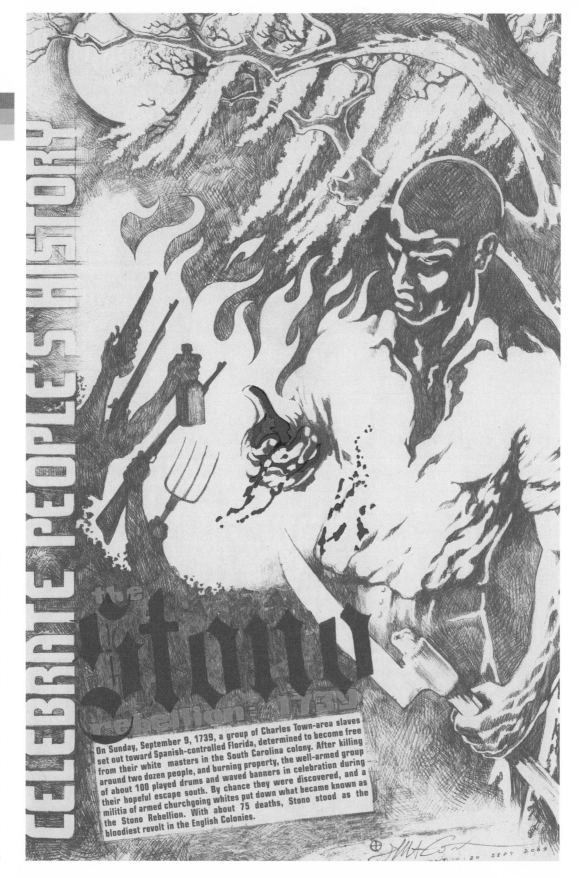

the Stono rebellion 1739

On Sunday, September 9, 1739, a group of Charles Town-area slaves determined to become free set out toward Spanish-controlled Florida, in the South Carolina colony. After killing from their white masters and burning property, the well-armed group around two dozen people, of about 100 played drums and waved banners in celebration during their hopeful escape south. By chance they were discovered, and a militia of armed churchgoing whites put down what became known as the Stono Rebellion. With about 75 deaths, Stono stood as the bloodiest revolt in the English Colonies.

MARK CORT AND RUSSELL HOWZE

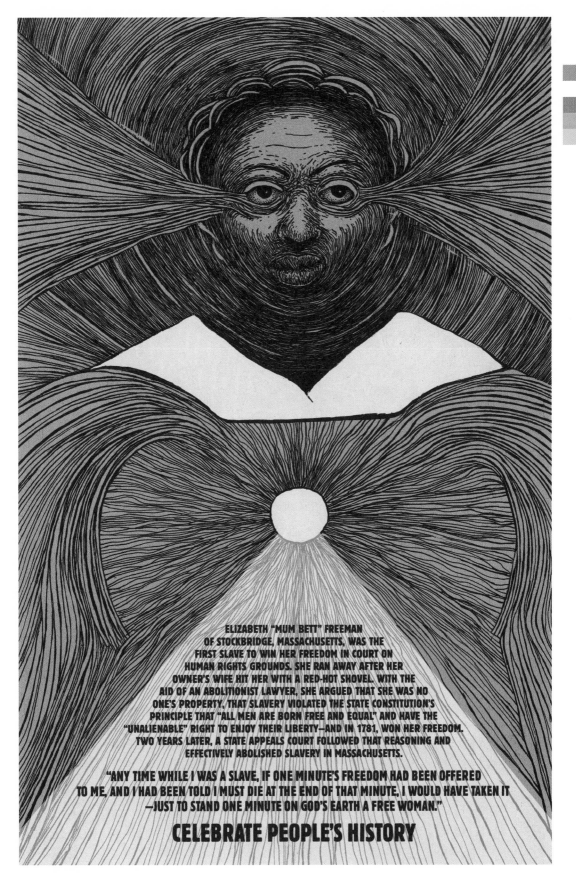

ELIZABETH "MUM BETT" FREEMAN
OF STOCKBRIDGE, MASSACHUSETTS, WAS THE
FIRST SLAVE TO WIN HER FREEDOM IN COURT ON
HUMAN RIGHTS GROUNDS. SHE RAN AWAY AFTER HER
OWNER'S WIFE HIT HER WITH A RED-HOT SHOVEL. WITH THE
AID OF AN ABOLITIONIST LAWYER, SHE ARGUED THAT SHE WAS NO
ONE'S PROPERTY, THAT SLAVERY VIOLATED THE STATE CONSTITUTION'S
PRINCIPLE THAT "ALL MEN ARE BORN FREE AND EQUAL" AND HAVE THE
"UNALIENABLE" RIGHT TO ENJOY THEIR LIBERTY—AND IN 1781, WON HER FREEDOM.
TWO YEARS LATER, A STATE APPEALS COURT FOLLOWED THAT REASONING AND
EFFECTIVELY ABOLISHED SLAVERY IN MASSACHUSETTS.

"ANY TIME WHILE I WAS A SLAVE, IF ONE MINUTE'S FREEDOM HAD BEEN OFFERED
TO ME, AND I HAD BEEN TOLD I MUST DIE AT THE END OF THAT MINUTE, I WOULD HAVE TAKEN IT
—JUST TO STAND ONE MINUTE ON GOD'S EARTH A FREE WOMAN."

CELEBRATE PEOPLE'S HISTORY

MUM BETT MAC MCGILL AND STEVE WISHNIA

The Underground Railroad

"YES I WAS A SLAVE AND I'll SAY This to The Whole World: SLAVERY WAS the Worst curse ever visited ON The PeoPle OF The UNITED STATES." —John Rudd

Celebrate PeoPle's history

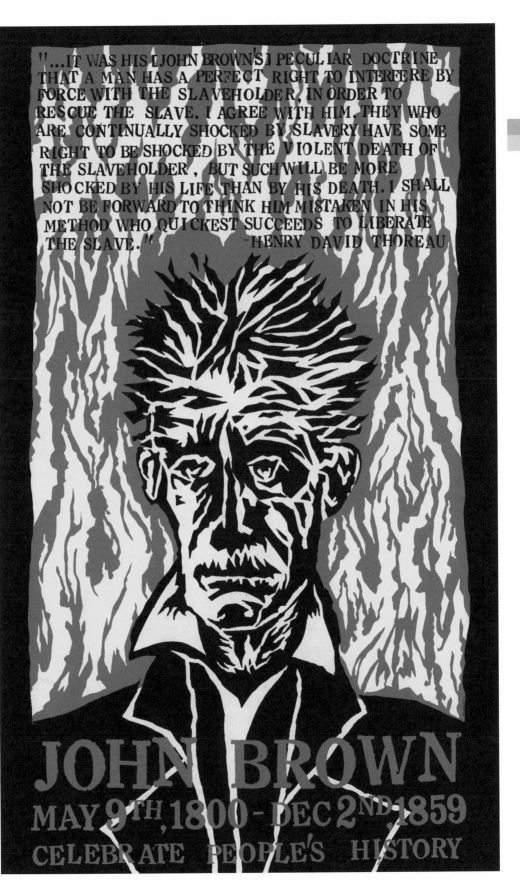

"...IT WAS HIS [JOHN BROWN'S] PECULIAR DOCTRINE THAT A MAN HAS A PERFECT RIGHT TO INTERFERE BY FORCE WITH THE SLAVEHOLDER, IN ORDER TO RESCUE THE SLAVE. I AGREE WITH HIM. THEY WHO ARE CONTINUALLY SHOCKED BY SLAVERY HAVE SOME RIGHT TO BE SHOCKED BY THE VIOLENT DEATH OF THE SLAVEHOLDER, BUT SUCH WILL BE MORE SHOCKED BY HIS LIFE THAN BY HIS DEATH. I SHALL NOT BE FORWARD TO THINK HIM MISTAKEN IN HIS METHOD WHO QUICKEST SUCCEEDS TO LIBERATE THE SLAVE." —HENRY DAVID THOREAU

JOHN BROWN

MAY 9TH, 1800 - DEC 2ND, 1859

CELEBRATE PEOPLE'S HISTORY

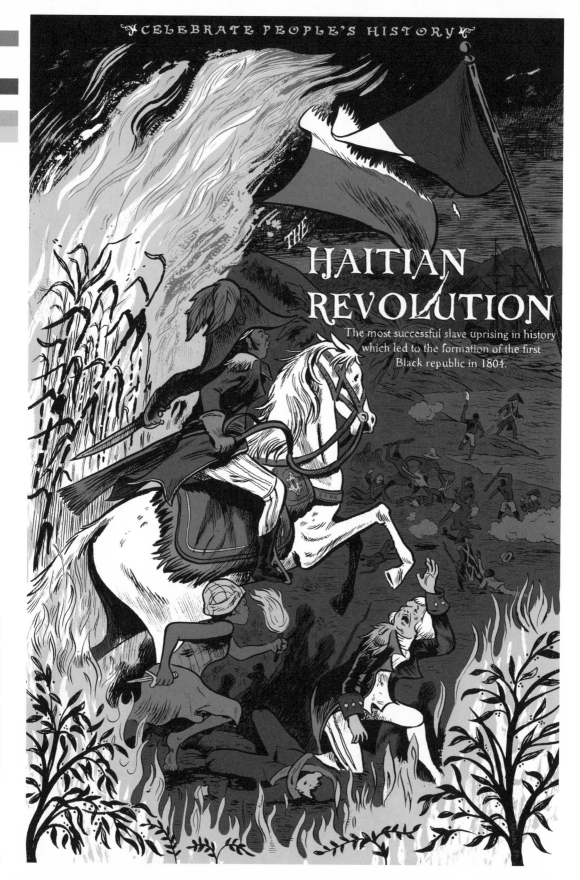

THE

HAITIAN REVOLUTION

The most successful slave uprising in history which led to the formation of the first Black republic in 1804.

"Certain inventions in machinery were introduced into the staple manufacturers of the north, which, greatly reducing the numbers of hands necessary to be employed, threw thousands out of work, and left them without legitimate means of sustaining life..."

WE PETITION NO MORE.
THAT WON'T DO - FIGHTING MUST.

LUDDITES

Being a Social Uprising in the Midlands of England between the Years of 1811 and 1813

TO PUT DOWN
ALL MACHINERY HURTFUL TO
COMMONALITY!

"Misery generates hate; these sufferers hated the machines which they believed took their bread from them; they hated the buildings which contained those machines; they hated the manufacturers who owned those buildings." -Charlotte Brontë, *Shirley*

CELEBRATE PEOPLE'S HISTORY

Signed by the General of the Army of Redressers
Ned Ludd, Clerk - Redressers for ever Amen.

ᎠᎴᏫᏯᎥ ᏴᏫ ᏯᏛᏟᏗᏯᎥ
CELEBRATE PEOPLE'S HISTORY

ᏣᎳᎩ ᎢᏓᏫᏟᎥᎢ
CHEROKEE WRITING SYSTEM

ᏆᎳᎩ ᏗᎧᎢᏟ ᎢᏓᎾᎢ
ᏏᎣᏗᏪᏟᎠ ᏔᎠᏫᏏ
ᏔᏆᎦᎭᎣᏔ ᏛᏈᏔᎠ
ᎣᏔᏴᏛᎢᏔ. ᏆᎠᎦᎭᎣᏔ
ᎠᏰᏗᎠ ᏣᎢᏏᏆᏟ ᏏᏍᏔ
ᏗᏣᎵᏃ ᎠᎣᏪᏟ ᏃᎢ
ᏠᏍᎢᏗᏟᏟ ᏣᎳᎩ ᎢᎠᎥᎤᏣ
ᏟᎭᎷᏟ ᎠᏫ ᏔᏍᎢ ᏗᎣᎢᎭᏟᎡᏔ
ᏏᎭᏗᎣᏟᎠᎢᎢᏔ.

A Cherokee dictionary was produced in the mid-1970s, 150 years after the first editors and printers of the *Cherokee Phoenix* came to New Echota to print the first Native American newspaper.

ᎠᏫᏏ ᏔᎣᎠᎴᎭᎣᏔ ᏪᏗᎠᎠ
ᏖᏴᏗᎵᏔ ᏈᏳ ᏟᏯᎥ
ᎤᏟᏞᏔᎢᎢᏔ.

In 1821 Sequoyah completed the development of a Cherokee writing system.

ᏖᏴ ᎠᏫᏯᎢ ᎤᏃᎢᏖ
ᏔᏍᎥᏜᎠᏁ.

Each character represents a syllable, instead of one sound as when one writes English, so it's called a syllabary.

ᏗᏖᎠᎠ ᏜᎩ ᏔᏍ ᏌᎠᏩᏫ
ᏣᎳᎩ ᎢᏓᎠᎤᎢᏗ ᏃᎢ
ᏪᎷᎩᎠᎩ ᏏᏍᎣᏝᏫᎵᏔ
ᏠᏍᎢᏗᏫᎢ ᎣᏈᏟᎢ.

There are 85 characters in the writing system and these were cast into metal for printing.

SEQUOYAH
ᏏᏉᏯᎤ

ᏔᏍᏛ ᏗᎣᎢᏟᏖ ᏏᏉᏯᎤ
ᏔᎠᏈᏝᎡᏇᏴ ᏃᎢ ᏏᏔᎠᎤᎡᏇᏴ
ᏈᏔᏔ. ᏛᏘᏃ ᏊᏃᎠᏌ ᏳᏟ
ᏔᎠᏈᏝᎡᏇᏴ ᏃᎢ ᏈᏃᎠᏌ ᎢᏓᎠᎤᎢᏗ
ᏍᏳ ᏈᏃᎠᏌ ᎢᏓᎠᎤᎢᏗ
ᎢᎤᏟᏏᏂᎢ.

Some say Sequoyah was illiterate, but how can you be illiterate if you're the person who developed your own system of writing?

ᏔᏍᏛ ᏗᎣᎢᏗᏔ Ꭻ ᏣᎳᎩ
ᎢᏓᎠᎤᎢᏗ ᏗᎧ ᏍᏖᏈ ᏍᎬᏫ
ᎧᏖᏘ Ꮘ ᏏᏉᏯᎤ ᏁᏟᏔ ᏈᏔᏔ.

Some say the writing system, or portion of it, may have existed even before Sequoyah.

ANARCHISM | COMMUNISM | SOCIALISM
ANTI-WAR | ANTI-IMPERIALISM | SOLIDARITY
ENVIRONMENTALISM
FEMINISM | QUEER LIBERATION
HEALTH | HOUSING | EDUCATION | CULTURE
LABOR | ANTI-CAPITALISM
SLAVERY | POLICE | PRISONS | ANTI-FASCISM
RACIAL JUSTICE | NATIONAL LIBERATION | INDIGENOUS STRUGGLE

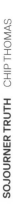

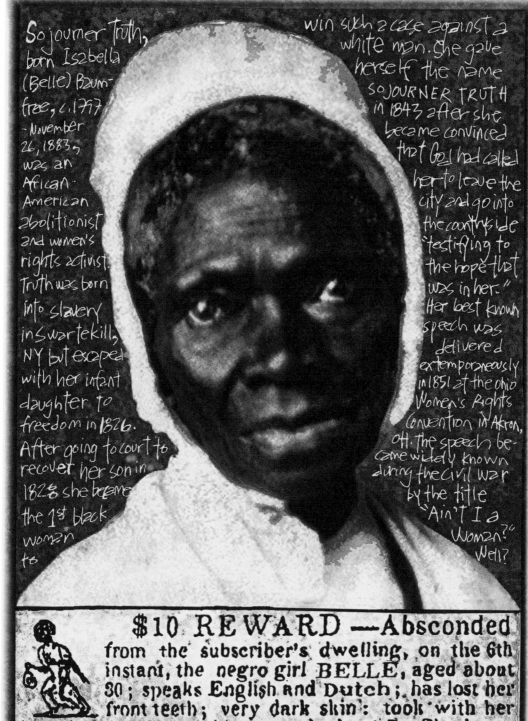

Sojourner Truth, born Isabella (Belle) Baumfree, c.1797 - November 26, 1883, was an African-American abolitionist and women's rights activist. Truth was born into slavery in Swartekill, NY but escaped with her infant daughter to freedom in 1826. After going to court to recover her son in 1828 she became the 1st black woman to win such a case against a white man. She gave herself the name SOJOURNER TRUTH in 1843 after she became convinced that God had called her to leave the city and go into the countryside "testifying to the hope that was in her." Her best known speech was delivered extemporaneously in 1851 at the Ohio Women's Rights Convention in Akron, OH. The speech became widely known during the civil war by the title "Ain't I a Woman?" Well?

 $10 REWARD —Absconded from the subscriber's dwelling, on the 6th instant, the negro girl BELLE, aged about 30; speaks English and Dutch; has lost her front teeth; very dark skin: took with her her daughter, a mulatto, aged about 7. She has a daughter on Girod street, No 185, and may go there at night. She absented herself without cause.

 CELEBRATE PEOPLE'S HISTORY

"We are a scattered tribe. We weren't claimed by the whites. We weren't claimed by the full bloods. They used to call us persons with no souls. Now at least we have an identity."

The Little Shell Band of Chippewa Indians

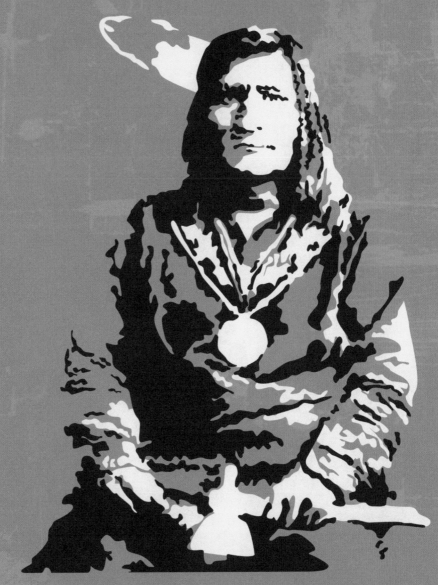

celebrate people's history

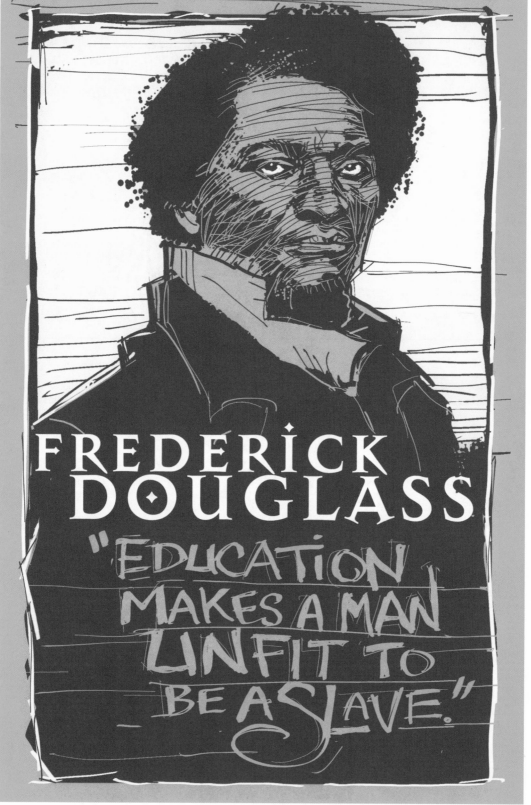

CELEBRATE PEOPLE'S HISTORY

FREDERICK DOUGLASS

"EDUCATION MAKES A MAN UNFIT TO BE A SLAVE."

RANI °F JHANSI

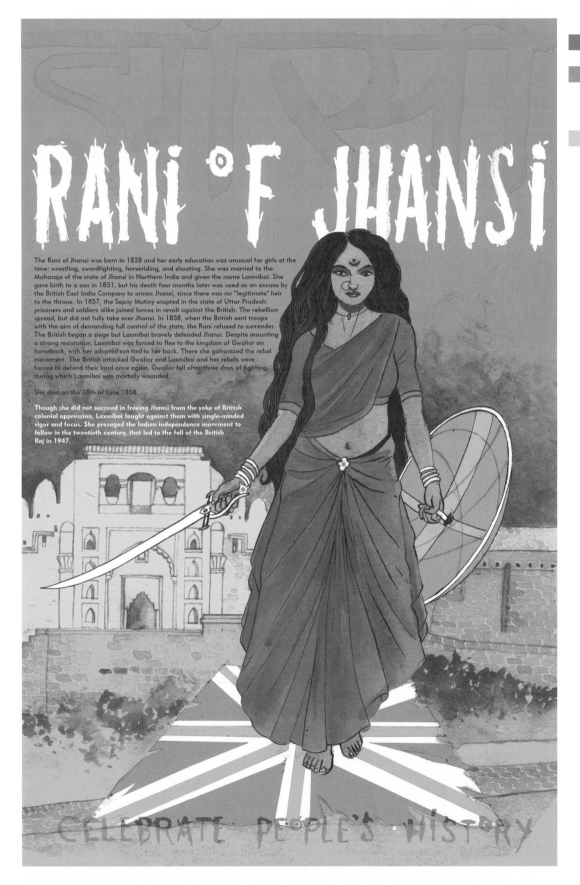

The Rani of Jhansi was born in 1828 and her early education was unusual for girls at the time: wrestling, swordfighting, horseriding, and shooting. She was married to the Maharaja of the state of Jhansi in Northern India and given the name Laxmibai. She gave birth to a son in 1851, but his death four months later was used as an excuse by the British East India Company to annex Jhansi, since there was no "legitimate" heir to the throne. In 1857, the Sepoy Mutiny erupted in the state of Uttar Pradesh: prisoners and soldiers alike joined forces in revolt against the British. The rebellion spread, but did not fully take over Jhansi. In 1858, when the British sent troops with the aim of demanding full control of the state, the Rani refused to surrender. The British began a siege but Laxmibai bravely defended Jhansi. Despite mounting a strong resistance, Laxmibai was forced to flee to the kingdom of Gwalior on horseback, with her adopted son tied to her back. There she galvanized the rebel movement. The British attacked Gwalior and Laxmibai and her rebels were forced to defend their land once again. Gwalior fell after three days of fighting, during which Laxmibai was mortally wounded.

She died on the 18th of June 1858.

Though she did not succeed in freeing Jhansi from the yoke of British colonial oppression, Laxmibai fought against them with single-minded vigor and focus. She presaged the Indian independence movement to follow in the twentieth century, that led to the fall of the British Raj in 1947.

CELEBRATE PEOPLE'S HISTORY

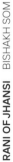

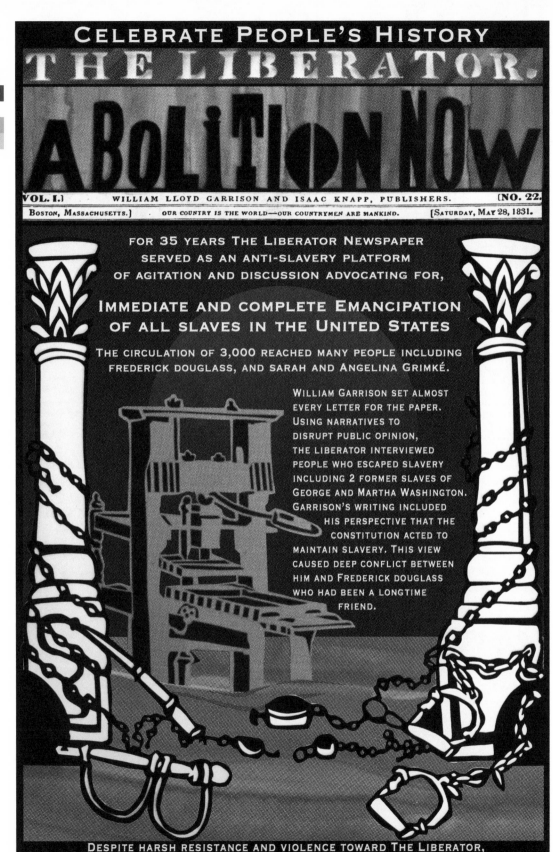

CELEBRATE PEOPLE'S HISTORY

THE LIBERATOR.

ABOLITION NOW

VOL. I.] WILLIAM LLOYD GARRISON AND ISAAC KNAPP, PUBLISHERS. [NO. 22.

BOSTON, MASSACHUSETTS.] · OUR COUNTRY IS THE WORLD—OUR COUNTRYMEN ARE MANKIND. · [SATURDAY, MAY 28, 1831.

FOR 35 YEARS THE LIBERATOR NEWSPAPER
SERVED AS AN ANTI-SLAVERY PLATFORM
OF AGITATION AND DISCUSSION ADVOCATING FOR,

IMMEDIATE AND COMPLETE EMANCIPATION
OF ALL SLAVES IN THE UNITED STATES

THE CIRCULATION OF 3,000 REACHED MANY PEOPLE INCLUDING
FREDERICK DOUGLASS, AND SARAH AND ANGELINA GRIMKÉ.

WILLIAM GARRISON SET ALMOST
EVERY LETTER FOR THE PAPER.
USING NARRATIVES TO
DISRUPT PUBLIC OPINION,
THE LIBERATOR INTERVIEWED
PEOPLE WHO ESCAPED SLAVERY
INCLUDING 2 FORMER SLAVES OF
GEORGE AND MARTHA WASHINGTON.
GARRISON'S WRITING INCLUDED
HIS PERSPECTIVE THAT THE
CONSTITUTION ACTED TO
MAINTAIN SLAVERY. THIS VIEW
CAUSED DEEP CONFLICT BETWEEN
HIM AND FREDERICK DOUGLASS
WHO HAD BEEN A LONGTIME
FRIEND.

DESPITE HARSH RESISTANCE AND VIOLENCE TOWARD THE LIBERATOR,
IT REMAINED FIERCELY DEDICATED TO ABOLITION THROUGH THE END OF THE CIVIL WAR.

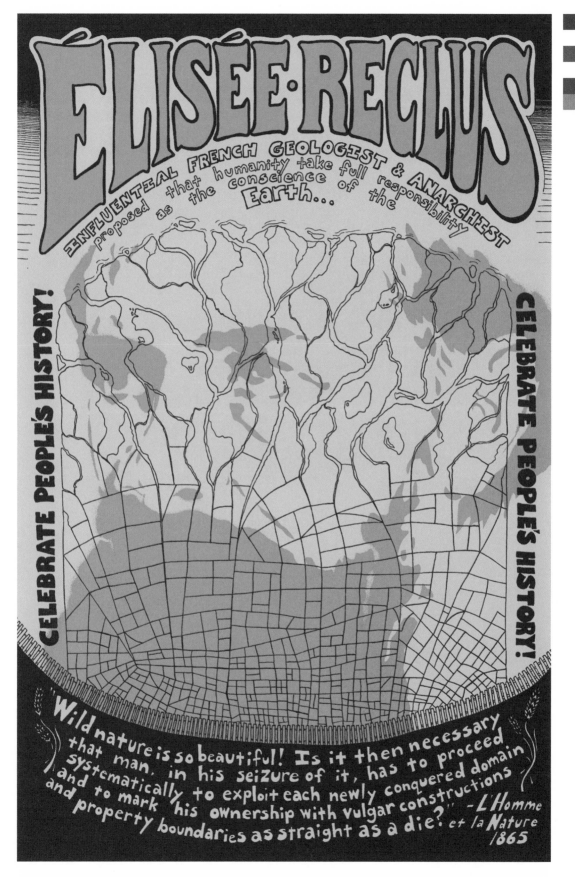

ÉLISÉE·RECLUS

INFLUENTEAL FRENCH GEOLOGIST & ANARCHEST proposed that humanity take full responsibility as the conscience of the Earth...

CELEBRATE PEOPLE'S HISTORY!

CELEBRATE PEOPLE'S HISTORY!

"Wild nature is so beautiful! Is it then necessary that man, in his seizure of it, has to proceed systematically to exploit each newly conquered domain and to mark his ownership with vulgar constructions and property boundaries as straight as a die?" —L'Homme et la Nature 1865

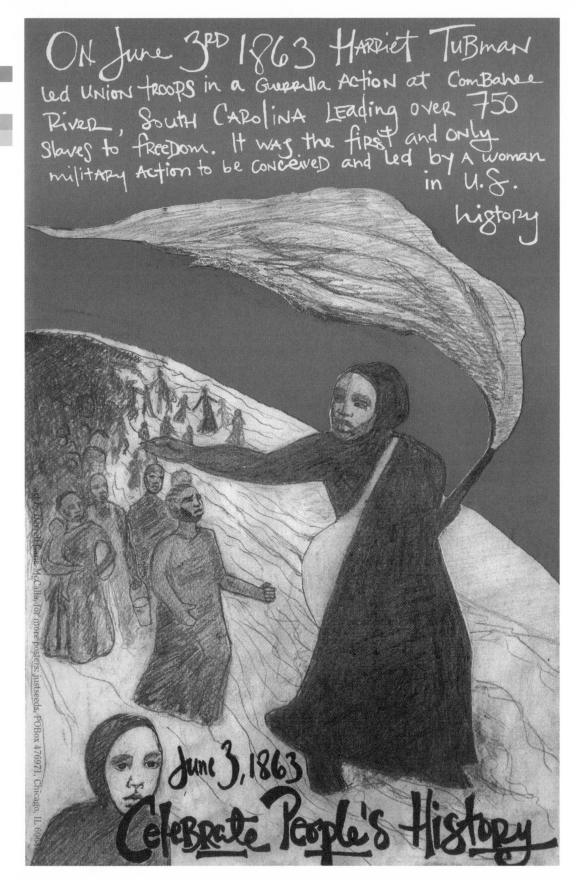

ON June 3RD 1863 HARRIET TUBMAN led UNION TROOPS in a GUERRILLA ACTION at ComBAhee RIVER, SOUTH CAROLINA LEADING over 750 slaves to freeDom. It was the first and only military Action to be CONCEIVED and led by A woman in U.S. history

June 3, 1863
Celebrate People's History

gabriel dumont
and the Métis Resistance of 1869-1870 & 1885

For the Métis of North America, the political and spiritual resistance of Gabriel Dumont stands against the Euro-Canadian expansion emerging from Ottawa.

As the Canadian Pacific Railway headed into the Native lands of the Upper Great Lakes

and the Western Prairie, the tradional lifeways of the Métis people were attacked.

As a 'leader' in the Great Buffalo Hunts, Dumont used advanced guerrilla tactics in various struggles of the Métis.

With the passing of the Dominion Lands Act of 1872, Euro-Canadian settlers began moving en mass to the Canadian West.

In the same year, Dumont was elected 'president' of his community, Batoche, Saskatchewan.

During the 1885 Resistance, Dumont led 'his people' into battle against the

encroaching policies and armies of

the Dominion of Canada.

celebrate people's history
We are the Otipemisiwak–the Free People!

ANARCHISM | COMMUNISM | SOCIALISM
ANTI-WAR | ANTI-IMPERIALISM | SOLIDARITY
ENVIRONMENTALISM
FEMINISM | QUEER LIBERATION
HEALTH | HOUSING | EDUCATION | CULTURE
LABOR | ANTI-CAPITALISM
SLAVERY | POLICE | PRISONS | ANTI-FASCISM
RACIAL JUSTICE | NATIONAL LIBERATION | INDIGENOUS STRUGGLE

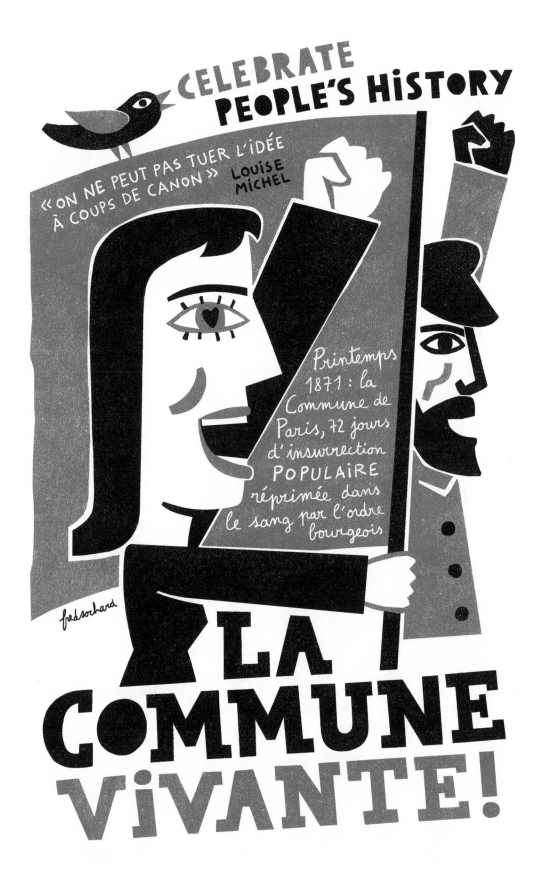

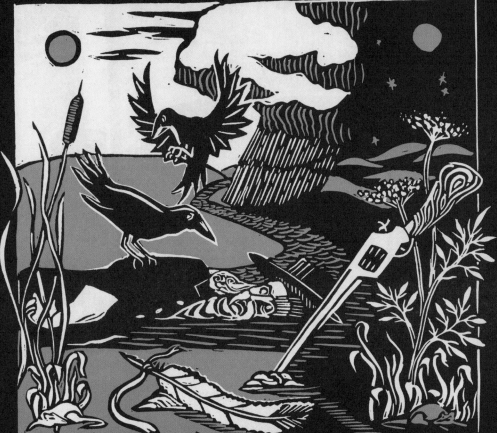

JUNE 25, 1876

LITTLE BIGHORN

On June 25th, 1876, General George Custer and a heavily armed cavalry regiment attacked a camp of Lakota, Arapaho and Cheyenne Indians on the banks of the Little Bighorn River in what is now Montana. Custer's regiment was part of the forces clearing the region of indigenous peoples so white settlers could mine gold in the Black Hills. That day Custer met a crushing defeat at the hands of the assembled tribes, under the leadership of Crazy Horse and Gall. Custer and his men were entirely wiped out in one of the greatest victories for Indian peoples during the last 500 years of Genocide in the Americas.

CELEBRATE PEOPLE'S HISTORY

...CELEBRATE PEOPLE'S HISTORY...

առնելու ժողովրդի պատմությունը

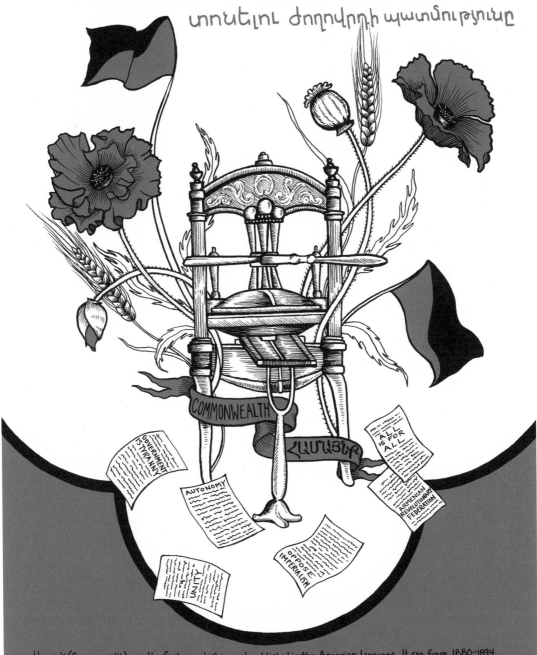

COMMONWEALTH

ՀԱՄԱՅՆՔ

GOVERNMENT IS TYRANNY

AUTONOMY

ALL IS FOR ALL

ARMENIAN REVOLUTIONARY FEDERATION

OPPOSE IMPERIALISM

UNITY

Hamaink (Commonwealth) was the first anarchist journal published in the Armenian language. It ran from 1880-1894, being printed outside of the repression of the Ottoman Empire first in Persia then later in Paris and London. The paper was published by the Armenian anarchist Alexandre Atabekian, a friend of anarcho-communist theorists Pyotr Kropotkin and Élisée Reclus. Commonwealth offered topics poignant to both regional and international revolutionary movements. It opposed the exploitation of the working class, European intervention, and centralization of the Armenian revolutionary movement. It called for self-determination, the communalization of land and stated that all government was tyranny. These beliefs would culminate into the development of the Armenian Revolutionary Federation. Today Commonwealth is remembered for spreading anarchist ideas in the Caucasus and agitating for direct action.

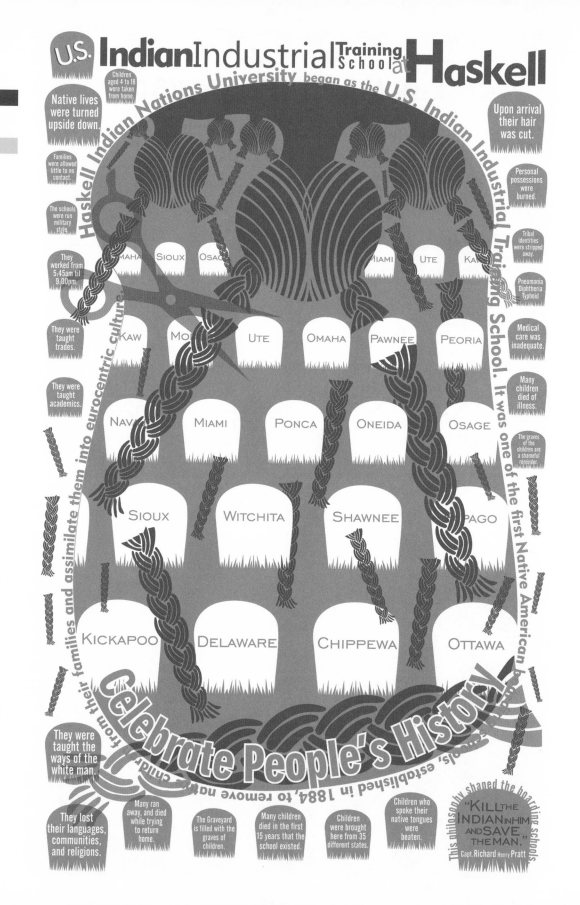

U.S. Indian Industrial Training School at Haskell

Haskell Indian Nations University began as the U.S. Indian Industrial Training School. It was one of the first Native American boarding schools, established in 1884, to remove native children from their families and assimilate them into eurocentric culture.

Native lives were turned upside down.

Children aged 4 to 18 were taken from home.

Families were allowed little to no contact.

The schools were run military style.

They worked from 5:45am til 9:00pm.

They were taught trades.

They were taught academics.

They were taught the ways of the white man.

They lost their languages, communities, and religions.

Upon arrival their hair was cut.

Personal possessions were burned.

Tribal identities were stripped away.

Pneumonia Diphtheria Typhoid

Medical care was inadequate.

Many children died of illness.

The graves of the children are a shameful reminder.

Many ran away, and died while trying to return home.

The Graveyard is filled with the graves of children.

Many children died in the first 15 years that the school existed.

Children were brought here from 35 different states.

Children who spoke their native tongues were beaten.

OMAHA SIOUX OSAGE MIAMI UTE KAW

KAW MO UTE OMAHA PAWNEE PEORIA

NAV MIAMI PONCA ONEIDA OSAGE

SIOUX WITCHITA SHAWNEE PAGO

KICKAPOO DELAWARE CHIPPEWA OTTAWA

Celebrate People's History

"KILL THE INDIAN IN HIM AND SAVE THE MAN."

This philosophy shaped the boarding schools.

Capt. Richard Henry Pratt

In response to the Chicago Police Department's killing of four workers during a strike at the McCormick Harvester's Works on May 3rd, labor leaders organized a meeting at Haymarket Square for the following night. About 3,000 persons assembled, later dwindling to a few hundred. A detachment of 180 policemen showed up. The speaker said the meeting was almost over. Then a bomb exploded in the midst of the police, wounding sixty-six, of whom seven later died (one died from the bomb blast, six others died from gunshot wounds from their fellow officers). The police fired into the crowd, killing several people, wounding 200.

haymarket
chicago may 4, 1886

Eight anarchists were arrested and put on trial. Facing an openly biased judge in Joseph Gary and a clearly hostile jury, the Haymarket Affair is one of the most infamously unjust trials in American history. The prosecution focused on the men's anarchist ties rather than determining whether the accused had any real connection to the crime. Essentially, eight men (seven of whom were not even present at the time the bomb was thrown) were tried and convicted because of their political beliefs.

August Spies, **Albert Parsons**, **George Engel**, and **Adolph Fischer** were hanged. **Louis Lingg** killed himself before the state could. **Samuel Fielden**, **Michael Schwab**, and **Oscar Neebe** were sentenced to prison (eventually being granted clemency in 1892).

The Haymarket Riot was an important event for the labor movement. The year 1886 became known as "the year of the great uprising of labor." From 1881 to 1885, strikes had averaged about 500 each year, involving perhaps 150,000 workers each year. In 1886 there were over 1,400 strikes, involving 500,000 workers.

celebrate

people's

history

"The time will come when our silence will be more powerful than the voices you are throttling today."

August Spies

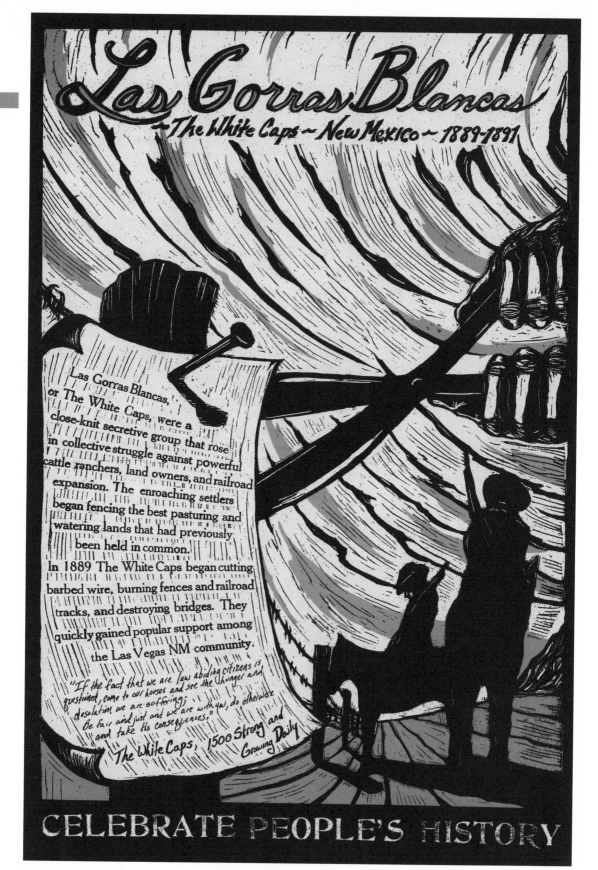

Las Gorras Blancas
~The White Caps~ New Mexico ~ 1889-1891

Las Gorras Blancas, or The White Caps, were a close-knit secretive group that rose in collective struggle against powerful cattle ranchers, land owners, and railroad expansion. The enroaching settlers began fencing the best pasturing and watering lands that had previously been held in common.

In 1889 The White Caps began cutting barbed wire, burning fences and railroad tracks, and destroying bridges. They quickly gained popular support among the Las Vegas NM community.

"If the fact that we are law abiding citizens is questioned, come to our houses and see the hunger and desolation we are suffering; be fair and just and we are with you, do otherwise and take the consequences."

The White Caps, 1500 Strong and Growing Daily

CELEBRATE PEOPLE'S HISTORY

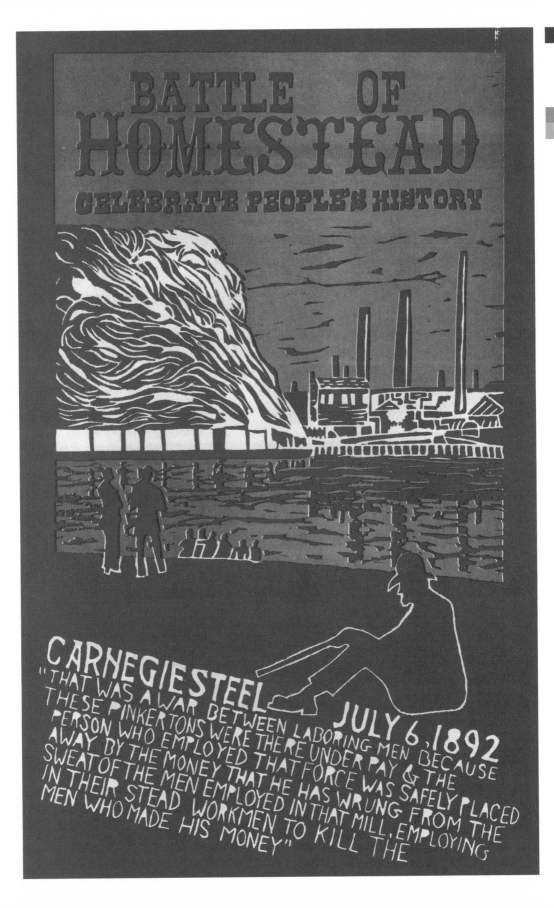

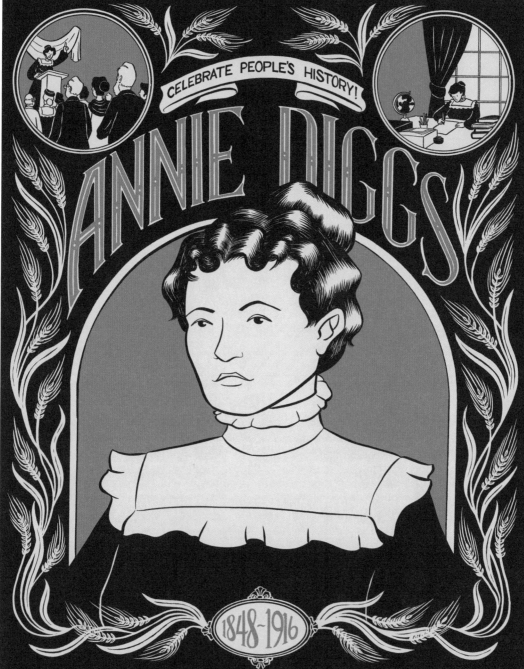

CELEBRATE PEOPLE'S HISTORY!

ANNIE DIGGS

1848~1916

"It has been said that the biggest man in the Populist party of Kansas today is a woman," wrote The Leavenworth Times in 1900. Annie Diggs became interested in the Populist movement in the 1870s through her involvement with the Unitarian Church in Lawrence. By 1882, she and her husband had begun publishing the Kansas Liberal from their home. Their paper criticized an economic and political system run by a small wealthy class, demanding rights for laborers and farmers. Throughout her career, Diggs became a respected journalist and orator. She held leadership positions in several local and national organizations, including the Kansas Equal Suffrage Association, National Populist Committee, Social Reform Union, and Kansas Women's Press Association. Her political influence led opponents to criticize her "petticoat politics." In 1898, she became the first woman to serve as Kansas State Librarian. In her later years, Diggs retired from politics to focus on writing, publishing two books before her death in 1916.

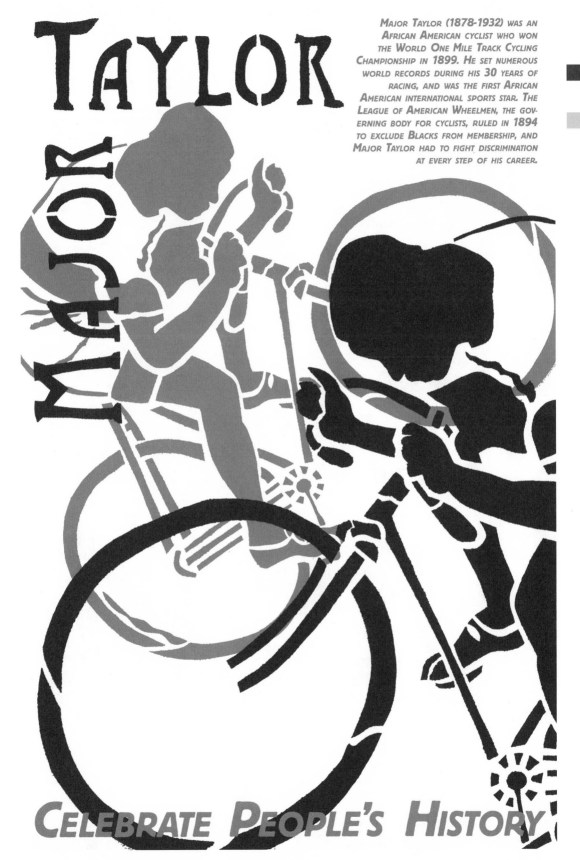

TAYLOR
MAJOR

Major Taylor (1878-1932) was an African American cyclist who won the World One Mile Track Cycling Championship in 1899. He set numerous world records during his 30 years of racing, and was the first African American international sports star. The League of American Wheelmen, the governing body for cyclists, ruled in 1894 to exclude Blacks from membership, and Major Taylor had to fight discrimination at every step of his career.

CELEBRATE PEOPLE'S HISTORY

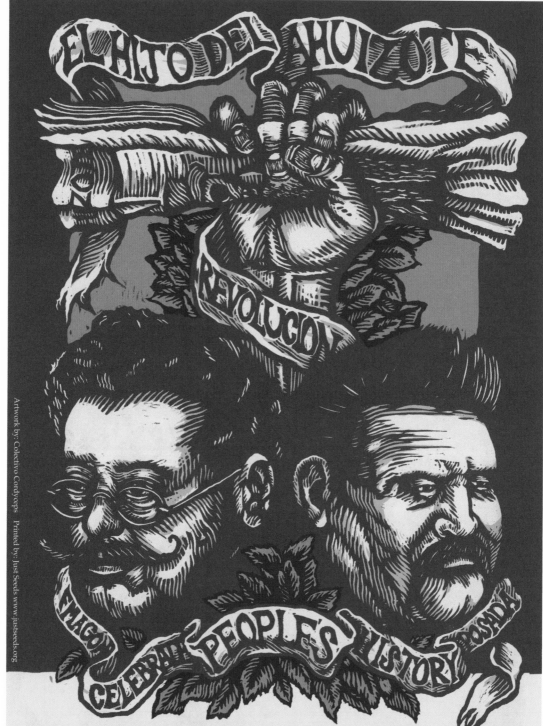

Artwork by: Colectivo Cordyceps Printed by: Just Seeds www.justseeds.org

El Hijo del Ahuizote was a revolutionary newspaper that fought against Porfirio Díaz's dictatorship in Mexico. The paper combined the anarchist ideas of Ricardo Flores Magón and his brother Enrique, with Jose Guadalupe Posada's graphics to unleash a war against authoritarianism. Founded in 1885, it was shut down and censored multiple times. Even after the paper fell victim to repression, Magón and Posada were involved in other publications that expressed the same unrest and helped pave the road towards the Mexican Revolution of 1910.

El Hijo del Ahuizote fue un periódico revolucionario que luchó contra la dictadura de Porfirio Díaz en Mexico. La publicación combinó el pensamiento anarquista de Ricardo Flores Magón y su hermano Enrique, con la gráfica popular de protesta de Jose Guadalupe Posada para desatar una larga guerra contra el autoritarismo, que después de que el periódico se ve reprimido y cerrado definitivamente se expresa en otras publicaciones que juntas irían a ayudar a pavimentar el camino hacia la Revolución Mexicana en 1910.

"That which is maintained with blood and fire through blood and fire shall fall."
-Ricardo Flores Magón.

"Que a sangre y fuego caiga, lo que a sangre y fuego se mantiene."
-Ricardo Flores Magón.

ANARCHISM | COMMUNISM | SOCIALISM
ANTI-WAR | ANTI-IMPERIALISM | SOLIDARITY
ENVIRONMENTALISM
FEMINISM | QUEER LIBERATION
HEALTH | HOUSING | EDUCATION | CULTURE
LABOR | ANTI-CAPITALISM
SLAVERY | POLICE | PRISONS | ANTI-FASCISM
RACIAL JUSTICE | NATIONAL LIBERATION | INDIGENOUS STRUGGLE

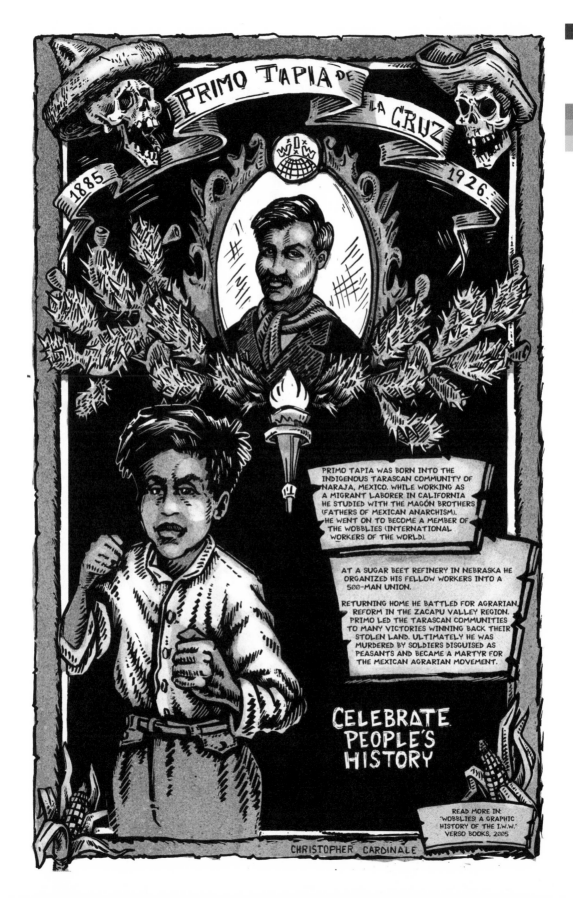

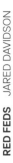

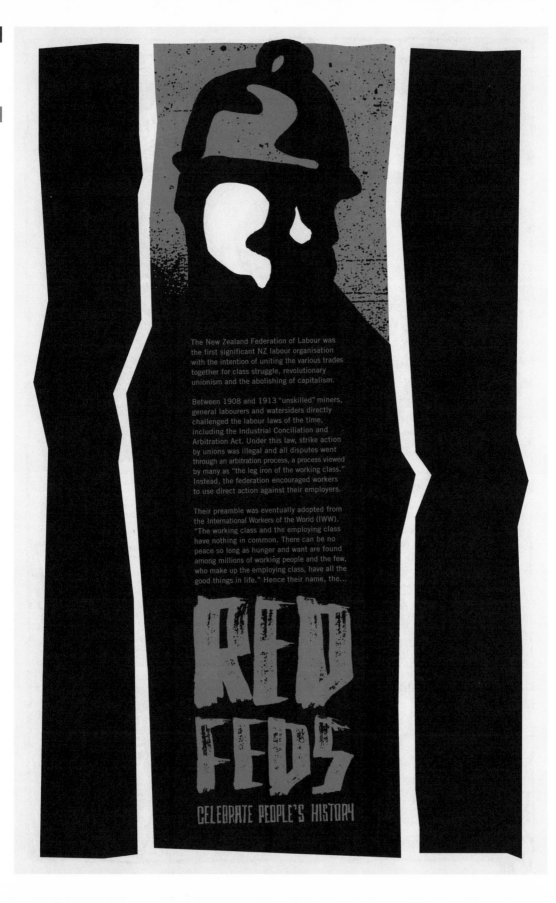

The New Zealand Federation of Labour was the first significant NZ labour organisation with the intention of uniting the various trades together for class struggle, revolutionary unionism and the abolishing of capitalism.

Between 1908 and 1913 "unskilled" miners, general labourers and watersiders directly challenged the labour laws of the time, including the Industrial Conciliation and Arbitration Act. Under this law, strike action by unions was illegal and all disputes went through an arbitration process, a process viewed by many as "the leg iron of the working class." Instead, the federation encouraged workers to use direct action against their employers.

Their preamble was eventually adopted from the International Workers of the World (IWW). "The working class and the employing class have nothing in common. There can be no peace so long as hunger and want are found among millions of working people and the few, who make up the employing class, have all the good things in life." Hence their name, the...

RED FEDS

CELEBRATE PEOPLE'S HISTORY

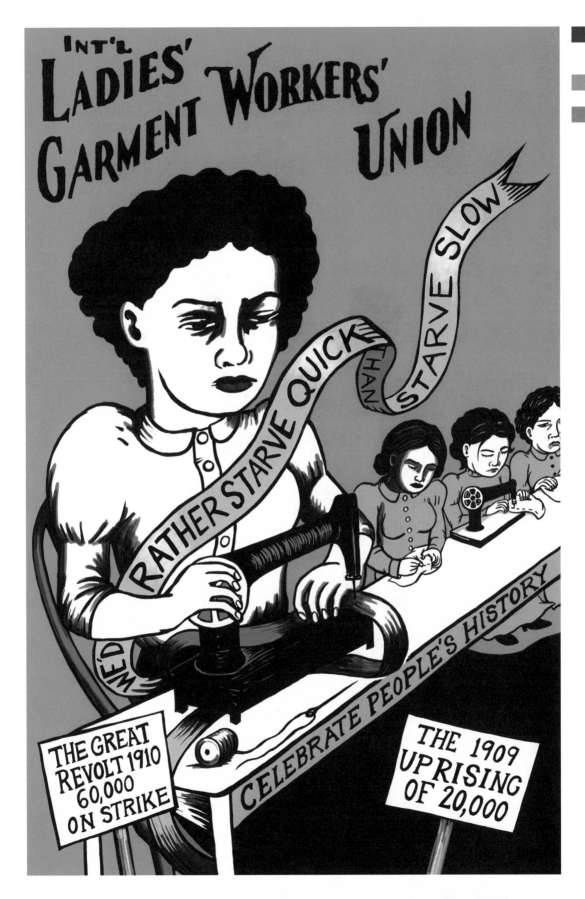

INTERNATIONAL LADIES' GARMENT WORKERS UNION JENNY SCHMID

ELIZABETH GURLEY FLYNN

Celebrate People's History

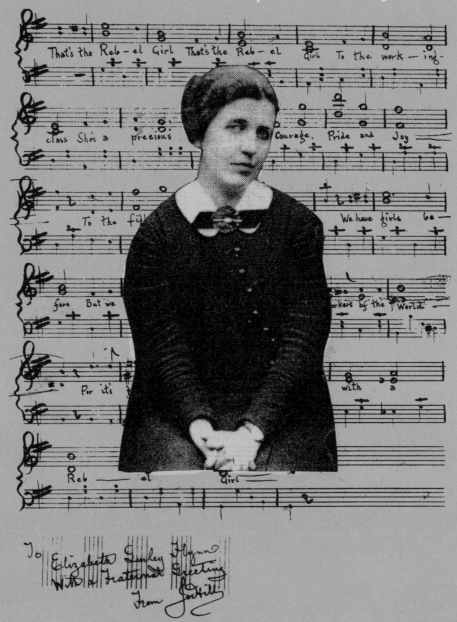

Elizabeth Gurley Flynn (1890-1964) – the "Rebel Girl" – gave her first speech, "What Socialism Will Do for Women," at age sixteen at the Harlem Socialist Club. Shortly thereafter she joined the IWW and quickly became one the organization's most important strike organizers and speakers. Flynn helped lead the IWW free speech fights in Missoula, Montana (1908), in Spokane, Washington (1909-1910), and was a strike organizer during the Lawrence Textile Strike (1912) and the silk workers' general strike in Paterson, New Jersey (1913). In 1920, she became a founding member of the American Civil Liberties Union (ACLU), and continued to fight for labor, social justice, and women's rights throughout her life.

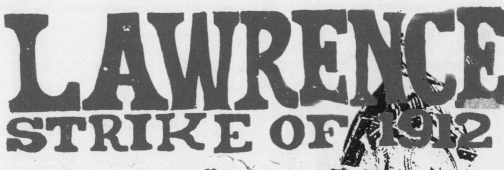

LAWRENCE
STRIKE OF 1912

LAWRENCE, Mass., Sept. 30.—

First "Demonstration Strike."

For the first time in this country a "demonstration strike" against the imprisonment of labor leaders took place here to-day. After hand-to-hand fights between rioters and police, from the opening of the textile mill gates in the morning until the closing at night, the demonstration was called off by the Industrial Workers of the World.

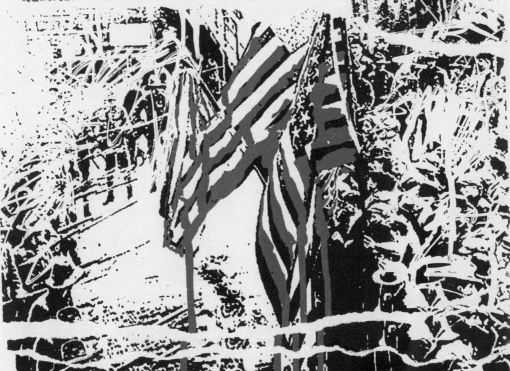

celebrate peoples history

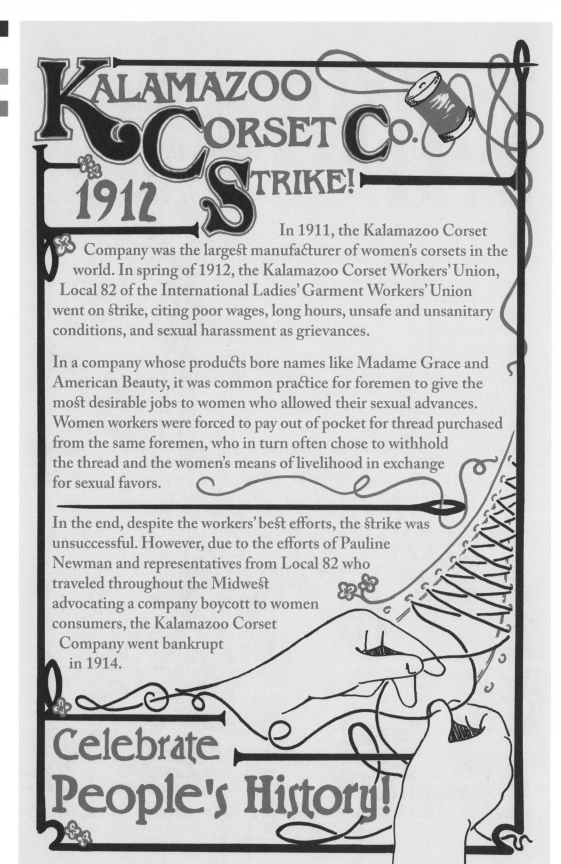

KALAMAZOO CORSET CO. 1912 STRIKE!

In 1911, the Kalamazoo Corset Company was the largest manufacturer of women's corsets in the world. In spring of 1912, the Kalamazoo Corset Workers' Union, Local 82 of the International Ladies' Garment Workers' Union went on strike, citing poor wages, long hours, unsafe and unsanitary conditions, and sexual harassment as grievances.

In a company whose products bore names like Madame Grace and American Beauty, it was common practice for foremen to give the most desirable jobs to women who allowed their sexual advances. Women workers were forced to pay out of pocket for thread purchased from the same foremen, who in turn often chose to withhold the thread and the women's means of livelihood in exchange for sexual favors.

In the end, despite the workers' best efforts, the strike was unsuccessful. However, due to the efforts of Pauline Newman and representatives from Local 82 who traveled throughout the Midwest advocating a company boycott to women consumers, the Kalamazoo Corset Company went bankrupt in 1914.

Celebrate People's History!

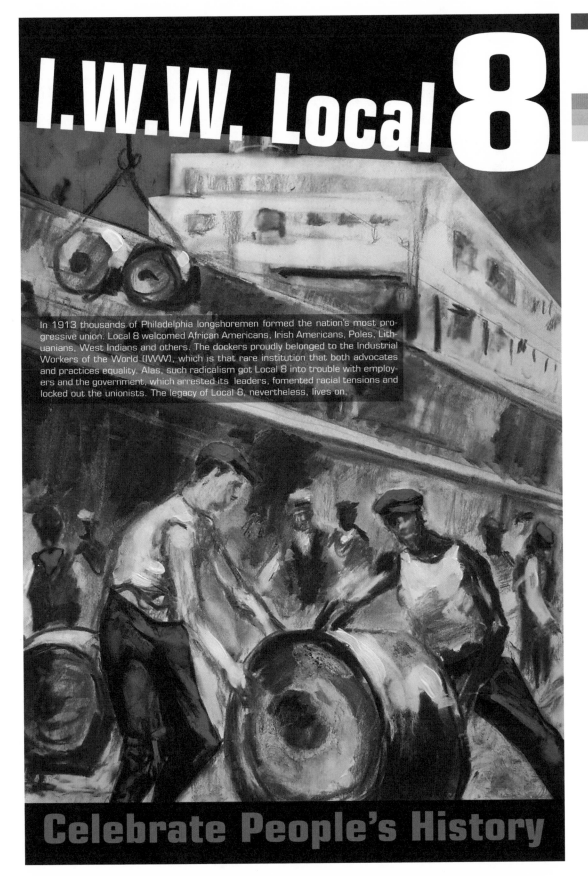

I.W.W. Local 8

In 1913 thousands of Philadelphia longshoremen formed the nation's most progressive union. Local 8 welcomed African Americans, Irish Americans, Poles, Lithuanians, West Indians and others. The dockers proudly belonged to the Industrial Workers of the World (IWW), which is that rare institution that both advocates and practices equality. Alas, such radicalism got Local 8 into trouble with employers and the government, which arrested its leaders, fomented racial tensions and locked out the unionists. The legacy of Local 8, nevertheless, lives on.

Celebrate People's History

IWW (INDUSTRIAL WORKERS OF THE WORLD) LOCAL 8 PETER COLE AND MARC NELSON

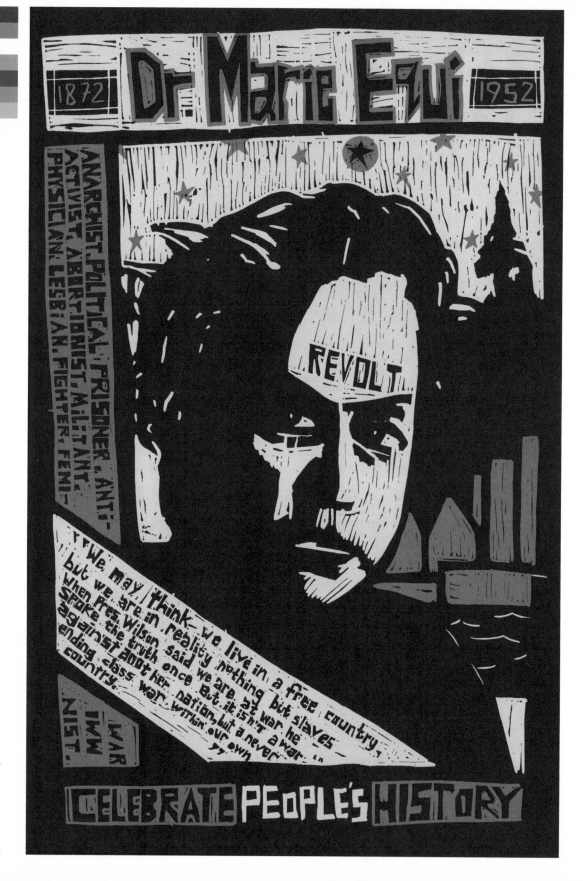

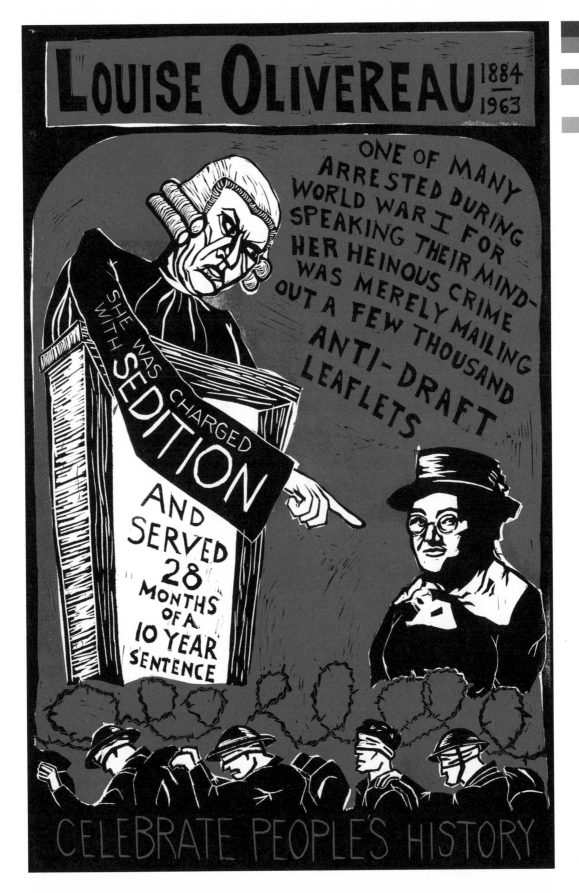

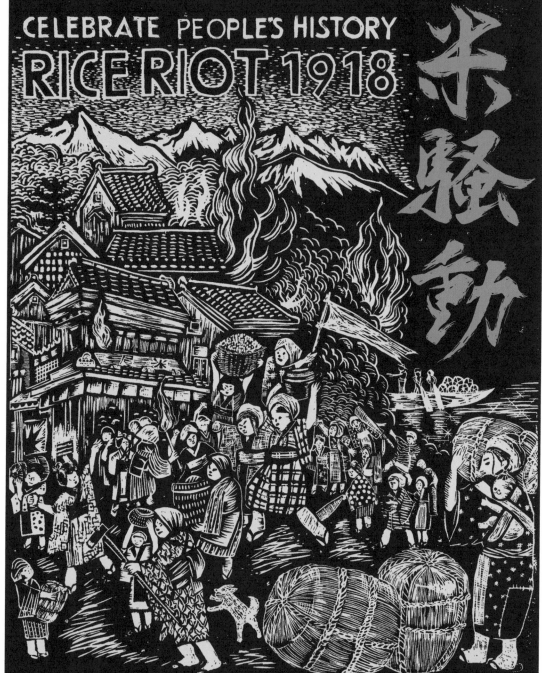

CELEBRATE PEOPLE'S HISTORY

RICE RIOT 1918

米騒動

Rice Riots began in 1918 when 10-20 female dock laborers made a direct demand for rice at a warehouse in Toyama, Japan. The demand was in response to merchants buying all the rice in the market so they could sell it to the Japanese government for their troops in Siberia, doubling the price and making rice inaccessible for the common folks. The demands turned into a massive uprising, inspiring more than 1 million people to take action all over Japan. These riots were no accident but an organized resistance led by female laborers, who only earned 60% of their male counterparts. The Rice Riots became a turning point for Japanese labor movements and class warfare.

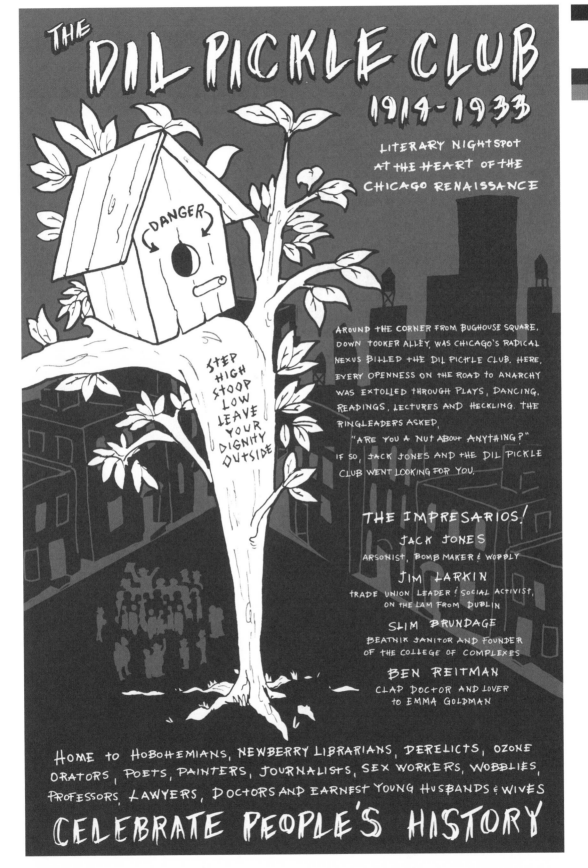

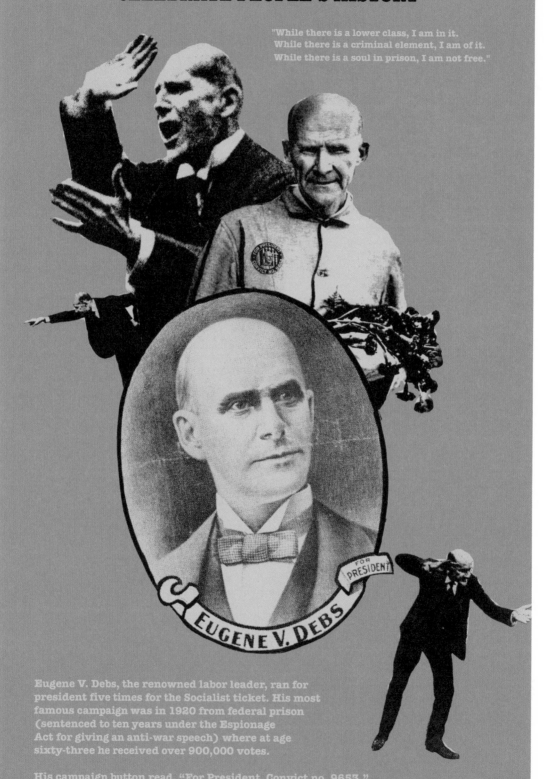

CELEBRATE PEOPLE'S HISTORY

"While there is a lower class, I am in it.
While there is a criminal element, I am of it.
While there is a soul in prison, I am not free."

EUGENE V. DEBS

FOR PRESIDENT

Eugene V. Debs, the renowned labor leader, ran for president five times for the Socialist ticket. His most famous campaign was in 1920 from federal prison (sentenced to ten years under the Espionage Act for giving an anti-war speech) where at age sixty-three he received over 900,000 votes.

His campaign button read, "For President, Convict no. 9653."

EUGENE V. DEBS NICOLAS LAMPERT

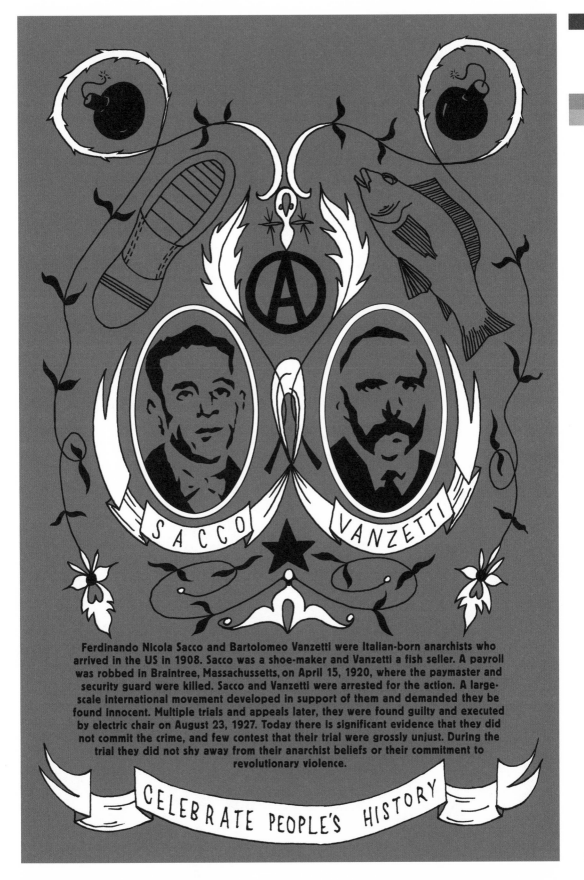

Ferdinando Nicola Sacco and Bartolomeo Vanzetti were Italian-born anarchists who arrived in the US in 1908. Sacco was a shoe-maker and Vanzetti a fish seller. A payroll was robbed in Braintree, Massachussetts, on April 15, 1920, where the paymaster and security guard were killed. Sacco and Vanzetti were arrested for the action. A large-scale international movement developed in support of them and demanded they be found innocent. Multiple trials and appeals later, they were found guilty and executed by electric chair on August 23, 1927. Today there is significant evidence that they did not commit the crime, and few contest that their trial were grossly unjust. During the trial they did not shy away from their anarchist beliefs or their commitment to revolutionary violence.

SACCO AND VANZETTI JOSH MACPHEE

In 1920, women incarcerated at New York's Bedford Hills Correctional Facility staged multiple sonic riots. "Devil's Chorus Sung by girl Rioters," read a headline. One of these women, Esther Brown, is immortalized in Saidiya Hartman's essay "The Anarchy of Colored girls Assembled in a Riotous Manner." Celebrate People's History!

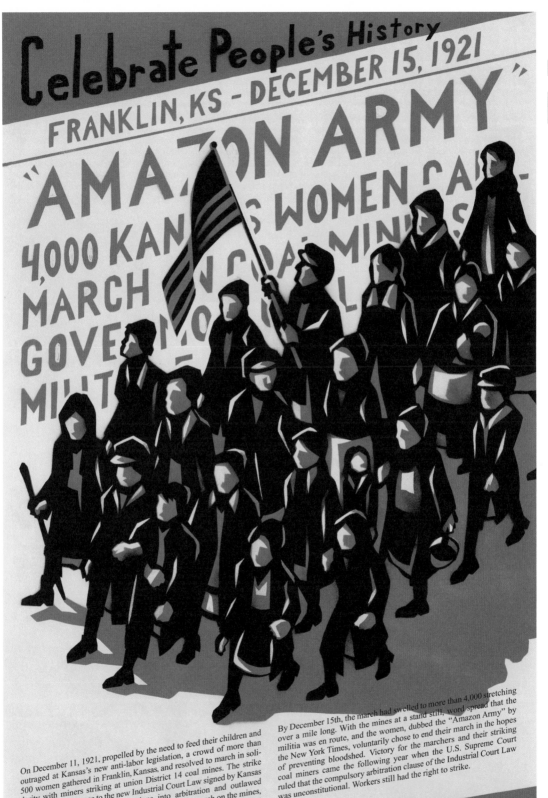

Celebrate People's History

FRANKLIN, KS - DECEMBER 15, 1921

"AMAZON ARMY"

4,000 KANSAS WOMEN CARRY MARCH ON COAL MINES GOVERNOR MILIT

On December 11, 1921, propelled by the need to feed their children and outraged at Kansas's new anti-labor legislation, a crowd of more than 500 women gathered in Franklin, Kansas, and resolved to march in solidarity with miners striking at union District 14 coal mines. The strike was called in response to the new Industrial Court Law signed by Kansas Governor Allen, which forced unions into arbitration and outlawed strikes. On December 12th, the women began their march on the mines, armed only with the American flag, which they carried to make clear that the values it symbolized were synonymous to those of their cause.

By December 15th, the march had swelled to more than 4,000 stretching over a mile long. With the mines at a stand still, word spread that the militia was en route, and the women, dubbed the "Amazon Army" by the New York Times, voluntarily chose to end their march in the hopes of preventing bloodshed. Victory for the marchers and their striking coal miners came the following year when the U.S. Supreme Court ruled that the compulsory arbitration clause of the Industrial Court Law was unconstitutional. Workers still had the right to strike.

in april 1921,

in the wake of the Japanese socialist league, which was formed in december of 1920, the sekirankai (red waves society) was formed with the adoption of socialism as its goal. it was the first anti-imperialist women's body in japan, a time when women were banned from participation in any political association. immediately after its formation, they participated in the second may day with their hand-made flag and earned plaudits from comrades of various labor movements and political organizations. they were vigorously suppressed by the police force and two members were taken into long-term custody. though there were clamp-downs, they actively carried on their movement by holding a lecture on women's problems in june, giving a five-day series of summer lectures in july, and, as needed, distributing newspapers and pamphlets denominated as book day. in the fall of the same year, on the occasion of extensive maneuvers by army troops, members of the seki ran kai distributed anti-military, anti-war fliers to the military personnel who stayed at different private residences. this action was regarded as a secret publication by police. the public saw this incident as the sekirankai persuading the army to turn red. key members were taken into long-term custody, which made it difficult for them to hold regular meetings on a monthly basis and naturally led to their dissolution after 8 months of activities. however, most members dedicated their whole life to social movements, women's movements, and anti-war movements.

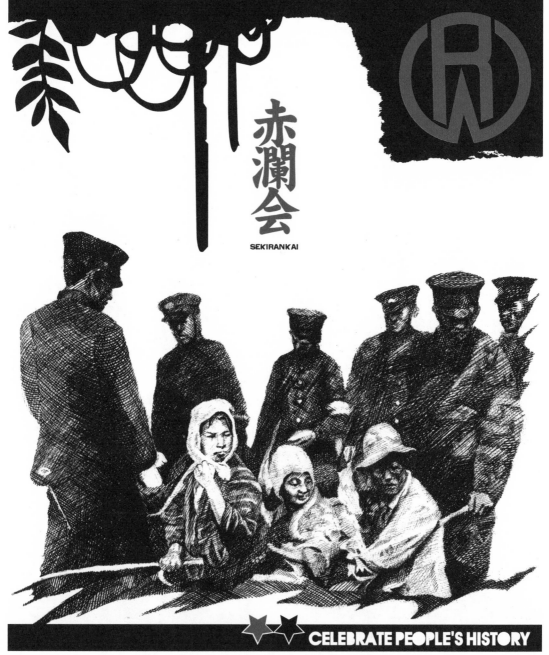

赤瀾会

SEKIRANKAI

CELEBRATE PEOPLE'S HISTORY

THE BATTLE OF BLAIR MOUNTAIN

After years of inhumane living and working conditions, in 1921 the coal miners of Appalachia answered the call to organize. The largest armed uprising in US labor history, 12,000 workers from West Virginia, Kentucky, Pennsylvania, and Ohio flooded Kanawha County, WV, to set up a union by force. Vehemently anti-union, a local sheriff and the coal companies attacked the miners. Thousands of armed and angry miners rushed into the lush hills and winding paths of Blair Mountain to fight for the union. Federal troops were called in and the miners dispersed in order to avoid further bloodshed. At the time the struggle was seen as a failure, but in retrospect the Battle of Blair Mountain led directly to a much larger and stronger union movement.

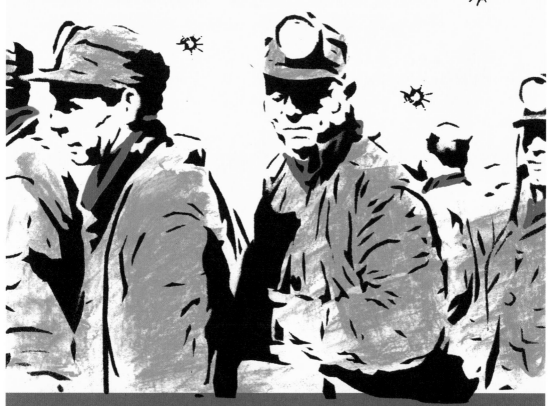

CELEBRATE PEOPLE'S HISTORY

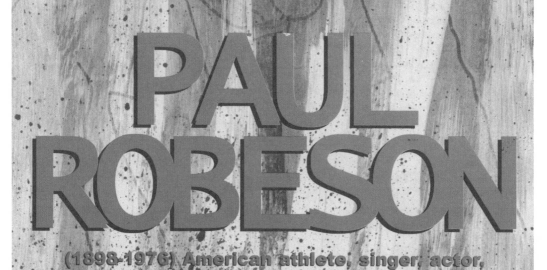

PAUL ROBESON

(1898-1976) American athlete, singer, actor, and political activist. Performed and spoke out against racism and in support of labour and peace. Fought for an anti-lynching law. The U.S. revoked his passport. To circumvent this travel restriction he performed two concerts on the U.S.-Canadian border. Forty thousand people came.

"The artist must elect to fight for Freedom or for Slavery. I made my choice. I had no alternative."

CELEBRATE
PEOPLE'S
HISTORY

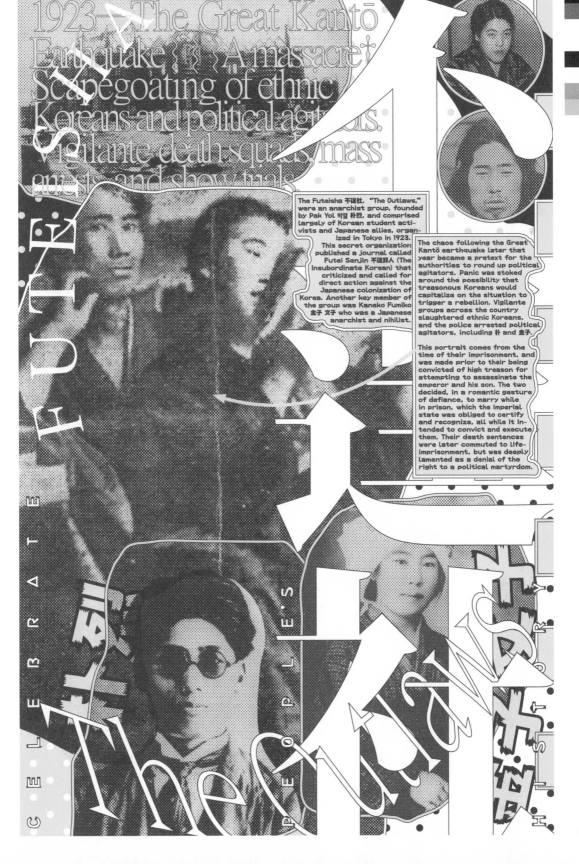

1923 — The Great Kantō Earthquake ☜ ☞ A massacre. Scapegoating of ethnic Koreans and political agitators. Vigilante death squads, mass arrests, and show trials.

The Futeisha 不逞社, "The Outlaws," were an anarchist group, founded by Pak Yol 박열 朴烈, and comprised largely of Korean student activists and Japanese allies, organized in Tokyo in 1923. This secret organization published a journal called Futei Senjin 不逞鮮人 (The Insubordinate Korean) that criticized and called for direct action against the Japanese colonization of Korea. Another key member of the group was Kaneko Fumiko 金子 文子 who was a Japanese anarchist and nihilist.

The chaos following the Great Kantō earthquake later that year became a pretext for the authorities to round up political agitators. Panic was stoked around the possibility that treasonous Koreans would capitalize on the situation to trigger a rebellion. Vigilante groups across the country slaughtered ethnic Koreans, and the police arrested political agitators, including 朴 and 金子.

This portrait comes from the time of their imprisonment, and was made prior to their being convicted of high treason for attempting to assassinate the emperor and his son. The two decided, in a romantic gesture of defiance, to marry while in prison, which the imperial state was obliged to certify and recognize, all while it intended to convict and execute them. Their death sentences were later commuted to life-imprisonment, but was deeply lamented as a denial of the right to a political martyrdom.

ANARCHISM | COMMUNISM | SOCIALISM
ANTI-WAR | ANTI-IMPERIALISM | SOLIDARITY
ENVIRONMENTALISM
FEMINISM | QUEER LIBERATION
HEALTH | HOUSING | EDUCATION | CULTURE
LABOR | ANTI-CAPITALISM
SLAVERY | POLICE | PRISONS | ANTI-FASCISM
RACIAL JUSTICE | NATIONAL LIBERATION | INDIGENOUS STRUGGLE

Angel Island Liberty Association 自治會

天使島自由協會（或"自治會"）是一個約在1922年至1952年間由被拘留在天使島移民局的華人們所組成的互助協會。在美籍華裔廚工的幫助下，該協會為被拘留在島上的華人走私信件，將信件蓋上蠟紙折疊其中並粘貼至餐具的底部，幫助同胞們通過嚴格縝密的移民審訊。

The Angel Island Liberty Association (or "Self-governing Association") was a mutual aid society run by Chinese detainees at the Angel Island Immigration Station from 1922 until about 1952. With the help of Chinese American kitchen staff, the Association smuggled letters to help detainees pass detailed immigration interrogations. Letters were folded inside wax paper and taped to the bottoms of dishes.

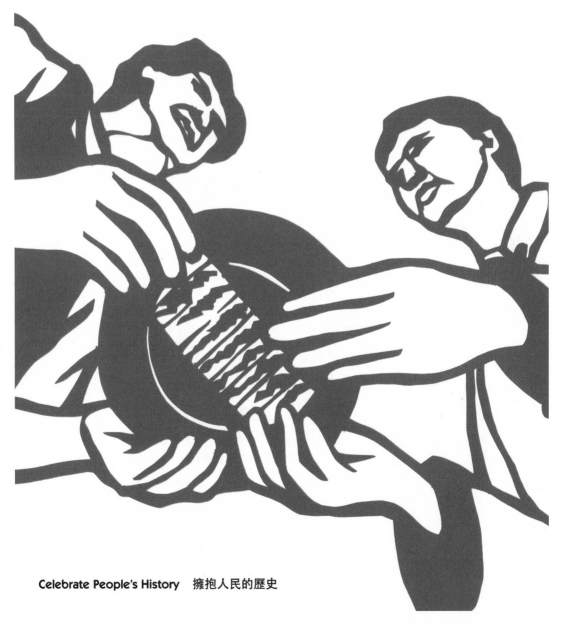

Celebrate People's History 擁抱人民的歷史

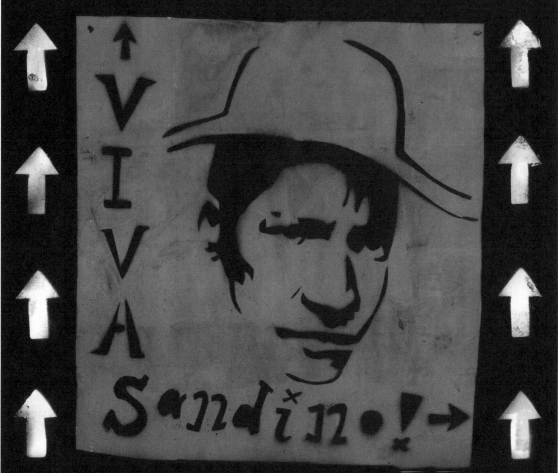

General Sandino's six year struggle in the Nicaraguan mountains leading a handful of campesinos and laborers must be viewed as the result of centuries of foreign domination of the country and of the repeated surrender by the ruling groups to those same foreign powers. Those men who fought bitterly with their machetes and antiquated rifles, who made bombs from empty tin cans filled with rocks and scrap iron, who brought down enemy planes practically with stones, who always maintained high morale in the face of an enemy a hundred times more powerful–they demonstrated something that until the appearance of that popular army had been concealed in the difficult terrain of Latin American history: the hopeful prospect that campesinos, with their own leaders, with tactics forged in the course of the fight, and doctrines arising from the process itself, could organize a successful struggle for national autonomy.

Sergio Ramírez

Augusto César Sandino 1895-1934

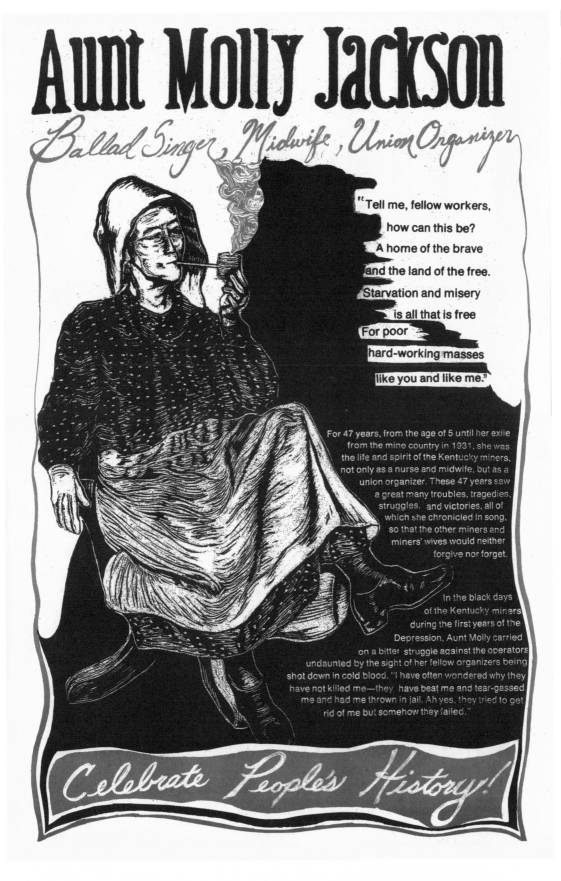

Aunt Molly Jackson

Ballad Singer, Midwife, Union Organizer

"Tell me, fellow workers,
how can this be?
A home of the brave
and the land of the free.
Starvation and misery
is all that is free
For poor
hard-working masses
like you and like me."

For 47 years, from the age of 5 until her exile from the mine country in 1931, she was the life and spirit of the Kentucky miners, not only as a nurse and midwife, but as a union organizer. These 47 years saw a great many troubles, tragedies, struggles, and victories, all of which she chronicled in song, so that the other miners and miners' wives would neither forgive nor forget.

In the black days of the Kentucky miners during the first years of the Depression, Aunt Molly carried on a bitter struggle against the operators undaunted by the sight of her fellow organizers being shot down in cold blood. "I have often wondered why they have not killed me—they have beat me and tear-gassed me and had me thrown in jail. Ah yes, they tried to get rid of me but somehow they failed."

Celebrate People's History!

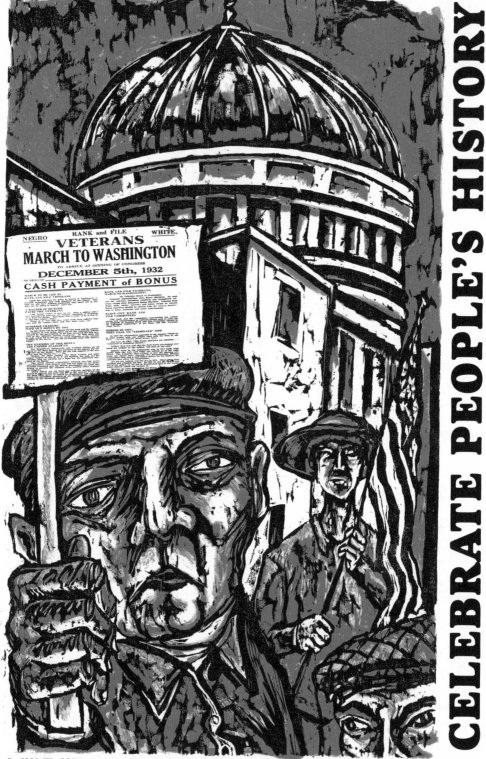

In 1932, World War I veterans came to Washington, DC, to demand payment for the service bonds they had been issued. They became known as the **Bonus Marchers**. Their actions helped turn the country against the Hoover Administration which treated them with brutal repression. General Douglas MacArthur led the last cavalry charge in US Military history against the 43,000 Bonus Marchers camped out on the Anacostia Flats in DC. Finally, in 1936 the veterans were allowed to redeem their service bonds.

THE FUNSTEN 500

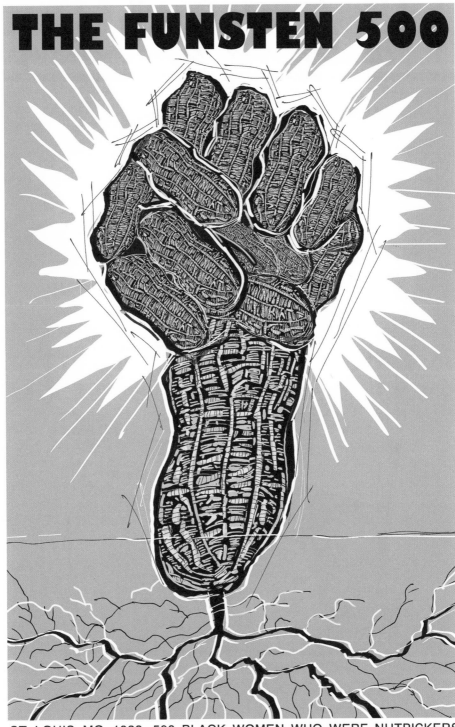

ST. LOUIS, MO, 1933. 500 BLACK WOMEN WHO WERE NUTPICKERS FOR THE FUNSTEN NUT COMPANY MOUNTED A SUCCESSFUL LABOR STRIKE AGAINST THE INDUSTRY GIANT CITING LOW WAGES AND INHUMANE WORKING CONDITIONS AS MAJOR CONCERNS. THIS STRIKE WAS ONE OF MANY MIDWESTERN RADICAL LABOR STRIKES ORGANIZED BY AFRICAN AMERICANS IN OUR COUNTRY'S HISTORY.

JOHN JENNINGS

FUNSTEN 500

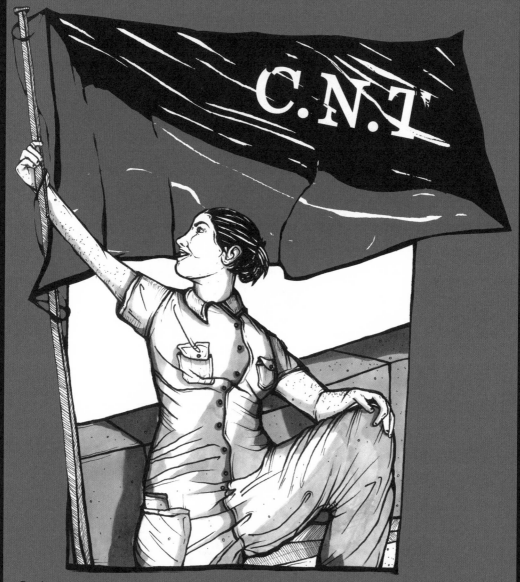

LAS MUJERES LIBRES
celebrate people's history

C.N.T

During an era of extreme gender division in Spain, women's freedom was severely restricted. In response to the women's situation, two groups of anarchist women in Barcelona and Madrid had begun organising two years before the revolution. In preparation for the revolution, they built up a network of women activists which would soon merge to form the Mujeres Libres (Free Women) organisation in September 1936. Over 30,000 of Las Mujeres Libres advocated the alliance of women and the anarchist movement, involved more women in the CNT (Confederación Nacional de Trabojo, the anarchist-syndicalist trade union), and raised consciousness and education to "free herself from triple enslavement: her enslavement to ignorance, her enslavement as a producer, and her enslavement as a woman." The social revolution in Spain was made by people, like Las Mujeres Libres, who pressed for radical changes in an oppressive, conformist society.

Flint Sit-Down Strike, 1936-1937

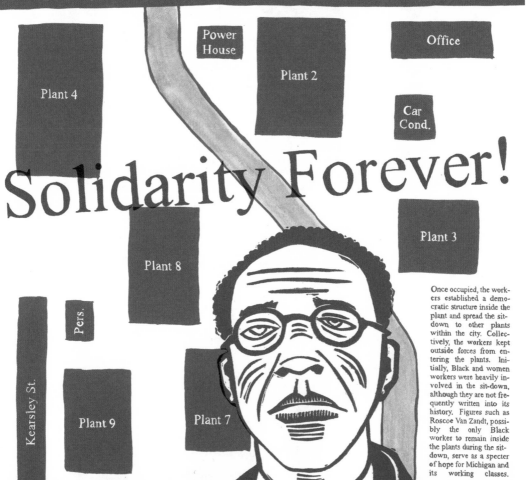

FLINT RIVER

Plant 5

Fisher 2

Although Michigan's economic future is in peril, the state's history as a hotbed of working-class radicalism is one that cannot be denied. In 1936, one year after the founding of the United Auto Workers, the union began organizing workers against the repressive Fordist tactics of the automotive industry. In December 1936, as a strategic maneuver, workers occupied Fisher Body Plant 1 to prevent the management from moving machinery to another plant.

THE SIT-DOWN STRIKE HURTS THE BOSS.

Power House

Office

Plant 2

Plant 4

Car Cond.

Solidarity Forever!

Plant 3

Plant 8

Once occupied, the workers established a democratic structure inside the plant and spread the sit-down to other plants within the city. Collectively, the workers kept outside forces from entering the plants. Initially, Black and women workers were heavily involved in the sit-down, although they are not frequently written into its history. Figures such as Roscoe Van Zandt, possibly the only Black worker to remain inside the plants during the sit-down, serve as a specter of hope for Michigan and its working classes.

Pers.

Kearsley St.

Plant 9

Plant 7

Celebrate People's History

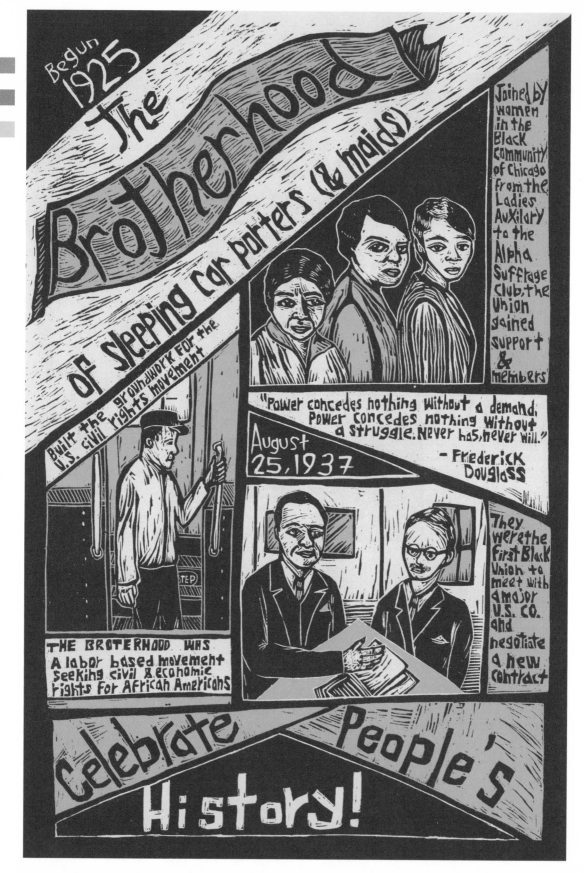

THE DURRUTI COLUMN

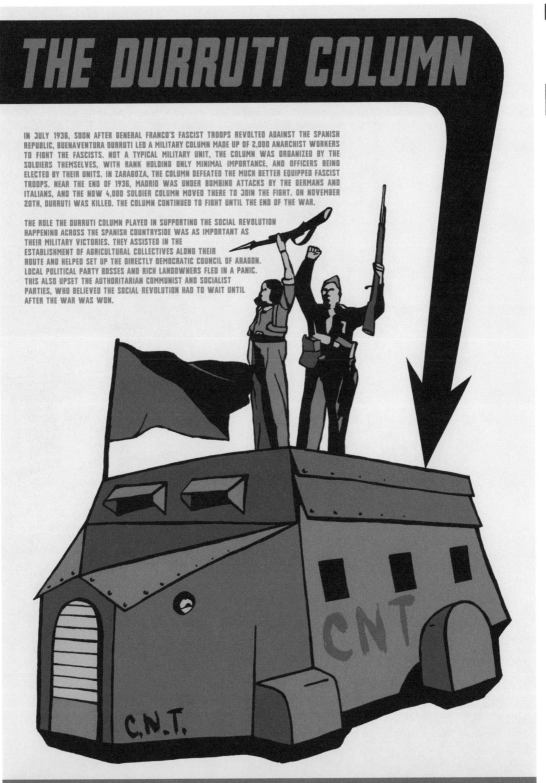

IN JULY 1936, SOON AFTER GENERAL FRANCO'S FASCIST TROOPS REVOLTED AGAINST THE SPANISH REPUBLIC, BUENAVENTURA DURRUTI LED A MILITARY COLUMN MADE UP OF 2,000 ANARCHIST WORKERS TO FIGHT THE FASCISTS. NOT A TYPICAL MILITARY UNIT, THE COLUMN WAS ORGANIZED BY THE SOLDIERS THEMSELVES, WITH RANK HOLDING ONLY MINIMAL IMPORTANCE, AND OFFICERS BEING ELECTED BY THEIR UNITS. IN ZARAGOZA, THE COLUMN DEFEATED THE MUCH BETTER EQUIPPED FASCIST TROOPS. NEAR THE END OF 1936, MADRID WAS UNDER BOMBING ATTACKS BY THE GERMANS AND ITALIANS, AND THE NOW 4,000 SOLDIER COLUMN MOVED THERE TO JOIN THE FIGHT. ON NOVEMBER 20TH, DURRUTI WAS KILLED. THE COLUMN CONTINUED TO FIGHT UNTIL THE END OF THE WAR.

THE ROLE THE DURRUTI COLUMN PLAYED IN SUPPORTING THE SOCIAL REVOLUTION HAPPENING ACROSS THE SPANISH COUNTRYSIDE WAS AS IMPORTANT AS THEIR MILITARY VICTORIES. THEY ASSISTED IN THE ESTABLISHMENT OF AGRICULTURAL COLLECTIVES ALONG THEIR ROUTE AND HELPED SET UP THE DIRECTLY DEMOCRATIC COUNCIL OF ARAGON. LOCAL POLITICAL PARTY BOSSES AND RICH LANDOWNERS FLED IN A PANIC. THIS ALSO UPSET THE AUTHORITARIAN COMMUNIST AND SOCIALIST PARTIES, WHO BELIEVED THE SOCIAL REVOLUTION HAD TO WAIT UNTIL AFTER THE WAR WAS WON.

CELEBRATE PEOPLE'S HISTORY

1941 Disney animators' strike

Walt Disney's Snow White and the Seven Dwarfs made the studio record profits in 1938. Yet its animators received no credits, and were instead left facing low wages and lay-offs. The Screen Cartoonist's Guild Local #858 Hollywood had won union contracts with MGM and Looney Tunes, and tried to open negotiations. But Disney refused to recognize the union, and on May 29th, the animators went to the picket line. The five-week strike only ended when FDR sent in federal mediators. They found in the guild's favour on every issue, from pay to screen credits.

After unionization, the atmosphere at Disney became intolerable for guild members. Several left to form United Productions of America, the studio that defined the modernist style of animation in the 1950s. Disney, meanwhile, testified before the House Un-American Activities Committee that he believed the strike leaders were communists. Many of his former artists were blacklisted.

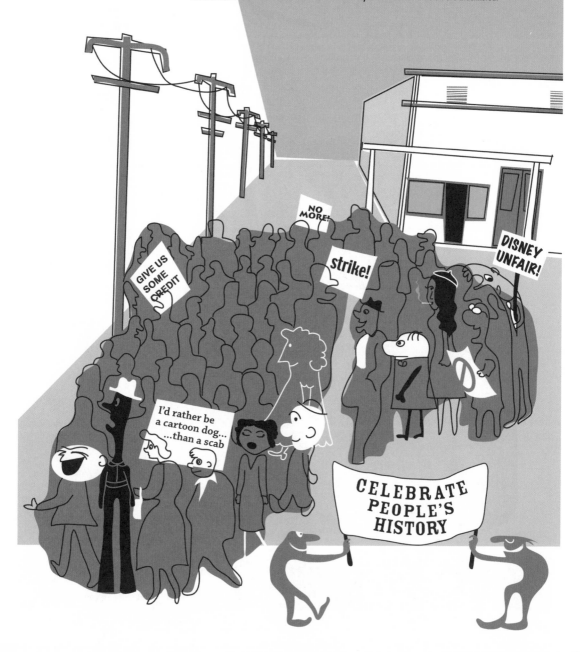

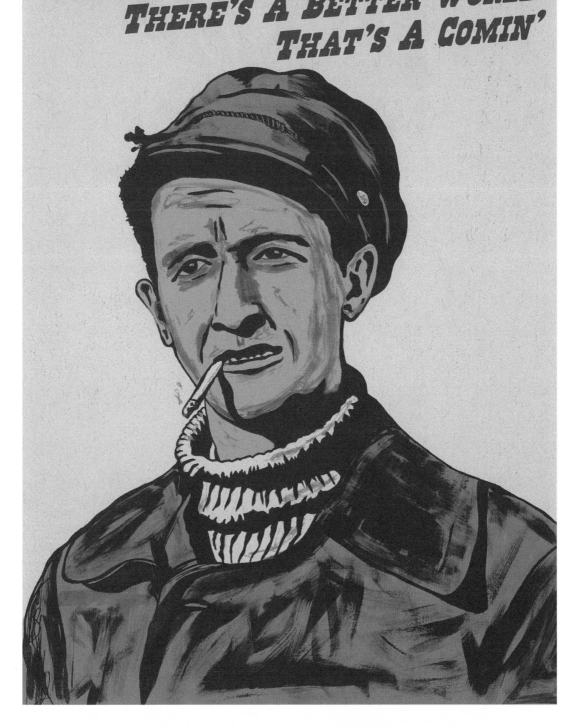

WOODY GUTHRIE

THERE'S A BETTER WORLD THAT'S A COMIN'

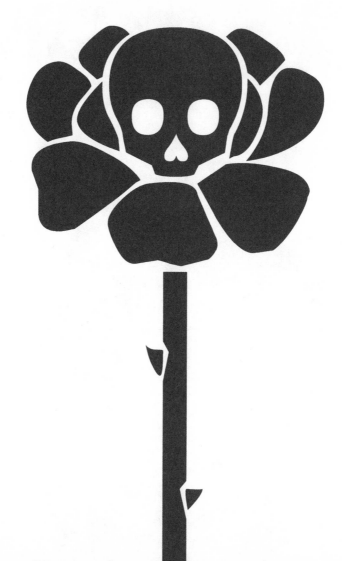

MATILDE LANDA (1904-1942) WAS A FAMOUS MILITANT OF THE PCE (SPANISH COMMUNIST PARTY) WHO FOUGHT IN THE SPANISH CIVIL WAR AGAINST FRANCO'S DICTATORSHIP. WHEN THE WAR WAS OVER, SHE WAS ARRESTED AND INCARCERATED. SINCE SHE WAS A WELL-KNOWN PUBLIC FIGURE, THE FASCIST REGIME DECIDED TO MAKE AN EXAMPLE OF HER. THEY TRIED TO FORCE MATILDE—A COMMUNIST AND AN ATHEIST—TO BE BAPTIZED, THREATENING TO STARVE THE CHILDREN OF HER FELLOW INMATES IF SHE DIDN'T ACCEPT. WHILE SHE WANTED WHAT WAS BEST FOR THE CHILDREN, SHE ALSO COULDN'T ABANDON HER IDEALS AND EVERYTHING SHE BELIEVED IN. ON SEPTEMBER 26TH, 1942, EVERYTHING WAS READY IN THE PALMA DE MALLORCA PRISON FOR HER BAPTISM. INSTEAD SHE COMMITTED SUICIDE, THROWING HERSELF FROM THE PRISON ROOFTOP TO THE COURTYARD BELOW. THE ECCLESIASTIC AUTHORITIES PRESENT BAPTIZED HER IN "ARTICULO MORTIS." THE POET MIGUEL HERNÁNDEZ WROTE THE POEM "A MATILDE" IN DEDICATION TO HER.

CELEBRATE PEOPLE'S HISTORY ★ MATILDE LANDA

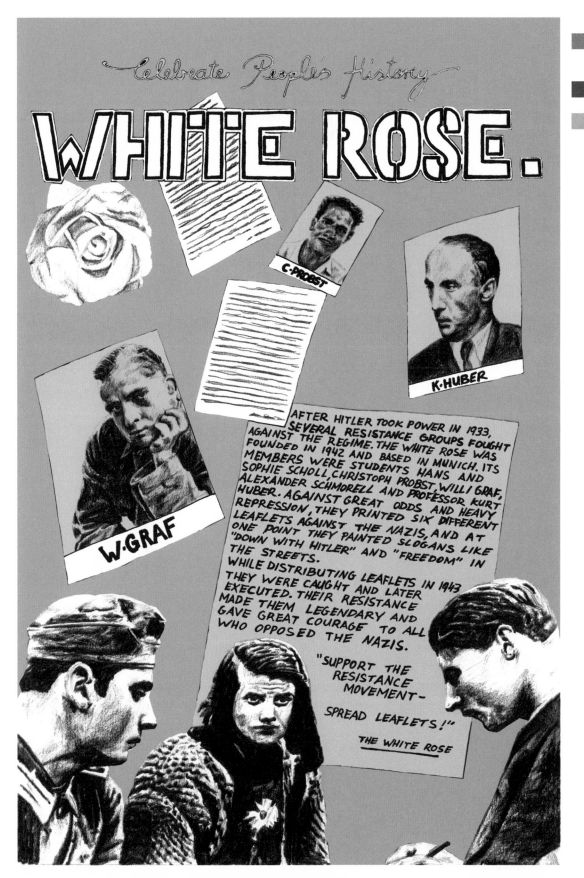

Celebrate People's History

WHITE ROSE.

C·PROBST

K·HUBER

W·GRAF

AFTER HITLER TOOK POWER IN 1933, SEVERAL RESISTANCE GROUPS FOUGHT AGAINST THE REGIME. THE WHITE ROSE WAS FOUNDED IN 1942 AND BASED IN MUNICH. ITS MEMBERS WERE STUDENTS HANS AND SOPHIE SCHOLL, CHRISTOPH PROBST, WILLI GRAF, ALEXANDER SCHMORELL AND PROFESSOR KURT HUBER. AGAINST GREAT ODDS AND HEAVY REPRESSION, THEY PRINTED SIX DIFFERENT LEAFLETS AGAINST THE NAZIS, AND AT ONE POINT THEY PAINTED SLOGANS LIKE "DOWN WITH HITLER" AND "FREEDOM" IN THE STREETS.

WHILE DISTRIBUTING LEAFLETS IN 1943 THEY WERE CAUGHT AND LATER EXECUTED. THEIR RESISTANCE MADE THEM LEGENDARY AND GAVE GREAT COURAGE TO ALL WHO OPPOSED THE NAZIS.

"SUPPORT THE RESISTANCE MOVEMENT—

SPREAD LEAFLETS!"

THE WHITE ROSE

Today:

Desegregation Workshop

Highlander opened its doors in 1932 with the express intent of enabling poor and working class people in the South to radically change society. Its educational philosophy valued democracy, justice and learners' self-empowerment. It became the first openly integrated educational space in the South while training union leaders in the 1940s. This led Highlander to be a nerve center of the civil rights movement, hosting desegregation workshops and providing space for radical groups such as SNCC to strategize. Highlander was closed by the Tennessee Supreme Court in 1961, the victim of a red-baiting campaign aided by those who wanted to maintain a segregated South and keep organized labor under control. Highlander rechartered and moved to New Market, TN. www.highlandercenter.org

celebrate people's history

"the best teachers of poor and working people are the people themselves. they are the experts on their own experiences and problems"

—Myles Horton, founder of Highlander

CELEBRATE PEOPLE'S HISTORY · EL MAQUIS

THE SPANISH MAQUIS WERE GUERRILLAS WHO FOUGHT AGAINST THE FRANCO REGIME. THEY CARRIED OUT SABOTAGE IN SPAIN, AS WELL AS CONTRIBUTING TO THE FIGHT AGAINST NAZI GERMANY AND THE VICHY REGIME IN FRANCE IN THE 1940S. THE ANTI-FRANCO GUERRILLA RESISTANCE IN SPAIN BEGAN BEFORE THE END OF THE SPANISH CIVIL WAR IN 1939. THE OUTBREAK OF WORLD WAR II SO SOON AFTER SURPRISED A LARGE PART OF THE SPANISH REPUBLICAN EXILES IN FRANCE; MANY OF THEM JOINED THE FRENCH RESISTANCE. BY 1944, WITH THE GERMAN FORCES IN RETREAT, MANY OF THE GUERRILLAS REFOCUSED THEIR FIGHT TOWARDS SPAIN. SOME COLUMNS FOUGHT ON INTO THE SPANISH INTERIOR AND CONNECTED WITH THE PARTISAN GROUPS THAT HAD REMAINED IN THE PYRENEES MOUNTAINS SINCE 1939. THE APOGEE OF GUERRILLA ACTION WAS BETWEEN 1945 AND 1947. AFTER THIS, FRANCO'S REPRESSION INTENSIFIED, AND LITTLE BY LITTLE THE GROUPS WERE DESTROYED. MANY OF THEIR MEMBERS DIED OR WERE INCARCERATED, WHILE OTHERS ESCAPED TO EXILE IN FRANCE.

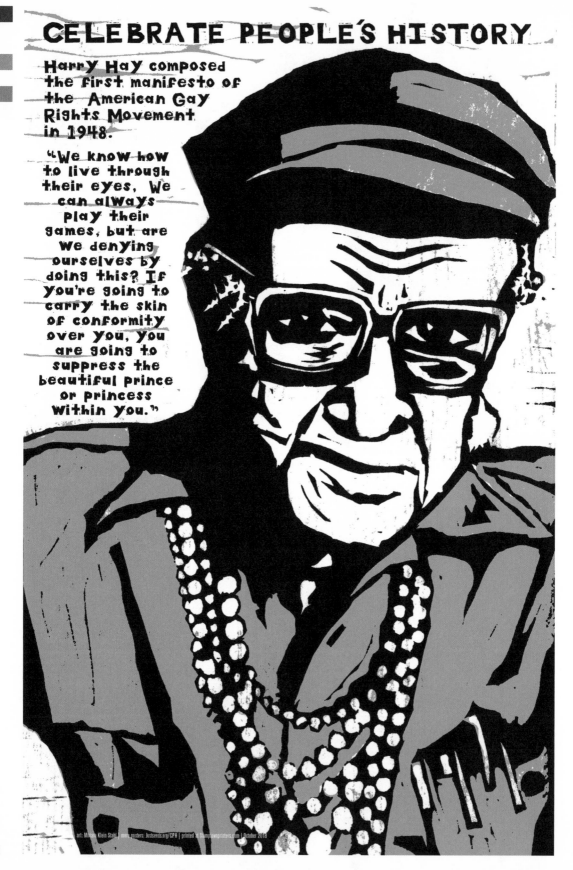

CELEBRATE PEOPLE'S HISTORY

Harry Hay composed the first manifesto of the American Gay Rights Movement in 1948.

"We know how to live through their eyes, We can always play their games, but are we denying ourselves by doing this? If you're going to carry the skin of conformity over you, you are going to suppress the beautiful prince or princess within you."

HARRY HAY MIRIAM KLEIN STAHL

ANARCHISM | COMMUNISM | SOCIALISM
ANTI-WAR | ANTI-IMPERIALISM | SOLIDARITY
ENVIRONMENTALISM
FEMINISM | QUEER LIBERATION
HEALTH | HOUSING | EDUCATION | CULTURE
LABOR | ANTI-CAPITALISM
SLAVERY | POLICE | PRISONS | ANTI-FASCISM
RACIAL JUSTICE | NATIONAL LIBERATION | INDIGENOUS STRUGGLE

Funmilayo Ransome Kuti

Francis Abigail Olufunmilayo Thomas was born in Nigeria in 1900. Funmilayo (the name she went by) was the first female student at her elementary school and then studied in England before returning to Nigeria and becoming a teacher. In 1932, she gathered a few young women together to start the Abeokuta Ladies Club (ALC) which began as a small, polite group focused on learning proper etiquette, drinking tea, and doing crafts.

In 1944, a former student came to see Funmilayo, and introduced her to a market woman who wanted to learn to read. Most of the market women were poor and illiterate, and wanted the ALC to help them learn to read. Under Funmilayo's direction, the club expanded its membership to include the market women, and began holding literacy classes. But illiteracy was not their only obstacle; Nigeria was then a British colony, and under British policies, market women also faced daily injustices at the hands of police and government officials.

Their products, especially rice, were often seized for no reason. In 1945, the members of the the ALC held a press conference to draw attention to the exploitation of women workers. The newspaper ran an article about it, and one week later, the rice seizures stopped. The ALC, emboldened, quickly grew to 20,000 members committed to reforming the country and empowering women through education, health care, and suffrage. In 1947, Funmilayo was the only female member of a delegation who went London to advocate for Nigeria's independence.

Funmilayo's legacy lives on in many ways, including the fact that her son, Fela Kuti, became the country's most popular musician, singing about corruption, neo-colonialism, and people's struggles.

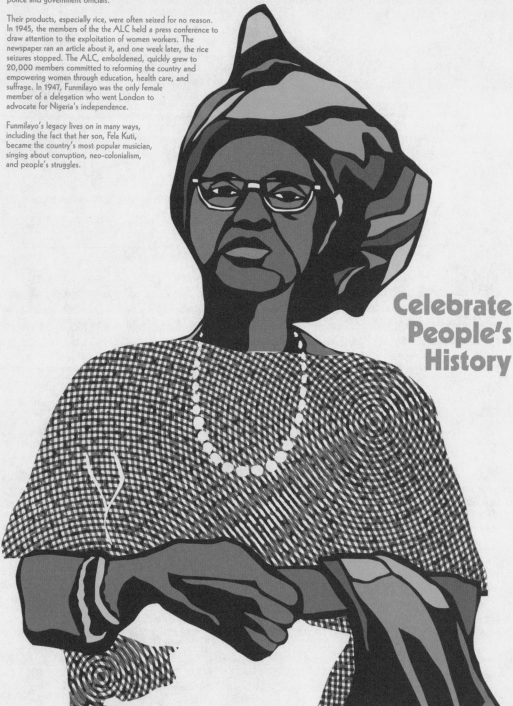

Celebrate People's History

PLEASE STAY OFF OF ALL BUSES ON MONDAY.

On 1 December 1955, Jo Ann Robinson wrote the text for the flyer calling for Negroes to boycott the Montgomery bus system. That night she, John Cannon, and two students used the mimeograph machines at Alabama State College to print 52,000 flyers. These flyers were distributed to the Negro citizens of Montgomery. And the boycott happened.

Celebrate People's History

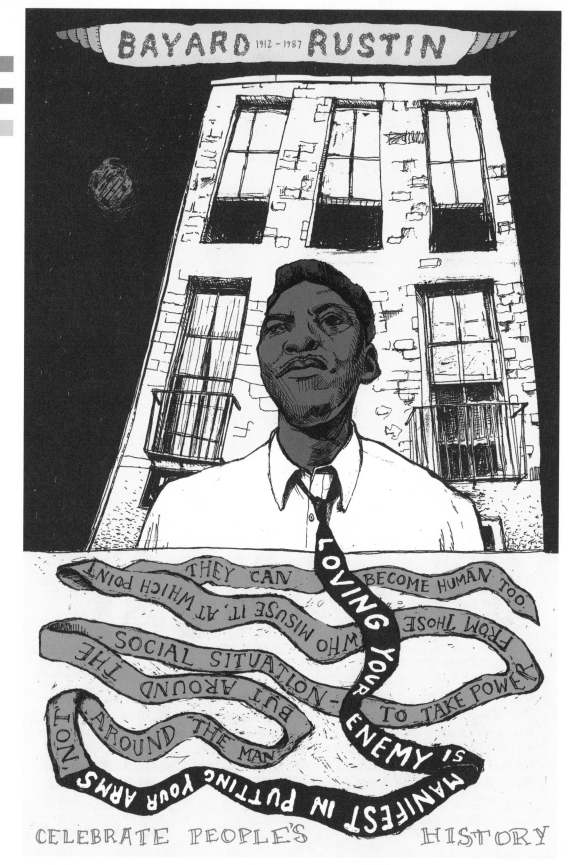

BAYARD RUSTIN ELI BROWN

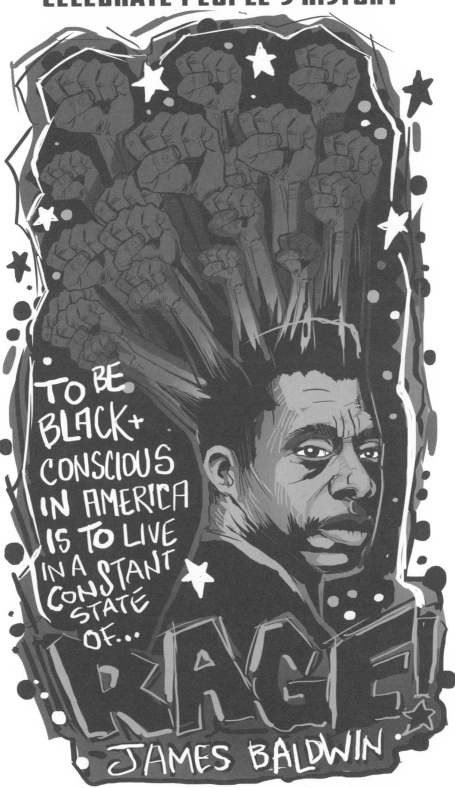

TO BE BLACK + CONSCIOUS IN AMERICA IS TO LIVE IN A CONSTANT STATE OF... RAGE!

JAMES BALDWIN

JAMES BALDWIN — JOHN JENNINGS

DOCKUM DRUG STORE SIT-IN WICHITA, KS — 1958 —

In 1958, Carol Parks Hahn and Ron Walters, two Wichita NAACP youth leaders decided to protest segregation of local lunch counters, starting with the largest drugstore chain in Kansas, Dockum Drug Store. Hahn and Walters began the peaceful sit-in protest along with twenty other members from the local NAACP. The plan was to occupy all of the lunch counter seats and ask to be served. This continued every Thursday and Saturday from July 19 – August 11 when the owner of Dockum Drug Stores visited the location and said, "Serve them. I'm losing too much money." As a result of this statement, all Dockum Drug Stores in Wichita and eventually in the state of Kansas were desegregated. This sit-in occurred almost two years before the nationally recognized sit-in in Greensboro, NC.

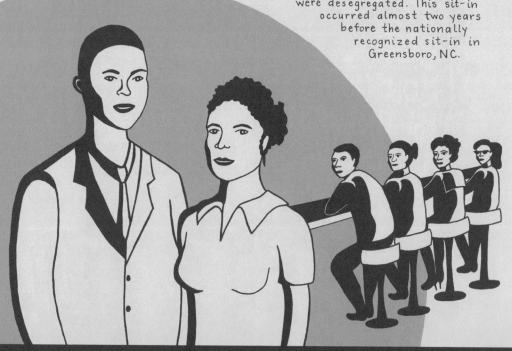

CELEBRATE PEOPLE'S HISTORY

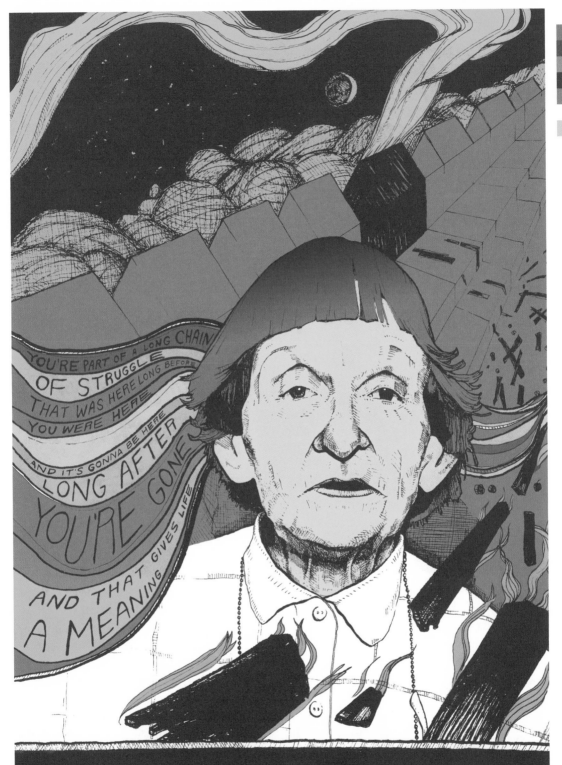

YOU'RE PART OF A LONG CHAIN OF STRUGGLE THAT WAS HERE LONG BEFORE YOU WERE HERE AND IT'S GONNA BE HERE LONG AFTER YOU'RE GONE AND THAT GIVES LIFE A MEANING.

ANNE BRADEN 1926-2003
CELEBRATE PEOPLE'S HISTORY

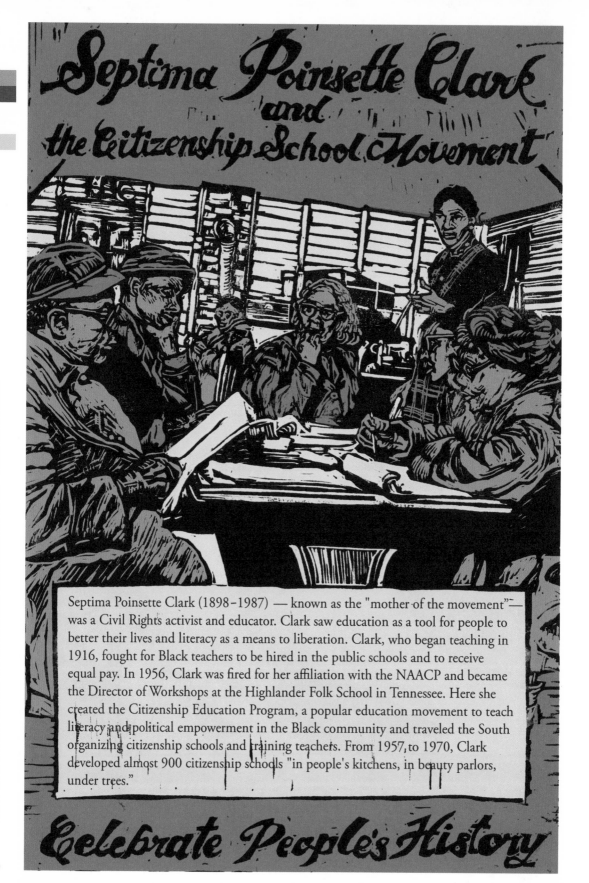

Septima Poinsette Clark and the Citizenship School Movement

Septima Poinsette Clark (1898–1987) — known as the "mother of the movement"— was a Civil Rights activist and educator. Clark saw education as a tool for people to better their lives and literacy as a means to liberation. Clark, who began teaching in 1916, fought for Black teachers to be hired in the public schools and to receive equal pay. In 1956, Clark was fired for her affiliation with the NAACP and became the Director of Workshops at the Highlander Folk School in Tennessee. Here she created the Citizenship Education Program, a popular education movement to teach literacy and political empowerment in the Black community and traveled the South organizing citizenship schools and training teachers. From 1957 to 1970, Clark developed almost 900 citizenship schools "in people's kitchens, in beauty parlors, under trees."

Celebrate People's History

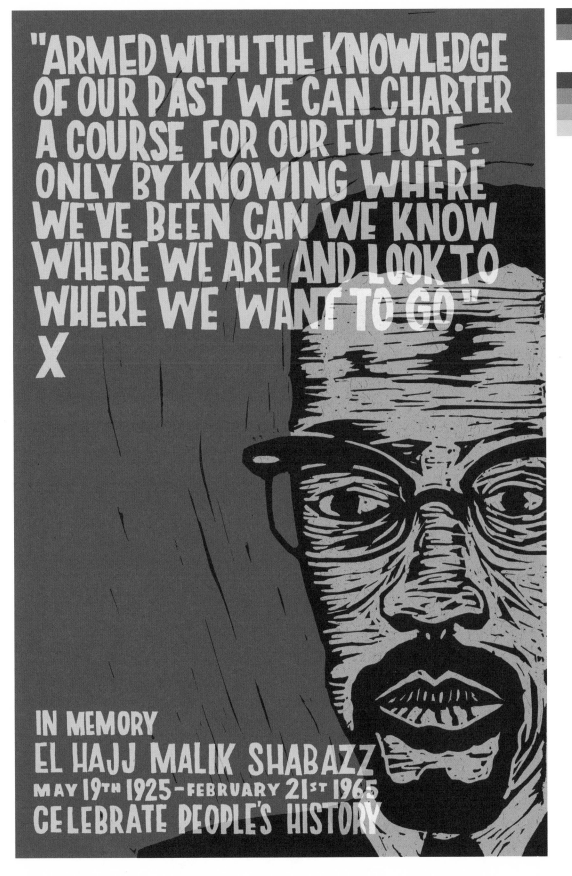

"ARMED WITH THE KNOWLEDGE OF OUR PAST WE CAN CHARTER A COURSE FOR OUR FUTURE. ONLY BY KNOWING WHERE WE'VE BEEN CAN WE KNOW WHERE WE ARE AND LOOK TO WHERE WE WANT TO GO." X

IN MEMORY
EL HAJJ MALIK SHABAZZ
MAY 19TH 1925 – FEBRUARY 21ST 1965
CELEBRATE PEOPLE'S HISTORY

MALCOLM X JOSH MACPHEE

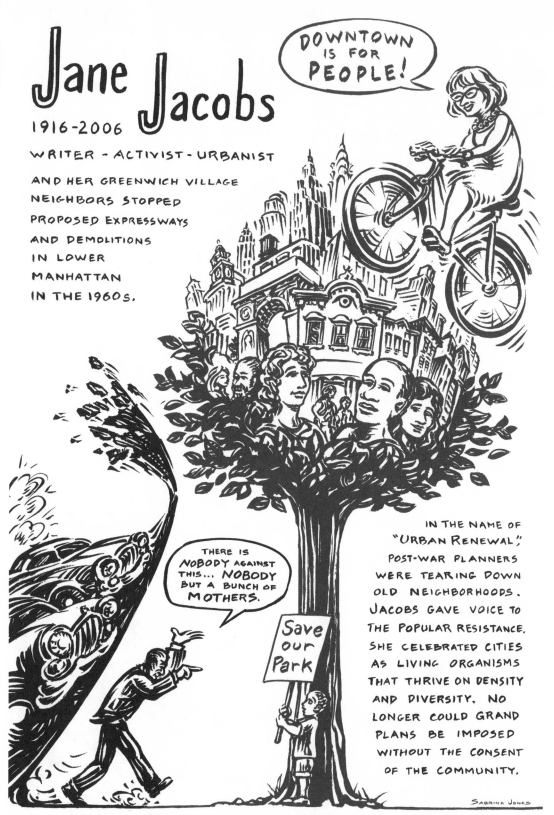

Jane Jacobs

1916-2006

DOWNTOWN IS FOR PEOPLE!

WRITER - ACTIVIST - URBANIST

AND HER GREENWICH VILLAGE NEIGHBORS STOPPED PROPOSED EXPRESSWAYS AND DEMOLITIONS IN LOWER MANHATTAN IN THE 1960s.

THERE IS NOBODY AGAINST THIS... NOBODY BUT A BUNCH OF MOTHERS.

Save our Park

IN THE NAME OF "URBAN RENEWAL," POST-WAR PLANNERS WERE TEARING DOWN OLD NEIGHBORHOODS. JACOBS GAVE VOICE TO THE POPULAR RESISTANCE. SHE CELEBRATED CITIES AS LIVING ORGANISMS THAT THRIVE ON DENSITY AND DIVERSITY. NO LONGER COULD GRAND PLANS BE IMPOSED WITHOUT THE CONSENT OF THE COMMUNITY.

SABRINA JONES

CELEBRATE PEOPLE'S HISTORY

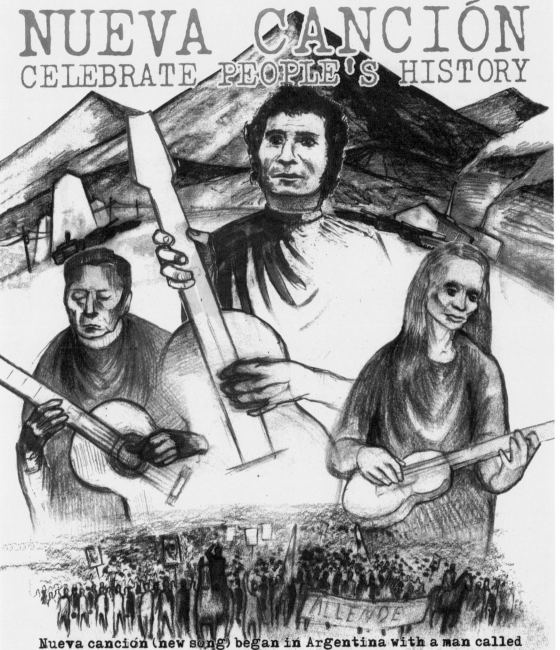

NUEVA CANCIÓN
CELEBRATE PEOPLE'S HISTORY

Nueva canción (new song) began in Argentina with a man called Atahualpa Yupanqui whose guitar became its voice, and whose exile became its birth. It began in Chile where Violeta Parra gathered a life of songs and gave them all away.

It began as Victor Jara wrote songs to the rhythm of falling canisters of tear gas on the streets of Santiago.

Many of its voices died there, from Pinochet's bullets and from a world's silence. Yet still we hear Victor Jara, audible through the noise of the crowd, "walking, walking. I am looking for a road, to continue walking..."
The song remains unfinished...

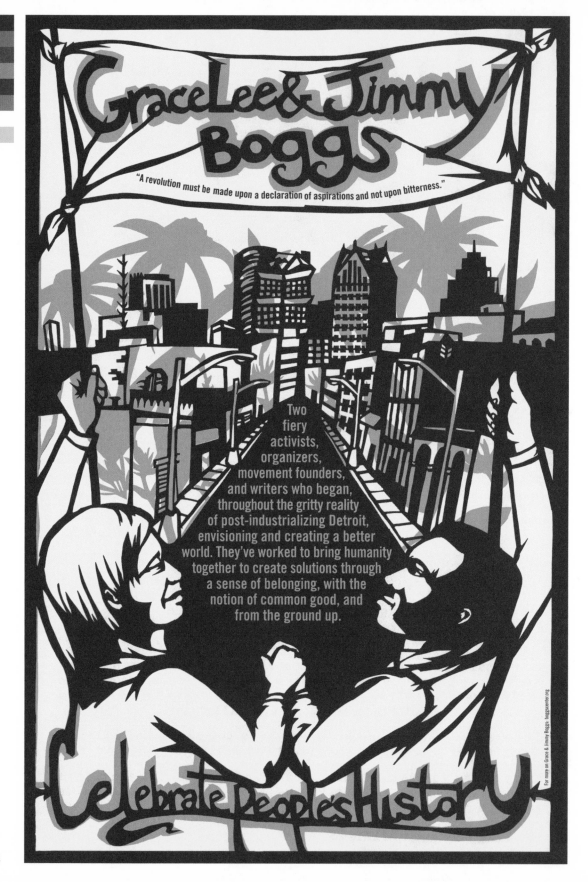

GRACE LEE AND JIMMY BOGGS BEC YOUNG

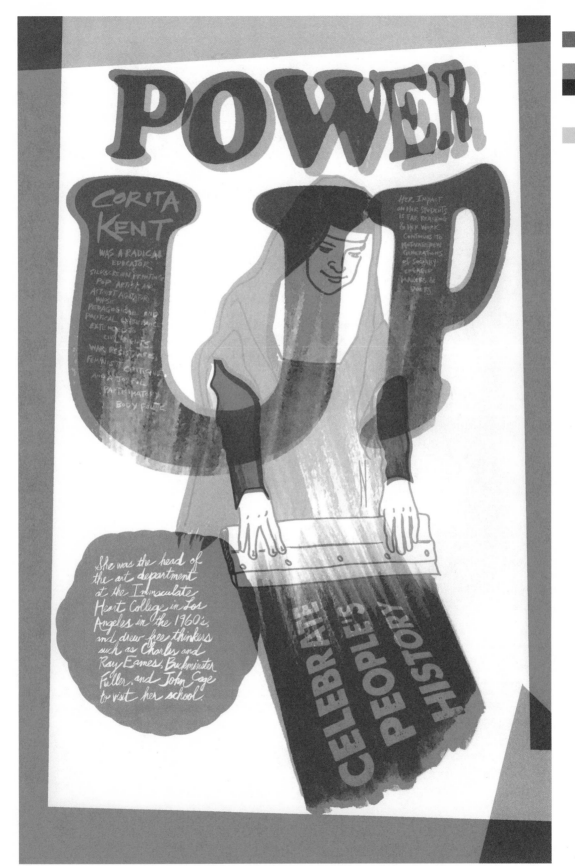

POWER UP

CORITA KENT WAS A RADICAL EDUCATOR, SILKSCREEN PRINTING POP ARTIST AND ACTIVIST AGITATOR WHOSE PEDAGOGICAL AND POLITICAL EXUBERANCE EXTENDED TO CIVIL RIGHTS, WAR RESISTANCE, FEMINIST CRITIQUE AND A JOY FOR PARTICIPATORY BODY POLITIC

HER IMPACT ON HER STUDENTS IS FAR REACHING & HER WORK CONTINUES TO MOTIVATE NEW GENERATIONS OF SOCIALLY-ENGAGED MAKERS & DOERS.

She was the head of the art department at the Immaculate Heart College in Los Angeles in the 1960's, and drew free thinkers such as Charles and Ray Eames, Buckminster Fuller, and John Cage to visit her school.

CELEBRATE PEOPLE'S HISTORY

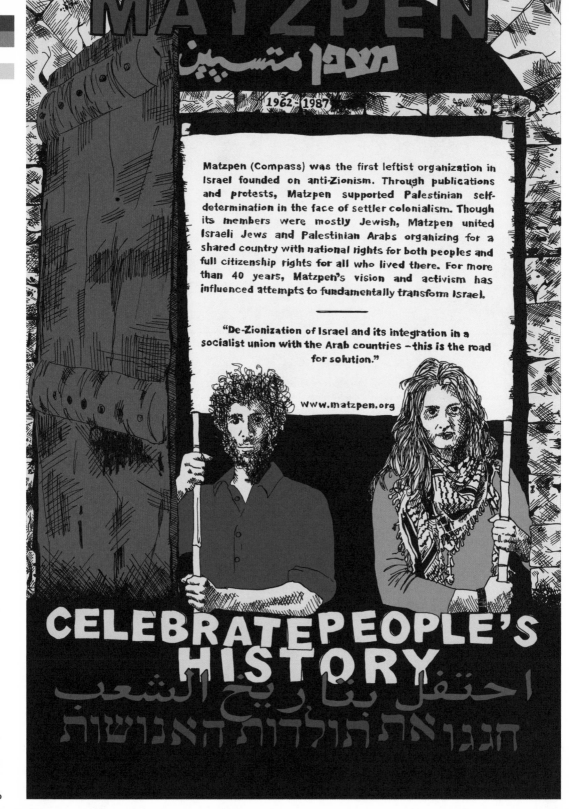

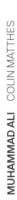

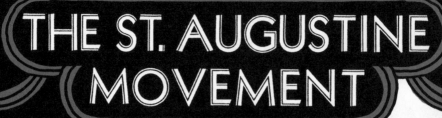

THE ST. AUGUSTINE MOVEMENT

MOVEMENTS ARE RADICAL ONLY IN LIGHT OF THE INJUSTICES THEY SEEK TO CORRECT---

THE YOUTH OF ST. AUGUSTINE DIDN'T UNDERSTAND WHY JUSTICE HAD TO WAIT. THEY TOOK IT UPON THEMSELVES TO MOVE FEARLESSLY IN THE FACE OF VIOLENT, LAWLESS SEGREGATIONISTS. TEENAGERS LED THE LUNCH COUNTER SIT-INS AND BEACH INTEGRATION, AND IT BEING THE OLDEST CITY IN THE COUNTRY, ALL EYES WERE SOON ON THE SMALL FLORIDA TOWN IN THE SUMMER OF 1963...

"WE WANTED A CHANGE! WE DIDN'T WANNA GO TO THE BACK DOOR ALL THE TIME!"
—JOEANNE ANDERSON

SEGREGATION MUST GO

MY FATHER DIED FOR HIS COUNTRY TOO

"WE ALL THOUGHT EVERYBODY LOVED EACH OTHER & EVERYBODY GOT ALONG UNTIL WE WANTED TO GO SIT AT THEIR COUNTER— LORD, THEY WENT COMPLETELY CRAZY! LORD, THEY WANTED TO KILL ALL OF US!"
—AUDREY HAMILTON

UNDER THE LEADERSHIP OF DR. R. B. HAYLING, THE NAACP YOUTH COUNCIL FORCED WHITE ST. AUGUSTINE TO CONFRONT THE INEQUALITY UPON WHICH BOTH ITS FALSE PEACE AND TOURIST ECONOMY RELIED.

THE ST. AUGUSTINE 4— JOEANNE ANDERSON, AUDREY EDWARDS, WILLIE CARL SINGLETON, AND SAMUEL WHITE — REFUSED, AFTER ARREST, TO SIGN A LEGAL DOCUMENT PROHIBITING THEIR PARTICIPATION IN FURTHER DEMONSTRATION ACTIVITY IN EXCHANGE FOR THEIR RELEASE. SUBSEQUENTLY, THEY SPENT 6 MONTHS IN COURT-ORDERED REFORM SCHOOL. AFTER THEIR RELEASE, THEY STAYED ACTIVE IN THE MOVEMENT.

IS THE PAST EVER REALLY PAST? WHOSE FREEDOMS MAY BE COMPROMISED BY OUR OWN, TODAY?

celebrate people's history

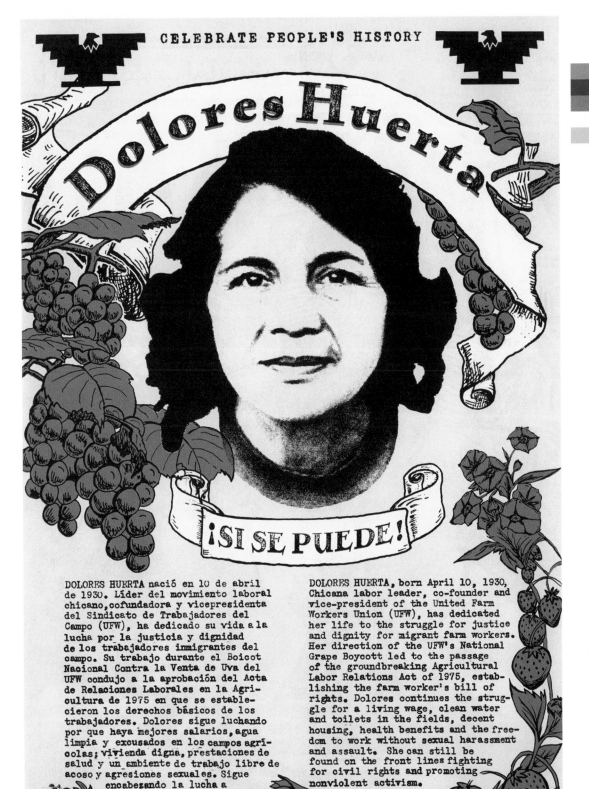

Dolores Huerta

¡SI SE PUEDE!

DOLORES HUERTA nació en 10 de abril de 1930. Líder del movimiento laboral chicano, cofundadora y vicepresidenta del Sindicato de Trabajadores del Campo (UFW), ha dedicado su vida a la lucha por la justicia y dignidad de los trabajadores inmigrantes del campo. Su trabajo durante el Boicot Nacional Contra la Venta de Uva del UFW condujo a la aprobación del Acta de Relaciones Laborales en la Agricultura de 1975 en que se establecieron los derechos básicos de los trabajadores. Dolores sigue luchando por que haya mejores salarios, agua limpia y excusados en los campos agrícolas; vivienda digna, prestaciones de salud y un ambiente de trabajo libre de acoso y agresiones sexuales. Sigue encabezando la lucha a favor de los derechos civiles y promoviendo el activismo no violento.

DOLORES HUERTA, born April 10, 1930, Chicana labor leader, co-founder and vice-president of the United Farm Workers Union (UFW), has dedicated her life to the struggle for justice and dignity for migrant farm workers. Her direction of the UFW's National Grape Boycott led to the passage of the groundbreaking Agricultural Labor Relations Act of 1975, establishing the farm worker's bill of rights. Dolores continues the struggle for a living wage, clean water and toilets in the fields, decent housing, health benefits and the freedom to work without sexual harassment and assault. She can still be found on the front lines fighting for civil rights and promoting nonviolent activism.

DOLORES HUERTA BOBBY CORTEZ AND BLAKE RILEY

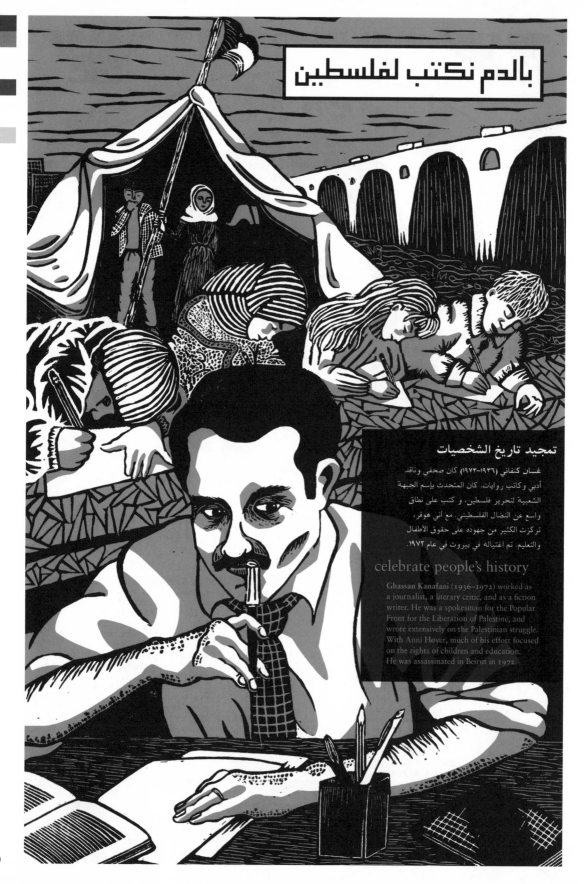

بالدم نكتب لفلسطين

تمجيد تاريخ الشخصيات

غسان كنفاني (١٩٣٦–١٩٧٢) كان صحفي وناقد
أدبي وكاتب روايات. كان المتحدث باسم الجبهة
الشعبية لتحرير فلسطين، و كتب على نطاق
واسع عن النضال الفلسطيني. مع أني هوفر،
تركزت الكثير من جهوده على حقوق الأطفال
والتعليم. تم اغتياله في بيروت في عام ١٩٧٢.

celebrate people's history

Ghassan Kanafani (1936–1972) worked as
a journalist, a literary critic, and as a fiction
writer. He was a spokesman for the Popular
Front for the Liberation of Palestine, and
wrote extensively on the Palestinian struggle.
With Anni Høver, much of his effort focused
on the rights of children and education.
He was assassinated in Beirut in 1972.

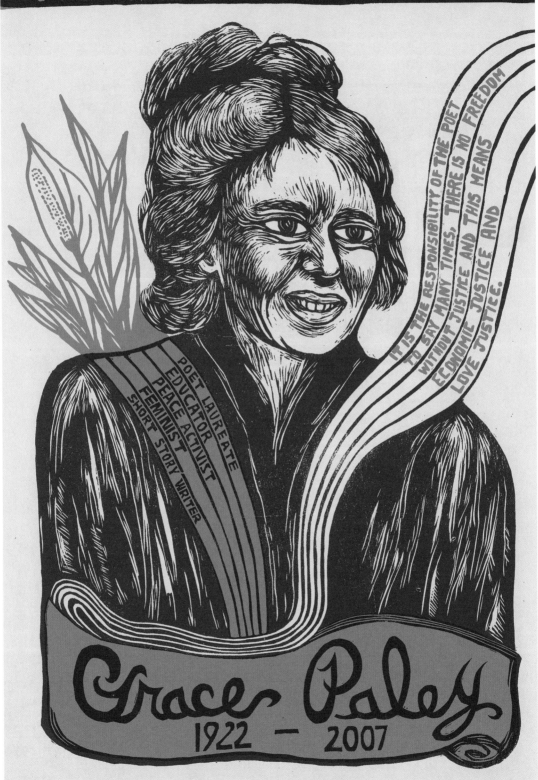

CELEBRATE PEOPLE'S HISTORY

POET LAUREATE
EDUCATOR
PEACE ACTIVIST
FEMINIST
SHORT STORY WRITER

IT IS THE RESPONSIBILITY OF THE POET TO SAY MANY TIMES; THERE IS NO FREEDOM WITHOUT JUSTICE AND THIS MEANS ECONOMIC JUSTICE AND LOVE JUSTICE.

Grace Paley
1922 — 2007

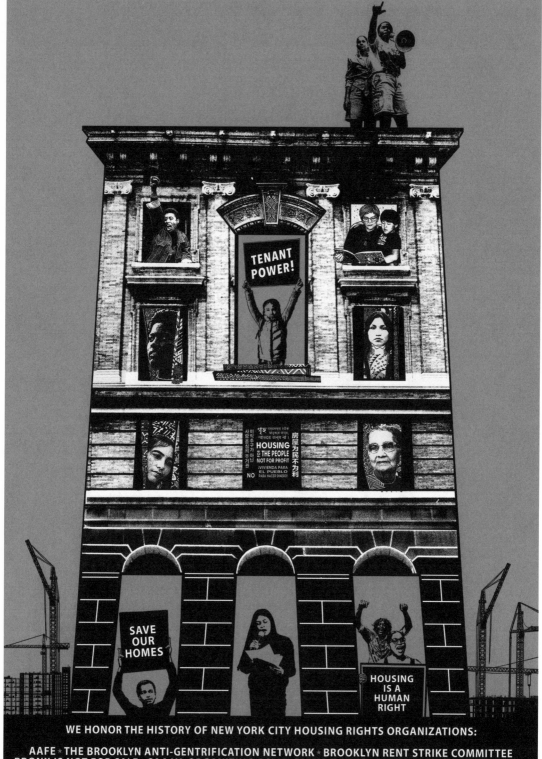

WE HONOR THE HISTORY OF NEW YORK CITY HOUSING RIGHTS ORGANIZATIONS:

AAFE ★ THE BROOKLYN ANTI-GENTRIFICATION NETWORK ★ BROOKLYN RENT STRIKE COMMITTEE
BRONX IS NOT FOR SALE ★ CAAAV: ORGANIZING ASIAN COMMUNITIES ★ CHINATOWN TENANTS UNION
CITYWIDE TENANTS COUNCIL ★ COALITION TO PROTECT CHINATOWN & THE L.E.S. ★ CHARAS, INC
COOPER SQUARE COMMITTEE ★ DRUM ★ GOOD OLD LOWER EAST SIDE ★ HATE FREE ZONE ★ MI CASA NO
ES SU CASA ★ METROPOLITAN COUNCIL ON HOUSING ★ MOTHERS ON THE MOVE ★ NO NEW JAILS
PICTURE THE HOMELESS ★ SEWARD PARK URBAN RENEWAL ASSOCIATION ★ UPROSE...

CELEBRATE PEOPLE'S HISTORY! ★ CELEBRAR LA HISTORIA DEL PUEBLO! ★ 擁抱人民的歷史!

ANARCHISM | COMMUNISM | SOCIALISM

ANTI-WAR | ANTI-IMPERIALISM | SOLIDARITY

ENVIRONMENTALISM

FEMINISM | QUEER LIBERATION

HEALTH | HOUSING | EDUCATION | CULTURE

LABOR | ANTI-CAPITALISM

SLAVERY | POLICE | PRISONS | ANTI-FASCISM

RACIAL JUSTICE | NATIONAL LIBERATION | INDIGENOUS STRUGGLE

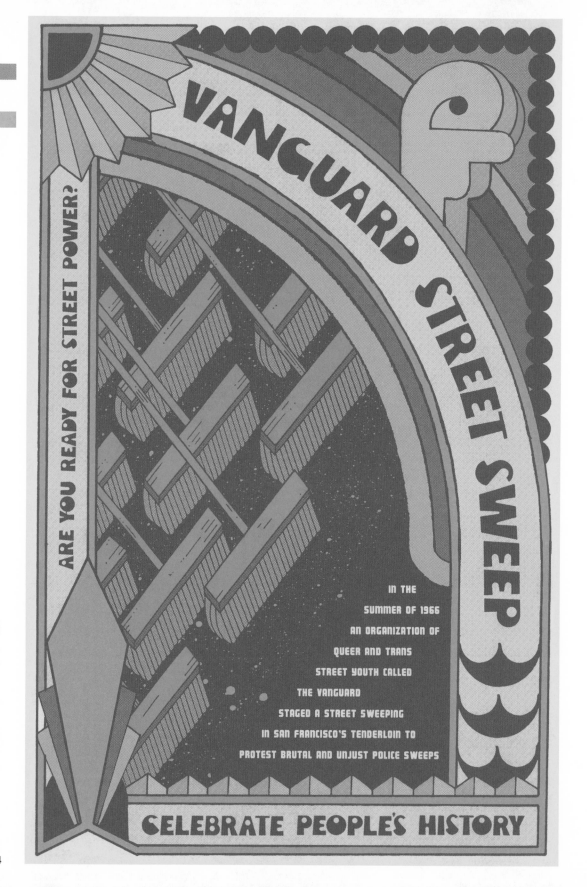

HIDE NOTHING FROM OUR PEOPLE. TELL NO LIES.
MASK NO DIFFICULTIES, MISTAKES, FAILURES. CLAIM NO EASY VICTORIES.

AMILCAR CABRAL 1924-1973 CELEBRATE PEOPLE'S HISTORY

POLITICAL THEORIST, STRATEGIST, AGRONOMIST, AND LEADER OF THE PARTIDO AFRICANO DA INDEPENDÊNCIA DA GUINÉ E CABO VERDE.

AMILCAR CABRAL JOSH MACPHEE

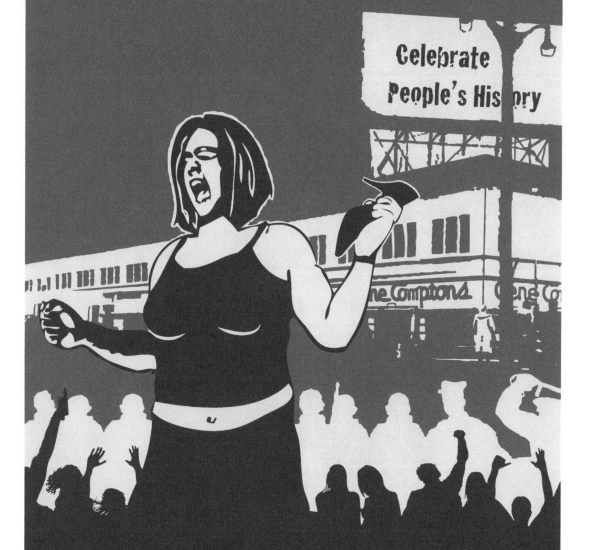

Compton's Cafeteria Riot

San Francisco 1966

Celebrate People's History

Transwomen and drag queens working in the Tenderloin district of San Fransisco often took refuge in Gene Compton's, an after-hours cafeteria. They would buy coffee and stay for hours, temporarily escaping the troubles of the street. The owner began harassing them with discriminatory policies, so the queens formed an organization they named Vanguard to fight for their rights to use Compton's. On a hot summer evening after an unsuccessful picket of the cafeteria, the owner called the police to evict the queens—they fought back, leading to a street riot.

KANSAS CITY
BLACK PANTHER PARTY

THE BLACK PANTHER PARTY WAS A GROUP OF STRONG, YOUNG BLACK MEN WHO WERE PART OF THE BLACK POWER MOVEMENT OF THE LATE 1960S AND EARLY 1970S. THE KANSAS CITY CHAIRMAN WAS PETE O'NEAL WHO WENT ON TO BECOME THE INTERNATIONAL BLACK PANTHER CHAIRMAN IN ALGERIA. THEY JOINED WITH CHURCH GROUPS TO PROVIDE BREAKFAST FOR NEIGHBORHOOD SCHOOLCHILDREN IN THE DAYS WHEN SCHOOLS DID NOT FEED KIDS. THEY TOOK NEIGHBORHOOD FOLKS TO THE HOSPITAL WHEN AMBULANCES DID NOT COME INTO BLACK NEIGHBORHOODS. THEY CREATED NEIGHBORHOOD WATCH PROGRAMS TO WATCH FOR POLICE BRUTALITY. THEY POSED A THREAT TO THE ESTABLISHMENT BY DEMANDING JUSTICE AND PROVIDING SELF-DEFENSE CLASSES.

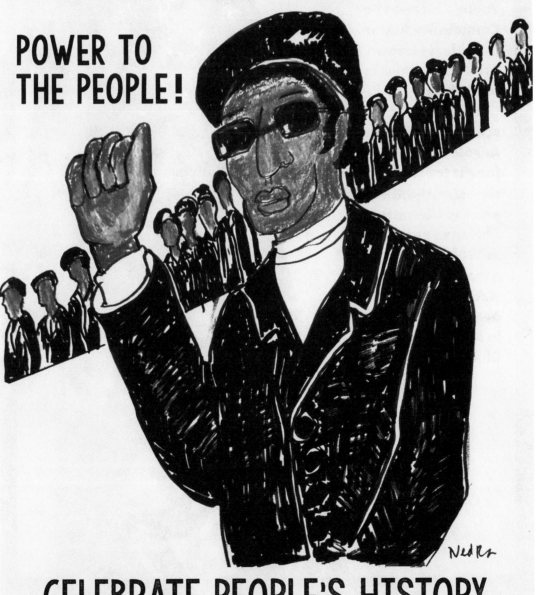

POWER TO
THE PEOPLE!

Nedra

CELEBRATE PEOPLE'S HISTORY

THE BROWN BERETS

Young Chicanos For Community Action (popularly known as the Brown Berets) was formed in 1967 by a group of Chicana and Chicano high school students in Los Angeles. They stood and fought for farm worker rights, anti-militarism, and the liberation of Chicanxs everywhere. In 1968 they organized a massive student walk out in East LA, demanding equality in schools for Chicanx students.

BROWN BERETS JULIO CORDOVA

CELEBRATE PEOPLE'S HISTORY

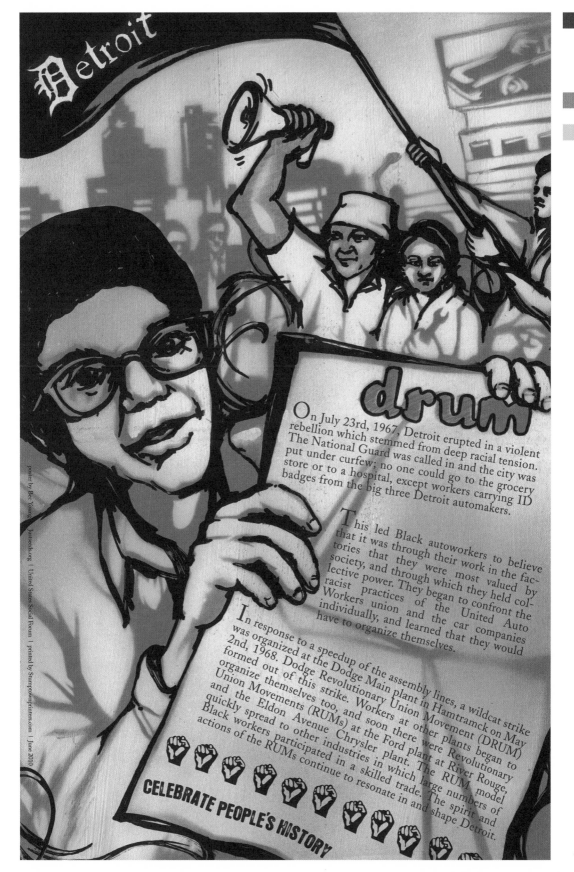

On July 23rd, 1967, Detroit erupted in a violent rebellion which stemmed from deep racial tension. The National Guard was called in and the city was put under curfew; no one could go to the grocery store or to a hospital, except workers carrying ID badges from the big three Detroit automakers.

This led Black autoworkers to believe that it was through their work in the factories that they were most valued by society, and through which they held collective power. They began to confront the racist practices of the United Auto Workers union and the car companies individually, and learned that they would have to organize themselves.

In response to a speedup of the assembly lines, a wildcat strike was organized at the Dodge Main plant in Hamtramck on May 2nd, 1968. Dodge Revolutionary Union Movement (DRUM) formed out of this strike. Workers at other plants began to organize themselves too, and soon there were Revolutionary Union Movements (RUMs) at the Ford plant at River Rouge, and the Eldon Avenue Chrysler plant. The RUM model quickly spread to other industries in which large numbers of Black workers participated in a skilled trade. The spirit and actions of the RUMs continue to resonate in and shape Detroit.

CELEBRATE PEOPLE'S HISTORY

poster by Bec Young | justseeds.org | United States Social Forum | printed by Stumptownprinters.com | June 2010

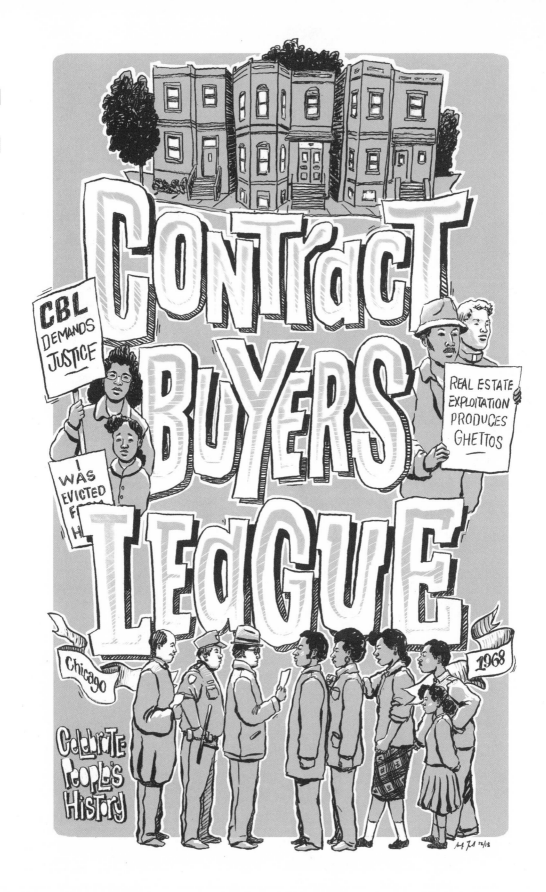

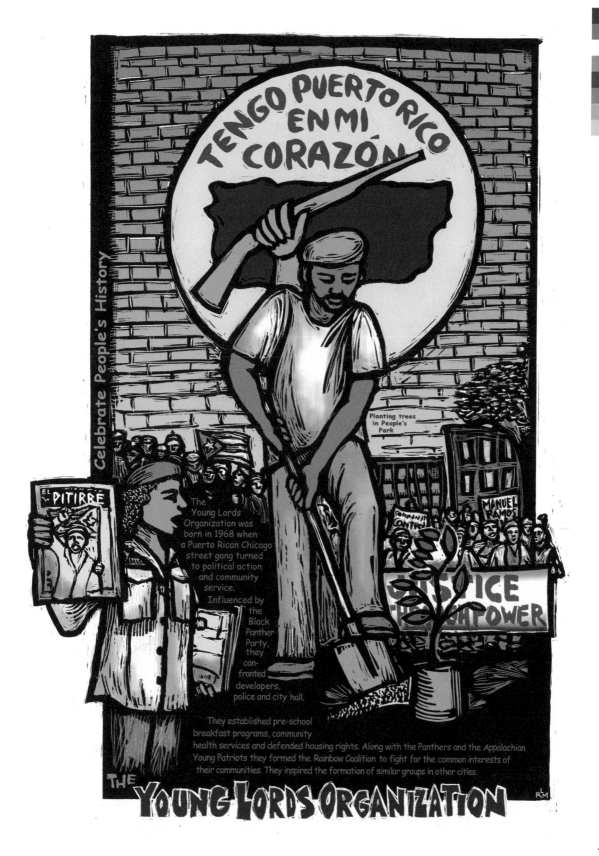

TENGO PUERTO RICO EN MI CORAZÓN

Celebrate People's History

Planting trees in People's Park

EL PITIRRE

MANUEL RAMOS

JUSTICE THROUGH POWER

The Young Lords Organization was born in 1968 when a Puerto Rican Chicago street gang turned to political action and community service.

Influenced by the Black Panther Party, they confronted developers, police and city hall.

They established pre-school breakfast programs, community health services and defended housing rights. Along with the Panthers and the Appalachian Young Patriots they formed the Rainbow Coalition to fight for the common interests of their communities. They inspired the formation of similar groups in other cities.

THE YOUNG LORDS ORGANIZATION

YOUNG LORDS ORGANIZATION RICARDO LEVINS MORALES

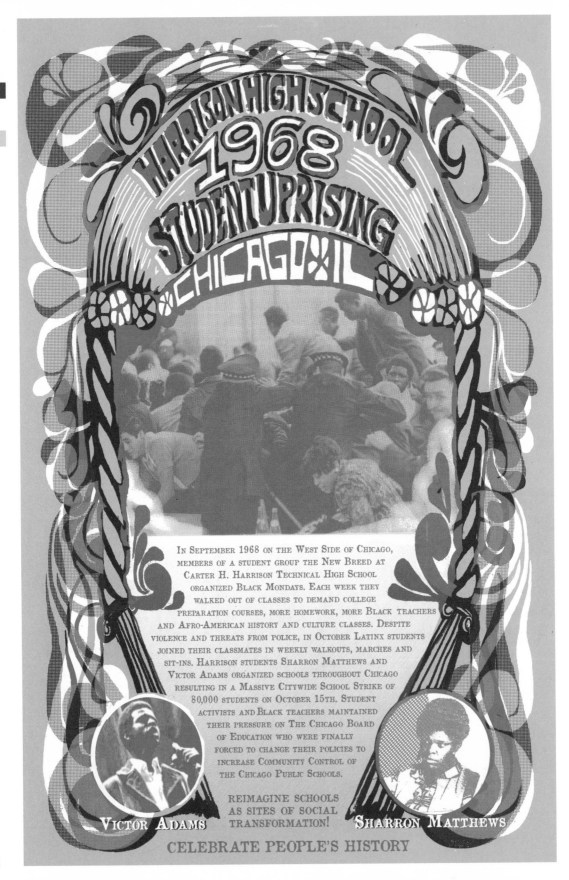

HARRISON HIGH SCHOOL
1968
STUDENT UPRISING
CHICAGO IL

IN SEPTEMBER 1968 ON THE WEST SIDE OF CHICAGO, MEMBERS OF A STUDENT GROUP THE NEW BREED AT CARTER H. HARRISON TECHNICAL HIGH SCHOOL ORGANIZED BLACK MONDAYS. EACH WEEK THEY WALKED OUT OF CLASSES TO DEMAND COLLEGE PREPARATION COURSES, MORE HOMEWORK, MORE BLACK TEACHERS AND AFRO-AMERICAN HISTORY AND CULTURE CLASSES. DESPITE VIOLENCE AND THREATS FROM POLICE, IN OCTOBER LATINX STUDENTS JOINED THEIR CLASSMATES IN WEEKLY WALKOUTS, MARCHES AND SIT-INS. HARRISON STUDENTS SHARRON MATTHEWS AND VICTOR ADAMS ORGANIZED SCHOOLS THROUGHOUT CHICAGO RESULTING IN A MASSIVE CITYWIDE SCHOOL STRIKE OF 80,000 STUDENTS ON OCTOBER 15TH. STUDENT ACTIVISTS AND BLACK TEACHERS MAINTAINED THEIR PRESSURE ON THE CHICAGO BOARD OF EDUCATION WHO WERE FINALLY FORCED TO CHANGE THEIR POLICIES TO INCREASE COMMUNITY CONTROL OF THE CHICAGO PUBLIC SCHOOLS.

REIMAGINE SCHOOLS AS SITES OF SOCIAL TRANSFORMATION!

VICTOR ADAMS SHARRON MATTHEWS

CELEBRATE PEOPLE'S HISTORY

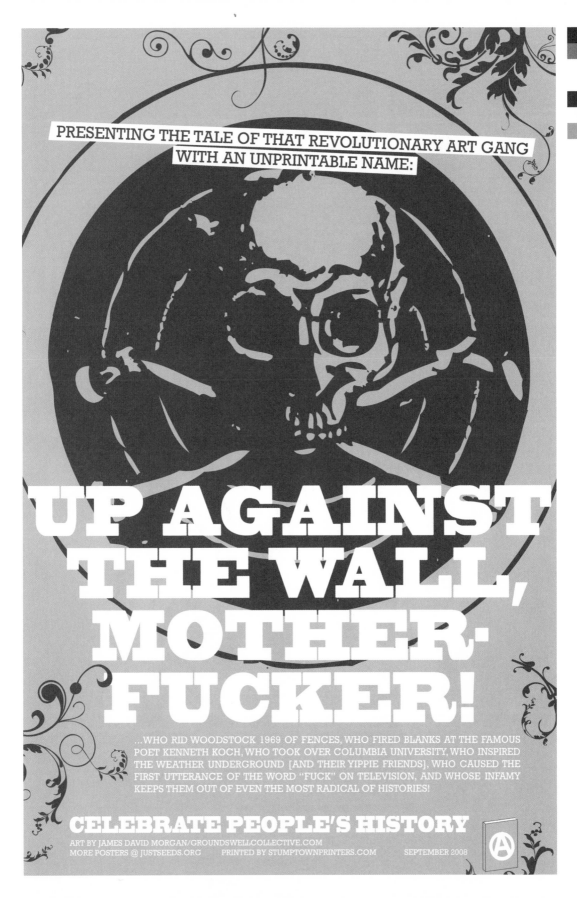

PRESENTING THE TALE OF THAT REVOLUTIONARY ART GANG WITH AN UNPRINTABLE NAME:

UP AGAINST THE WALL, MOTHER-FUCKER!

...WHO RID WOODSTOCK 1969 OF FENCES, WHO FIRED BLANKS AT THE FAMOUS POET KENNETH KOCH, WHO TOOK OVER COLUMBIA UNIVERSITY, WHO INSPIRED THE WEATHER UNDERGROUND [AND THEIR YIPPIE FRIENDS], WHO CAUSED THE FIRST UTTERANCE OF THE WORD "FUCK" ON TELEVISION, AND WHOSE INFAMY KEEPS THEM OUT OF EVEN THE MOST RADICAL OF HISTORIES!

CELEBRATE PEOPLE'S HISTORY

ART BY JAMES DAVID MORGAN/GROUNDSWELLCOLLECTIVE.COM
MORE POSTERS @ JUSTSEEDS.ORG PRINTED BY STUMPTOWNPRINTERS.COM SEPTEMBER 2008

UP AGAINST THE WALL MOTHERFUCKER JAMES DAVID MORGAN

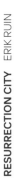

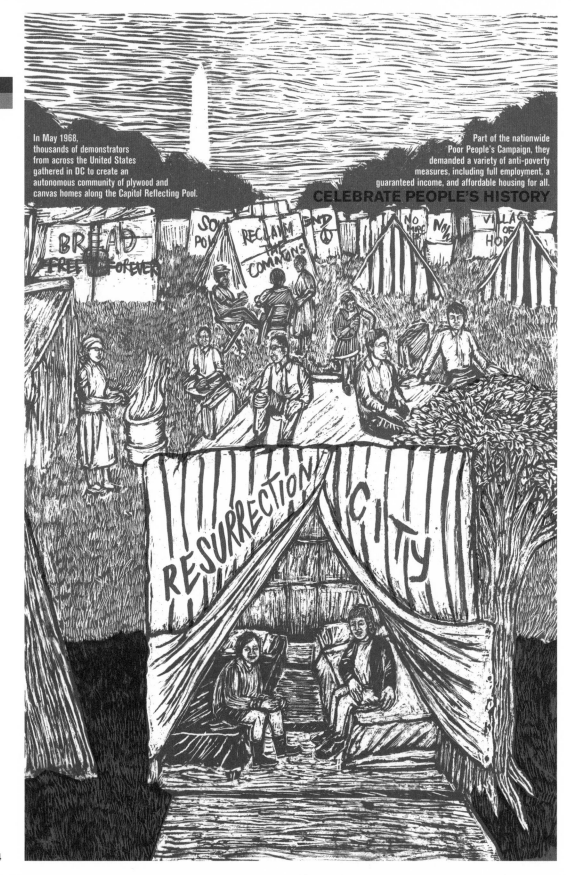

In May 1968, thousands of demonstrators from across the United States gathered in DC to create an autonomous community of plywood and canvas homes along the Capitol Reflecting Pool.

Part of the nationwide Poor People's Campaign, they demanded a variety of anti-poverty measures, including full employment, a guaranteed income, and affordable housing for all.

CELEBRATE PEOPLE'S HISTORY

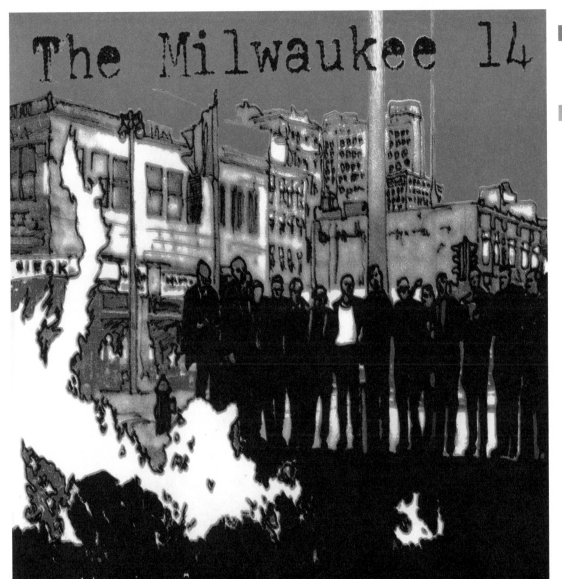

The Milwaukee 14

On September 24th, 1968, fourteen people—including five priests and a minister removed approximately 10,000 draft files from Milwaukee's Selective Service and burned them with homemade napalm

Celebrate People's History

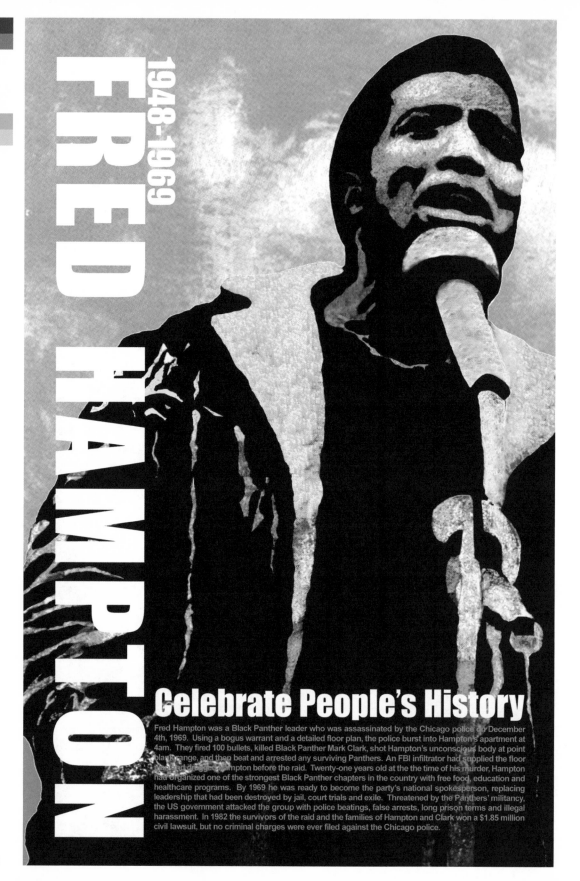

1948-1969

FRED HAMPTON

Celebrate People's History

Fred Hampton was a Black Panther leader who was assassinated by the Chicago police on December 4th, 1969. Using a bogus warrant and a detailed floor plan, the police burst into Hampton's apartment at 4am. They fired 100 bullets, killed Black Panther Mark Clark, shot Hampton's unconscious body at point blank range, and then beat and arrested any surviving Panthers. An FBI infiltrator had supplied the floor plan and drugged Hampton before the raid. Twenty-one years old at the the time of his murder, Hampton had organized one of the strongest Black Panther chapters in the country with free food, education and healthcare programs. By 1969 he was ready to become the party's national spokesperson, replacing leadership that had been destroyed by jail, court trials and exile. Threatened by the Panthers' militancy, the US government attacked the group with police beatings, false arrests, long prison terms and illegal harassment. In 1982 the survivors of the raid and the families of Hampton and Clark won a $1.85 million civil lawsuit, but no criminal charges were ever filed against the Chicago police.

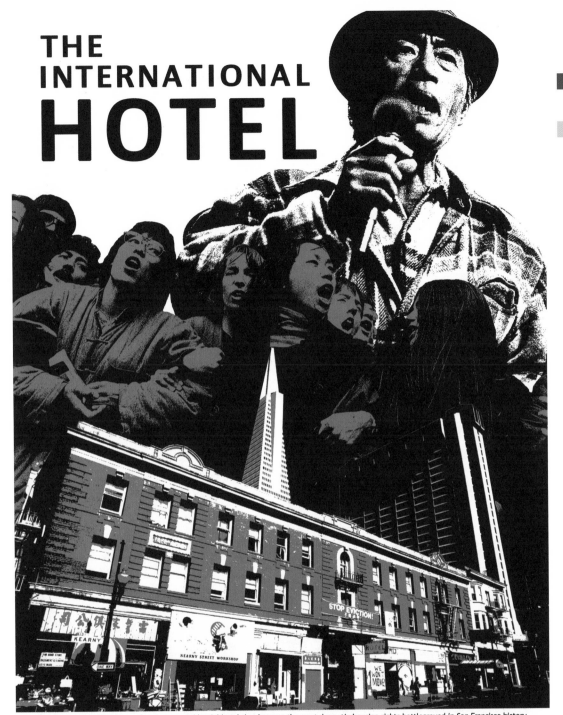

THE INTERNATIONAL HOTEL

The International Hotel was a low-income residential hotel that became the most dramatic housing-rights battleground in San Francisco history. As a center for Asian American activism in the 1970s, the building housed nearly 150 Filipino and Chinese seniors, three community groups, an art workshop, a radical bookstore and three Asian newspapers. The I-Hotel stood on the last remaining block of Manilatown, a once-thriving Filipino neighborhood that was gradually displaced by San Francisco's expanding financial district.

From 1968 to 1977, landlords of the hotel tried to evict the residents and build a parking lot. Resisting eviction for almost a decade, the tenants organized a mass-based, multiracial alliance which included students, unions and churches. During a final 3am eviction on August 4, 1977, over 3,000 people unsuccessfully defended the I-Hotel from hundreds of club-wielding riot police. The building was demolished in 1979, and it remained a vacant hole for over two decades. Thanks to a concerted effort by local neighborhood groups, the I-Hotel was rebuilt in 2005, providing 104 units of low-income senior housing and a community center to continue the legacy of Manilatown.

CELEBRATE PEOPLE'S HISTORY

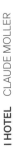

I HOTEL CLAUDE MOLLER

137

RAINBOW COALITION 25¢

1968 - 1977 CELEBRATE PEOPLE'S HISTORY VOL.4 NO.4

- CLASS STRUGGLE -

IN UNITY, THERE IS SURVIVAL

First photo: Fred Hampton speaking at a Chicago Black Panther Rally - Second photo: The Original Rainbow Coalition holding a press conference at the WTTW Channel 11 Studios, photo by Michael James. Both 1969

STUDENT HISTORY IS PEOPLE'S HISTORY

A PROFESSOR SAID, "YOU KNOW, YOU SHOULD NOT TAKE THIS PERSONALLY. THE ADMINISTRATION RENEGES ON ITS PROMISES TO US FACULTY ALL THE TIME." ONE OF THE BLACK STUDENTS, ALMOST IN DISBELIEF, LOOKED AT HIM AND REPLIED, "WELL, WHY DO YOU TAKE IT?"

THE OCCUPATION OF FORD HALL

IN THE WAKE OF THE ASSASSINATION OF MARTIN LUTHER KING JR., A STUDENT GROUP CALLED THE AFRO-AMERICAN ORGANIZATION AT BRANDEIS UNIVERSITY DECIDED THEY WERE SICK OF GETTING TREATED LIKE SECOND CLASS CITIZENS AT THEIR OWN COLLEGE. AT 2:00 PM ON JANUARY 8, 1969, 65 AFRICAN-AMERICAN STUDENTS ARMED THEMSELVES AND OCCUPIED FORD HALL, OFFICIALLY INAUGURATING IT MALCOLM X UNIVERSITY. OVER 150 BLACK STUDENTS FROM OTHER COLLEGES CAME TO FORD HALL TO DEMONSTRATE SOLIDARITY. WHITE BRANDEIS STUDENTS HELD SIT-INS, DEMONSTRATIONS, HUNGER STRIKES, AND PRINTED NEWSPAPERS IN SUPPORT OF THE OCCUPATION. AFTER 11 DAYS THE OCCUPATION ENDED, AND THE STUDENTS WERE GRANTED FULL AMNESTY. THEIR ACTIONS RESULTED IN ONE OF THE FIRST ACADEMIC DEPARTMENTS OF AFRICAN AND AFRICAN-AMERICAN STUDIES IN THE NATION. THE STUDENTS' OTHER DEMANDS WERE SOON REALIZED AS WELL, INCLUDING INCREASED RECRUITMENT OF BLACK STUDENTS, MARTIN LUTHER KING JR. SCHOLARSHIPS, AND BLACK STUDENT CONTROL OF THE HIRING OF CERTAIN ADMINISTRATORS. THE FORD HALL TAKEOVER COINCIDED WITH SIMULTANEOUS OCCUPATIONS AT UNIVERSITIES AROUND THE COUNTRY, INCLUDING THE UNIVERSITY OF CALIFORNIA, COLUMBIA, CORNELL, SAN FRANCISCO STATE, AND SWARTHMORE. EVEN THOUGH FORD HALL WAS DEMOLISHED IN 2009, ITS MEMORY INSPIRES STUDENTS TO THIS DAY.

CELEBRATE PEOPLE'S HISTORY

THE OCCUPATION OF FORD HALL JOSHUA KAHN RUSSELL

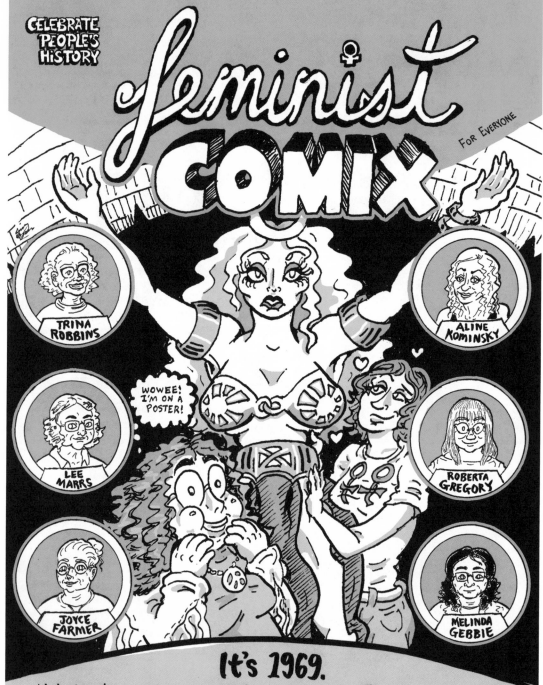

feminist COMIX

FOR EVERYONE

TRINA ROBBINS

ALINE KOMINSKY

LEE MARRS

ROBERTA GREGORY

JOYCE FARMER

MELINDA GEBBIE

WOWEE! I'M ON A POSTER!

It's 1969.

Underground comix express counter-cultural values in San Francisco (and elsewhere), breaking new ground with **raw** and **fearless** storytelling. **Second-wave feminism** simultaneously gains influence, reintroducing ideas of equality to American women. Comix captivated young female cartoonists with their openness and freedom of expression, but women were excluded by the male dominated comix scene. **These frustrated feminist cartoonists** produced their own work specifically to promote female empowerment. <u>It Ain't Me, Babe,</u> the first comic produced entirely by women, came out in 1970, sparking a wave of feminist comix in the 1970s – 80s. Their legacy inspires countless female cartoonists today.

PICTURED ABOVE (left to right): PUDGE (MARRS), GODDESS FROM <u>ALL GIRL THRILLS</u> (ROBBINS), SUPER DYKE (GREGORY)

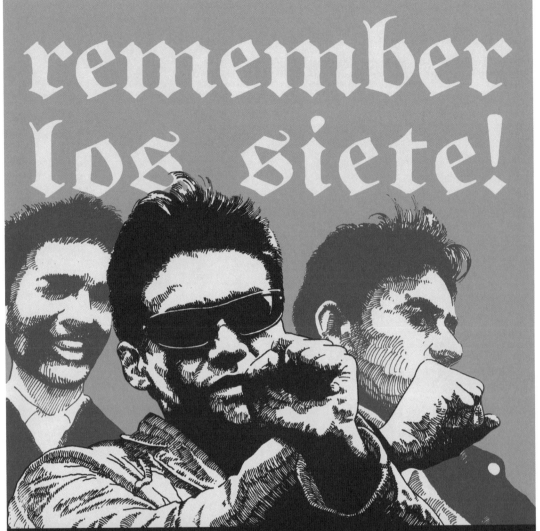

remember los siete!

Los Siete de la Raza eran siete jovenes de la Misión de San Francisco, acusados de matar a un policia el primero de mayo de 1969. Su juicio fue un momento clave en la concientización de Latin@s en la Bahía. Despues de un juicio de 18 meses que mobilizó a la comunidad, todos fueron absueltos. El Comité de Defensa de Los Siete se transformó en una organización comunitaria radical, animada por principios de auto-determinación y "servir al pueblo," comenzando un programa de desayunos gratis, una clínica médica gratis, un restorán de trabajadores, y el periódico "Basta Ya!" Los Siete desarrollaron un internacionalismo tercermundista revolucionario, encarnado en el término inclusivo "Raza," ligando las luchas de Latin@s con otras comunidades de color, incluyendo la toma de Alcatraz, las Panteras Negras, y los Young Lords Puertoriqueños. Los temas que alzaron Los Siete – incluyendo la lucha contra represión policíaca, desplazamiento, y líderes vendidos, la necesidad de programas del pueblo contra dependencia en caridad o el estado, ligando organización comunitaria con trabajo cultural, y enfrentando el desafio de ser "revolucionario" y mantener su base en la comunidad – continúan siendo relevantes en las luchas de hoy.

Los Siete de la Raza were seven youths from San Francisco's Mission District, accused of killing a cop on May 1, 1969. Their trial was a key moment in the awakening of consciousness for Latin@s in the Bay Area. After an 18-month trial that mobilized the community, all of Los Siete were acquitted. The Los Siete Defense Committee transformed itself into a radical community organization, animated by principles of self-determination and "serve the people," starting a free breakfast program, a free medical clinic, a workers' restaurant, and the "Basta Ya!" newspaper. Los Siete developed a revolutionary Third World internationalism, embodied in the inclusive term "Raza," linking the struggles of Latin@s with those of other communities of color including the Alcatraz occupation, the Black Panthers, and the Puerto Rican Young Lords. The issues that Los Siete de la Raza raised – including fighting police repression, gentrification, and sellout leaders, the necessity for people's programs vs. dependence on charity or government, linking community organizing with cultural work, and facing the challenges of being "revolutionary" and staying community-based – continue to be relevant in today's struggles.

celebrate people's history

ANARCHISM | COMMUNISM | SOCIALISM
ANTI-WAR | ANTI-IMPERIALISM | SOLIDARITY
ENVIRONMENTALISM
FEMINISM | QUEER LIBERATION
HEALTH | HOUSING | EDUCATION | CULTURE
LABOR | ANTI-CAPITALISM
SLAVERY | POLICE | PRISONS | ANTI-FASCISM
RACIAL JUSTICE | NATIONAL LIBERATION | INDIGENOUS STRUGGLE

Since 1492 to the present, November 9th, 1969, the Indian people have been held in bondage. Alcatraz is a release from that bondage...
John Trudell, "Radio Free Alcatraz"

THE OCCUPATION OF ALCATRAZ

From November 1969 to June 1971 a coalition of American Indian students and urban Indians, calling themselves Indians of All Tribes, occupied Alcatraz Island off the coast of San Francisco as a call to resistance against U.S. domination of Native peoples and land. The coalition publicized the occupation through a widely distributed newsletter and a radio show broadcast in multiple cities. This action sparked years of Native resistance, including the 1972 takeover of the Bureau of Indian Affairs Headquarters in Washington, DC, and the re-occupation of Wounded Knee in 1973.

WARNING KEEP OFF INDIAN PROPERTY

CELEBRATE PEOPLE'S HISTORY

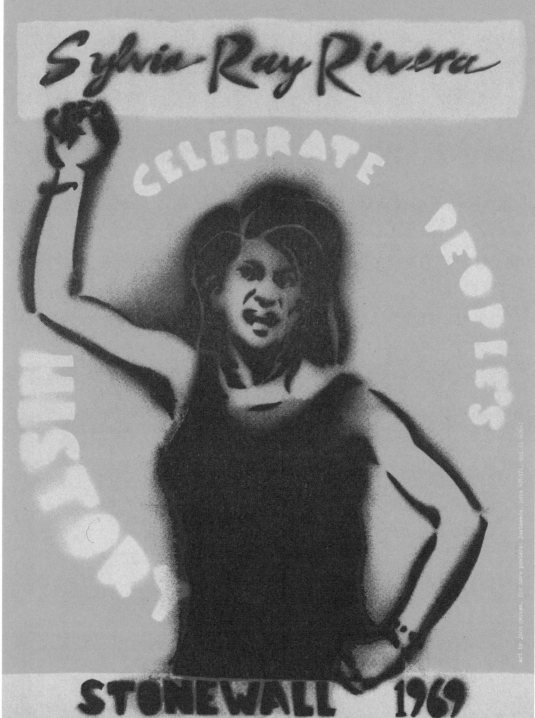

Sylvia-Ray Rivera

CELEBRATE PEOPLES

HISTORY

STONEWALL 1969

art by John Gerken, for more posters: justseeds, jobs 475-971, ext. 46 6567

Everybody says it was me that threw the first bottle. No, it was somebody behind me that threw it. But when that first bottle went by me, I said, "Oh lord, the revolution is finally here! Hallelujah, it's time to go do your thing!"

The movement was born that night, and we knew that we had done something that everybody in the whole world would know about. They would know that gay people stood up and fought, and that would make everybody else stand up and fight.

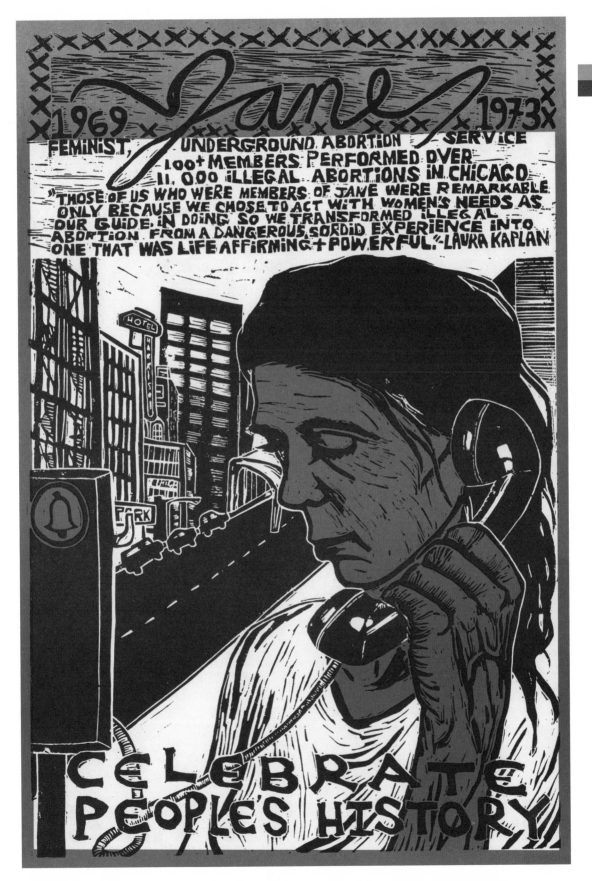

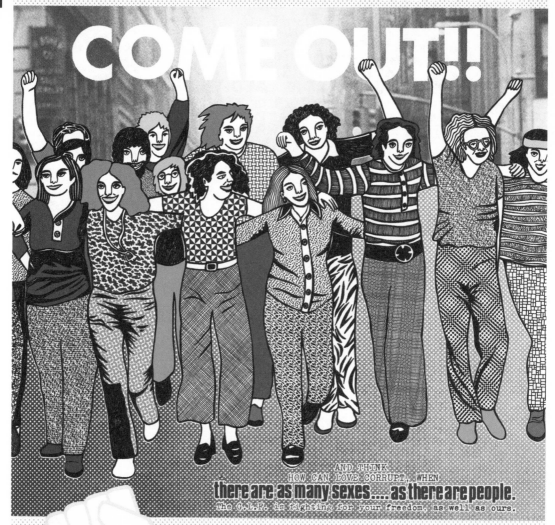

CELEBRATE PEOPLE'S HISTORY

COME OUT!!

AND THINK
HOW CAN LOVE CORRUPT, WHEN
there are as many sexes as there are people.
The G.L.F. is fighting for your freedom, as well as ours.

THE GAY LIBERATION FRONT WAS THE FIRST LGBT ACTIVIST ORGANIZATION FORMED AFTER THE STONEWALL REBELLION IN NEW YORK CITY IN JUNE 1969. BY INCLUDING "GAY" IN THEIR NAME–WHICH NO OTHER QUEER ORGANIZATION HAD DONE PRIOR TO THE GLF–THEY SIGNALLED TO THE WORLD THEIR RADICAL, UNAPOLOGETIC, ANTI-ASSIMILATIONIST STANDPOINT. A CENTRAL GOAL OF THE GLF WAS TO ESTABLISH "A SOCIETY IN WHICH ALL PEOPLE ENJOY FREEDOM OF EXISTENCE AND FREEDOM TO RELATE TO EACH OTHER IN WHATEVER MANNER THEY SEE FIT, WITHOUT FEAR OF OPPRESSION OR CONDEMNATION." WHILE FIERCELY INSISTING THAT THE PERSONAL IS POLITICAL, THEY SOUGHT A WIDESPREAD CULTURAL REVOLUTION WHERE QUEERS AND OTHER OPPRESSED PEOPLES WOULD "START DEMANDING, NOT POLITELY REQUESTING, OUR RIGHTS."

FOR SEVERAL YEARS IN MANY U.S. CITIES AND ABROAD, THE GLF OPERATED AS A UTOPIAN, REVOLUTIONARY ORGANIZATION THAT BIRTHED OTHER RADICAL QUEER GROUPS SUCH AS THE RADICALESBIANS, THIRD WORLD GAY REVOLUTION, AND STREET TRANSVESTITE ACTION REVOLUTIONARIES (STAR). BY 1973, THE EFFORTS OF THE GLF AND OTHER ACTIVISTS HELPED PUSH THE AMERICAN PSYCHIATRIC ASSOCIATION TO DECLASSIFY HOMOSEXUALITY AS A MENTAL DISORDER, PAVING THE WAY FOR MORE GROUNDBREAKING SOCIETAL CHANGES, MANY OF WHICH ARE STILL EVOLVING TO THIS DAY. WITH THE CHRISTOPHER STREET LIBERATION DAY COMMITTEE AND OTHER NYC GAY ORGANIZATIONS, THE GLF HELPED BEGIN WHAT EVENTUALLY WOULD BECOME GAY PRIDE MARCHES, ENCOURAGING QUEERS TO "COME OUT" WORLDWIDE. DESPITE THEIR SHORT TIME FORMALLY ORGANIZING, THE LEGACY AND TECHNIQUES OF THE GLF ARE LONG REACHING AND STILL INFORM THE MANY INDIVIDUALS, ACTIVISTS, AND ORGANIZATIONS FIGHTING FOR LGBTQIA RIGHTS TO THIS DAY.

GAY LIBERATION FRONT

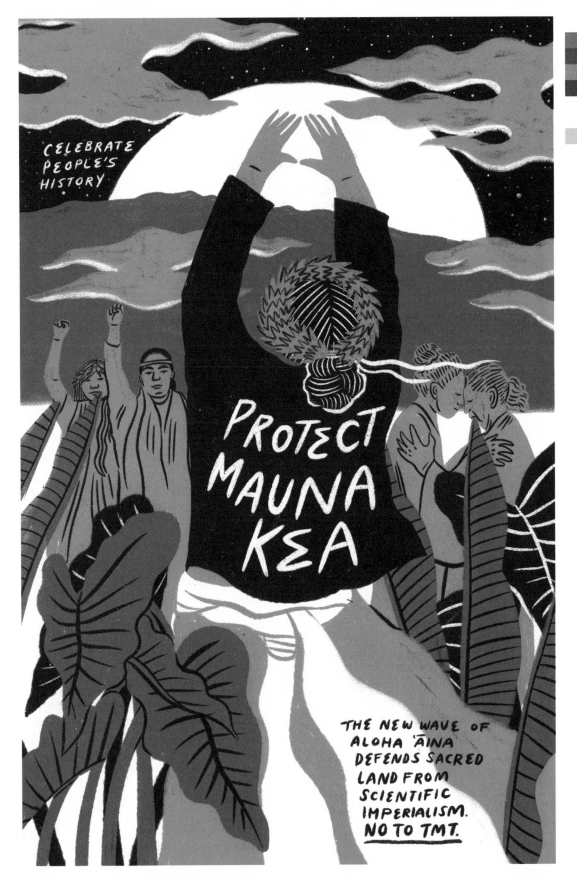

CELEBRATE PEOPLE'S HISTORY

PROTECT MAUNA KEA

THE NEW WAVE OF ALOHA ʻĀINA DEFENDS SACRED LAND FROM SCIENTIFIC IMPERIALISM. NO TO TMT.

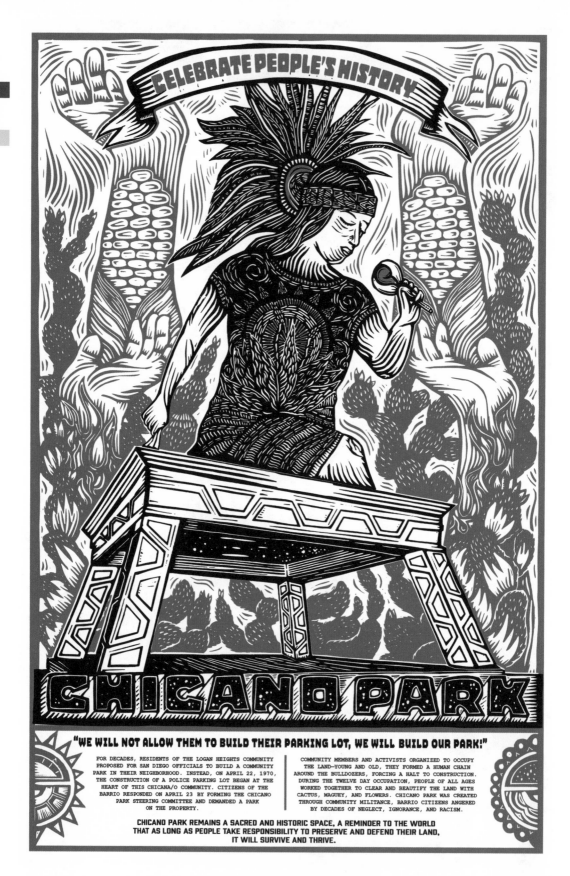

CELEBRATE PEOPLE'S HISTORY

CHICANO PARK

"WE WILL NOT ALLOW THEM TO BUILD THEIR PARKING LOT, WE WILL BUILD OUR PARK!"

FOR DECADES, RESIDENTS OF THE LOGAN HEIGHTS COMMUNITY PROPOSED FOR SAN DIEGO OFFICIALS TO BUILD A COMMUNITY PARK IN THEIR NEIGHBORHOOD. INSTEAD, ON APRIL 22, 1970, THE CONSTRUCTION OF A POLICE PARKING LOT BEGAN AT THE HEART OF THIS CHICANA/O COMMUNITY. CITIZENS OF THE BARRIO RESPONDED ON APRIL 23 BY FORMING THE CHICANO PARK STEERING COMMITTEE AND DEMANDED A PARK ON THE PROPERTY.

COMMUNITY MEMBERS AND ACTIVISTS ORGANIZED TO OCCUPY THE LAND—YOUNG AND OLD, THEY FORMED A HUMAN CHAIN AROUND THE BULLDOZERS, FORCING A HALT TO CONSTRUCTION. DURING THE TWELVE DAY OCCUPATION, PEOPLE OF ALL AGES WORKED TOGETHER TO CLEAR AND BEAUTIFY THE LAND WITH CACTUS, MAGUEY, AND FLOWERS. CHICANO PARK WAS CREATED THROUGH COMMUNITY MILITANCE, BARRIO CITIZENS ANGERED BY DECADES OF NEGLECT, IGNORANCE, AND RACISM.

CHICANO PARK REMAINS A SACRED AND HISTORIC SPACE, A REMINDER TO THE WORLD THAT AS LONG AS PEOPLE TAKE RESPONSIBILITY TO PRESERVE AND DEFEND THEIR LAND, IT WILL SURVIVE AND THRIVE.

CHICANO PARK ALFONSO ACEVES

148

Our decolonisation starts now
as we, as a people,
will no longer accept that we are
third class citizens in our own lands.

Our colonised status will now be changed
as we take back what is rightfully ours.

We must and will speak with one voice
and walk as one people.

CELEBRATE PEOPLE'S HISTORY

RAY JACKSON

Indigenous Social Justice Association | Laureate of the Human Rights Prize of the French Republic 2013

Ray Jackson was a proud Aboriginal activist, father, grandfather, great-grandfather, unionist, wharfie, feminist, internationalist, organiser, and insurgent intellectual. Over five decades, Ray dedicated himself to movements fighting to hold the powerful to account and to bring justice to the denied. As one of the founders of the NSW Aboriginal Deaths in Custody Watch Committee and the co-founder and president of the Indigenous Social Justice Association, Ray played a crucial role organising alongside and on behalf of those most targeted by lethal state violence and racist impunity: our sisters, our brothers, and transgender people, incarcerated in police lock-ups, state prisons, and refugee and immigration prisons. Ray's fierce commitment, leadership, gentleness, and generosity in the midst of unrelenting suffering and oppression will forever demonstrate that all the abuse of power in the world will never be more powerful than Aboriginal sovereignty and solidarity.

'FKJ – For Koori Justice'

"We live in capitalism, its power seems inescapable— but then, so did the divine right of kings. Any human power can be resisted and changed by human beings. Resistance and change often begin in art. Very often in our art, the art of words."

ursula k. le guin
Writer, feminist, envisioner of possibilities & anarchic societies · 1929-2018

celebrate people's history

HØNSESTRIKK

HØNSESTRIKK, OR HEN KNITTING, IS A TYPE OF NARRATIVE FEMINIST KNITTING THAT EMERGED IN DENMARK DURING THE 1970S. KNITTERS CREATED SWEATERS USING BRIGHT COLORS, UNCONVENTIONAL TECHNIQUES, AND IMAGERY WITH NARRATIVES ABOUT THE PERSON INTENDING TO WEAR IT. HØNSESTRIKK IS STILL EXECUTED BY KNITTERS TODAY, INCORPORATING CONTEMPORARY POLITICAL AND SOCIAL ISSUES.

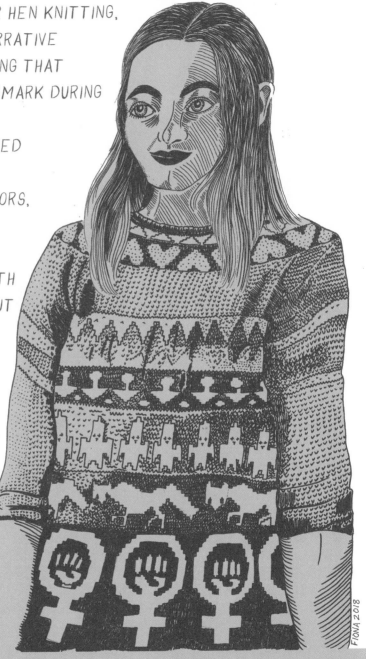

FIONA 2018

CELEBRATE PEOPLE'S HISTORY

THE FROEBEL HIGH SCHOOL UPRISING NICOLE MARROQUIN

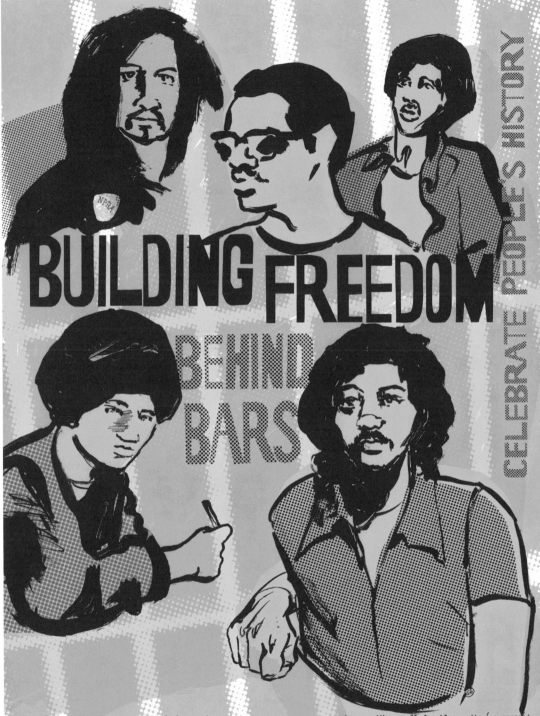

BUILDING FREEDOM

BEHIND BARS

In 1973 a group of workers in Walpole, MA, forged a cross race coalition demanding better pay, improved safety, and a bigger say in determining their working conditions. When the "managers" went on strike--a company lock out--the workers seized control.

That the workers were prisoners and that in taking control of the factory they also took control of the prison makes the story even more amazing. During their period of control, Walpole went from one of the most dangerous prisons in the US to one of the safest. Education classes were developed and the idea of rehabilitation actually became a possibility.

Behind fellow inmates Bobby Dellelo and Ralph Hamm, prisoners organized as the National Prisoners Reform Association with a call for blue unity (as opposed to the brown uniforms of the guards). The NPRA fought for NLRB recognition and to democratically run Walpole prison. For an all-too-brief period the men of MCI-Walpole proved that the abolition of prison can be reality.

To learn more check out *When the Prisoners Ran Walpole* and *3,000 Years and Life.*

The Lesbian Herstory Archives

CELEBRATING 35 YEARS

The Lesbian Herstory Archives opened in 1974 in the Upper West Side Manhattan apartment of Joan Nestle and Deborah Edel. Along with others in the original collective, they were concerned about the failure of mainstream publishers, libraries, archives, and research institutions to value Lesbian culture. They recognized that an independent archive, governed by Lesbians, would best protect, preserve, and share Lesbian history.

In 1990, the Archives purchased a three-story landmark district limestone building in Brooklyn's Park Slope neighborhood. It was the first, and is the only, building owned by a Lesbian organization in the New York metropolitan area, and was purchased with donations from Lesbians, Gay men, and friends from the extended community of caring individuals who support our work. The building, which is wheelchair accessible, was opened in 1993 after volunteers had helped with the renovations.

Inspired by the courage of Lesbians who lived, struggled, and loved in more difficult times, the Archives is governed by a group of volunteer co-ordinators and sustained by the collective work of volunteers and the passions of women the world over. Today the Lesbian Herstory Archives is the largest and longest-lived Lesbian archive anywhere.

We've got your past.

Who's got your future?

Keeping it real since 1974!

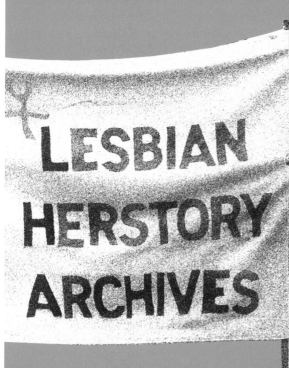

Mabel Hampton,
NYC Gay Pride Parade

LESBIAN HERSTORY ARCHIVES CARRIE MOYER

154

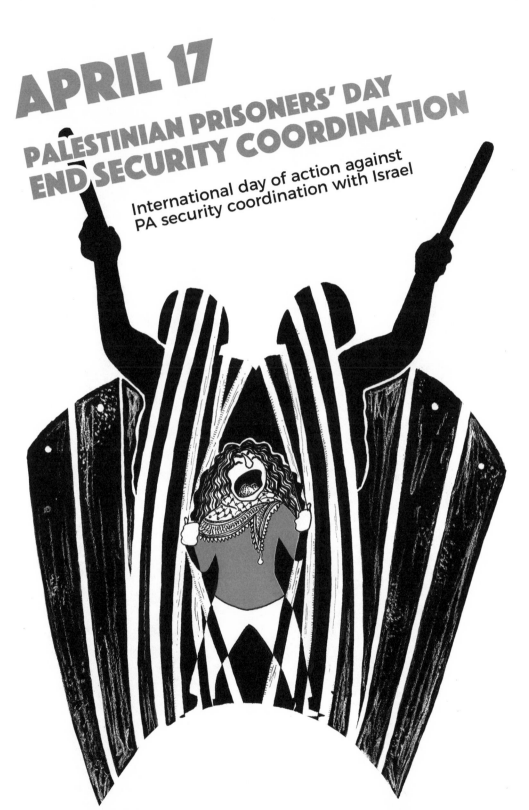

APRIL 17
PALESTINIAN PRISONERS' DAY
END SECURITY COORDINATION

International day of action against
PA security coordination with Israel

CELEBRATE PEOPLE'S HISTORY

Palestinian Prisoners' Day was initiated in 1974 to mark the successful release the first Palestinian political prisoner.

PALESTINIAN PRISONERS' DAY LEILA ABDELRAZAQ

ANARCHISM | COMMUNISM | SOCIALISM
ANTI-WAR | ANTI-IMPERIALISM | SOLIDARITY
ENVIRONMENTALISM
FEMINISM | QUEER LIBERATION
HEALTH | HOUSING | EDUCATION | CULTURE
LABOR | ANTI-CAPITALISM
SLAVERY | POLICE | PRISONS | ANTI-FASCISM
RACIAL JUSTICE | NATIONAL LIBERATION | INDIGENOUS STRUGGLE

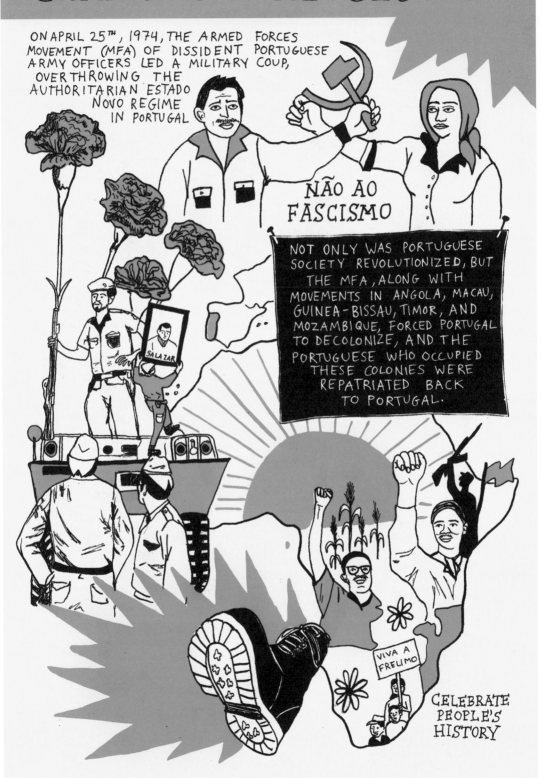

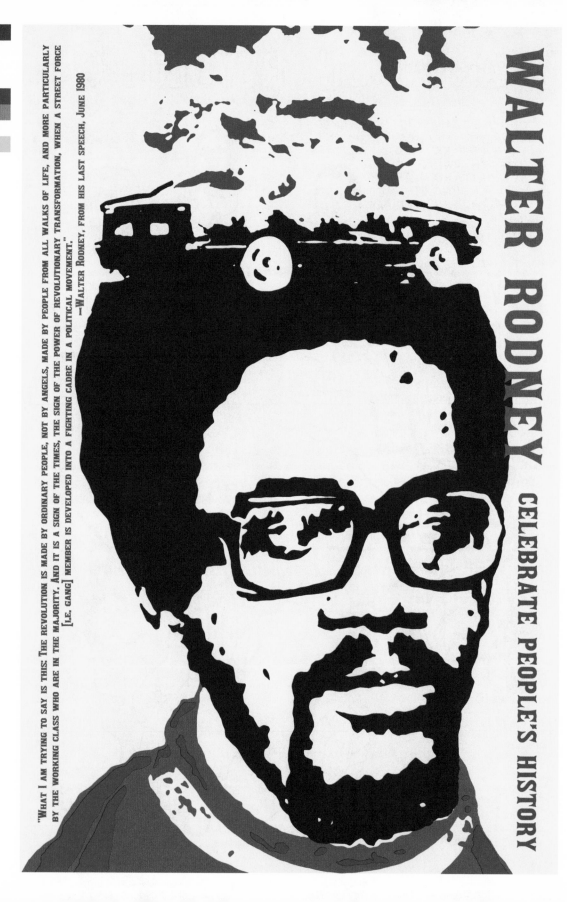

WALTER RODNEY

CELEBRATE PEOPLE'S HISTORY

"WHAT I AM TRYING TO SAY IS THIS: THE REVOLUTION IS MADE BY ORDINARY PEOPLE, NOT BY ANGELS, MADE BY PEOPLE FROM ALL WALKS OF LIFE, AND MORE PARTICULARLY BY THE WORKING CLASS WHO ARE IN THE MAJORITY. AND IT IS A SIGN OF THE TIMES, THE SIGN OF THE POWER OF REVOLUTIONARY TRANSFORMATION, WHEN A STREET FORCE [I.E. GANG] MEMBER IS DEVELOPED INTO A FIGHTING CADRE IN A POLITICAL MOVEMENT."
—WALTER RODNEY, FROM HIS LAST SPEECH, JUNE 1980

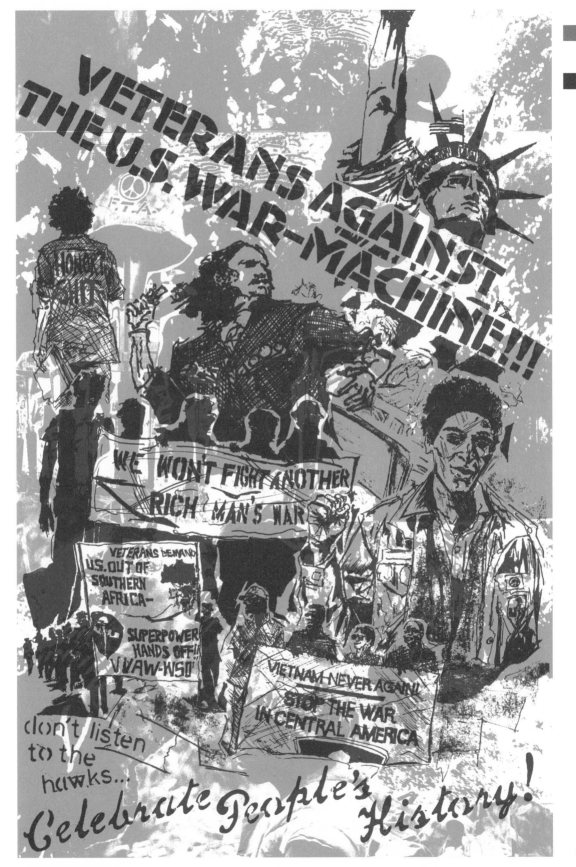

the Suicide Club

IN THE MID 1970s, THIS UNRULY BAND OF CULTURAL REVOLUTIONARIES TURNED SAN FRANCISCO INTO A PLAYGROUND, STAGING ELABORATE PRANKS AND URBAN ADVENTURES IN PURSUIT OF CHAOS, ANARCHY, AND HIGH TIMES. THE SPIRIT PERSISTS IN GROUPS LIKE THE CACOPHONY SOCIETY, DARK PASSAGE, AND THE BILLBOARD LIBERATION FRONT.

CELEBRATE PEOPLE'S HISTORY

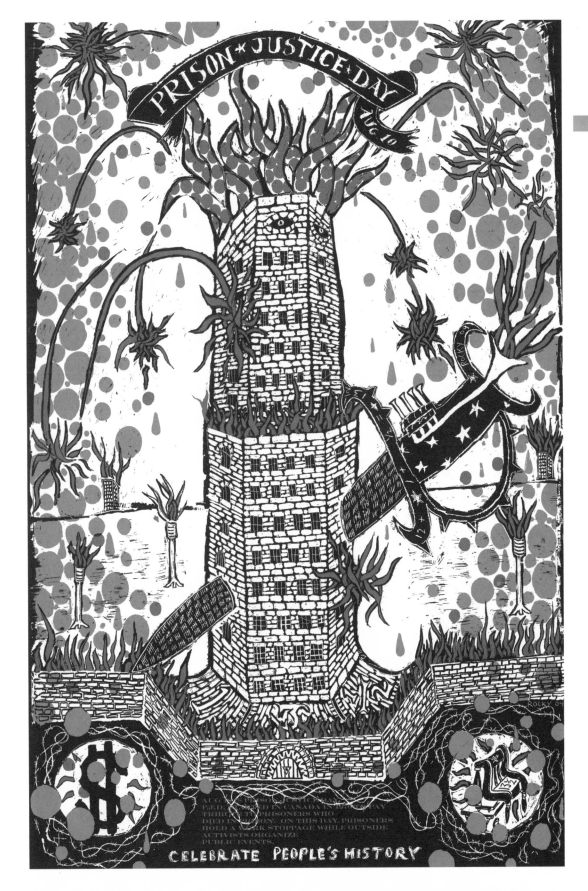

PRISON JUSTICE DAY ROCKY DOBEY

CELEBRATE PEOPLE'S HISTORY

The Animal Liberation Front (ALF) is an animal liberation group that engages in direct action on behalf of animals. These activities include removing animals from laboratories and fur farms and sabotaging facilities. Any act that furthers the cause of animal liberation, where all reasonable precautions are taken not to harm human or non-human life, may be claimed as an ALF action. The ALF is not a group with a membership, but a leaderless resistance. ALF volunteers see themselves as similar to the Underground Railroad, the 19th-century anti-slavery network, with activists removing animals from laboratories and farms, arranging safe houses and veterinary care, and operating sanctuaries where the animals live out the rest of their lives. ALF activists believe that animals should not be viewed as property and that scientists and industry have no right to assume ownership of living beings. They reject the animal welfarist position that more humane treatment is needed for animals; their aim is empty cages, not bigger ones.

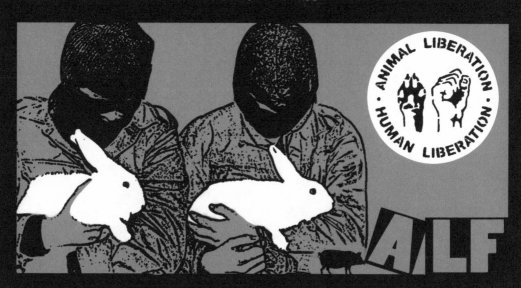

ALF (ANIMAL LIBERATION FRONT) KAREN FIORITO

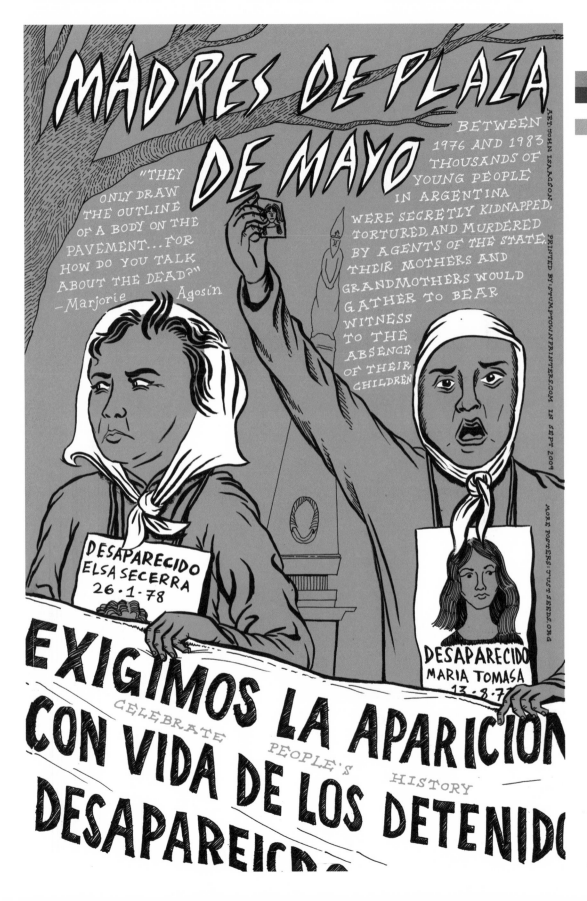

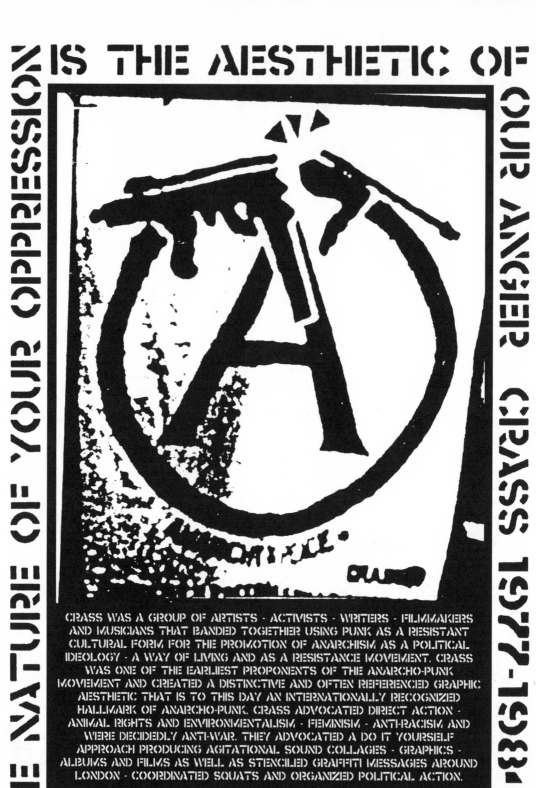

IS THE AESTHETIC OF

THE NATURE OF YOUR OPPRESSION

OUR ANGER CRASS 1977-1984

CRASS WAS A GROUP OF ARTISTS · ACTIVISTS · WRITERS · FILMMAKERS AND MUSICIANS THAT BANDED TOGETHER USING PUNK AS A RESISTANT CULTURAL FORM FOR THE PROMOTION OF ANARCHISM AS A POLITICAL IDEOLOGY · A WAY OF LIVING AND AS A RESISTANCE MOVEMENT. CRASS WAS ONE OF THE EARLIEST PROPONENTS OF THE ANARCHO-PUNK MOVEMENT AND CREATED A DISTINCTIVE AND OFTEN REFERENCED GRAPHIC AESTHETIC THAT IS TO THIS DAY AN INTERNATIONALLY RECOGNIZED HALLMARK OF ANARCHO-PUNK. CRASS ADVOCATED DIRECT ACTION · ANIMAL RIGHTS AND ENVIRONMENTALISM · FEMINISM · ANTI-RACISM AND WERE DECIDEDLY ANTI-WAR. THEY ADVOCATED A DO IT YOURSELF APPROACH PRODUCING AGITATIONAL SOUND COLLAGES · GRAPHICS · ALBUMS AND FILMS AS WELL AS STENCILED GRAFFITI MESSAGES AROUND LONDON · COORDINATED SQUATS AND ORGANIZED POLITICAL ACTION.

CELEBRATE PEOPLES
HISTORY · ANOK4U2

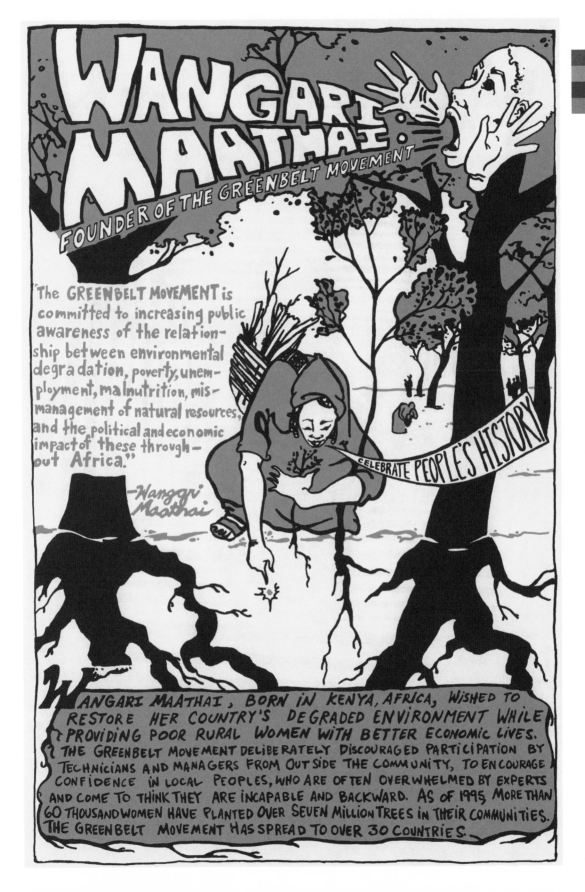

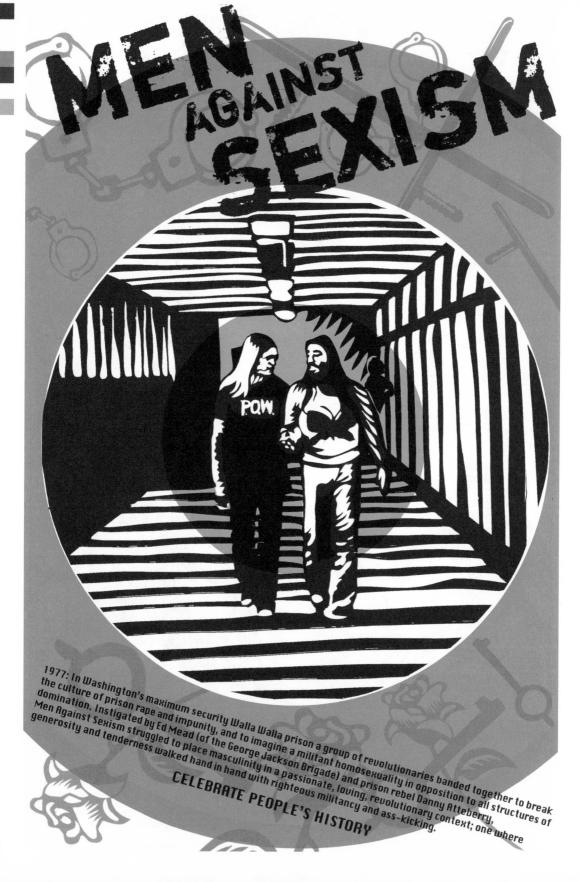

MEN AGAINST SEXISM

1977: In Washington's maximum security Walla Walla prison a group of revolutionaries banded together to break the culture of prison rape and impunity, and to imagine a militant homosexuality in opposition to all structures of domination. Instigated by Ed Mead (of the George Jackson Brigade) and prison rebel Danny Atteberry, Men Against Sexism struggled to place masculinity in a passionate, loving, revolutionary context; one where generosity and tenderness walked hand in hand with righteous militancy and ass-kicking.

CELEBRATE PEOPLE'S HISTORY

CO-MADRES

COMITÉ DE MADRES MONSEÑOR ROMERO, EL SALVADOR

DESAPARECIDOS Y ASESINATOS

THE DISAPPEARED & ASSASSINATED 1977–PRESENT

CELEBRATE PEOPLE'S HISTORY

En los años setenta el gobierno Salvadoreño de la derecha inició un periodo de represión brutal en contra de grupos y personas que participaron en las protestas publicas y otras formas de "actividades subversivas", usando secuestros o "desapariciones forzadas", tortura y asesinatos como metodos para intimidarlos y mantenerlos en silencio. Esto periodo duró hasta los años noventa.

El Comité de Madres de los Desaparecidos y Asesinatos de El Salvador (Co-Madres) fue fundado por mujeres buscando a sus hijos desaparecidos. Las Co-Madres han trabajado incansablemente y sin temor por los ultimos 33 años para documentar y denunciar las desapariciones y asesinatos. Ellas continuarán su misión hasta que los casos sean traidos a la justicia, con el refrán: "Podemos perdonar, pero no podemos olvidar".

In the 1970s the right-wing Salvadoran government initiated a period of brutal repression against any group or individual that participated in public protest or other so called "subversive activities," using abduction or "disappearance," torture and assassination as methods to intimidate the public into silence. This lasted through the 1990s.

The Committee of the Mothers of the Disappeared and Assassinated of El Salvador (Co-Madres) was formed by women seeking their missing children. The Co-Madres have worked tirelessly and fearlessly over the past 33 years to document and denounce the disappearances and murders. They will continue their mission until these cases are brought to justice, saying "We can forgive, but we cannot forget".

Text and Research: Mara Komoska, Art: Nicole Schulman
More Info: www.comadres.org | www.nicoleschulman.com
More posters: www.justseeds.org
printed at stumptownprinters.com in November 2010

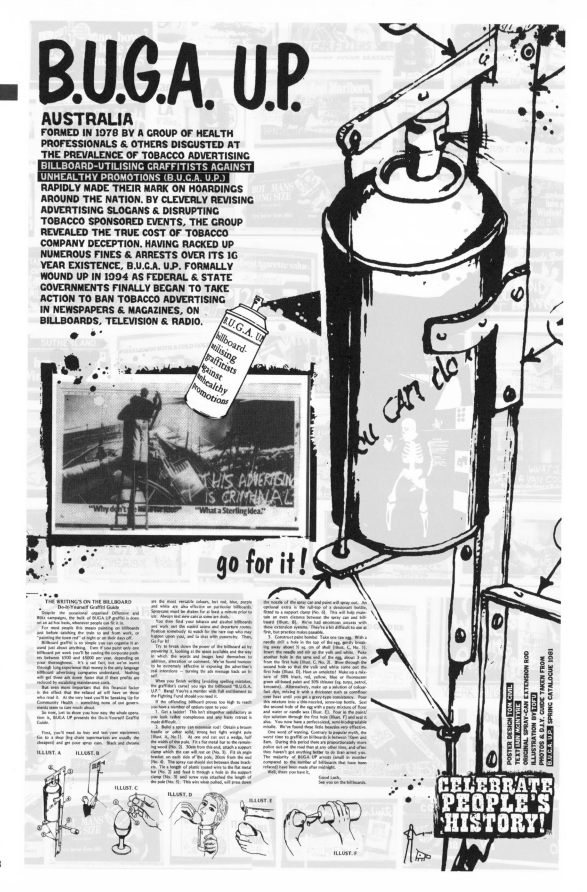

B.U.G.A. U.P.

AUSTRALIA

FORMED IN 1978 BY A GROUP OF HEALTH PROFESSIONALS & OTHERS DISGUSTED AT THE PREVALENCE OF TOBACCO ADVERTISING BILLBOARD-UTILISING GRAFFITISTS AGAINST UNHEALTHY PROMOTIONS (B.U.G.A. U.P.) RAPIDLY MADE THEIR MARK ON HOARDINGS AROUND THE NATION. BY CLEVERLY REVISING ADVERTISING SLOGANS & DISRUPTING TOBACCO SPONSORED EVENTS, THE GROUP REVEALED THE TRUE COST OF TOBACCO COMPANY DECEPTION. HAVING RACKED UP NUMEROUS FINES & ARRESTS OVER ITS 16 YEAR EXISTENCE, B.U.G.A. U.P. FORMALLY WOUND UP IN 1994 AS FEDERAL & STATE GOVERNMENTS FINALLY BEGAN TO TAKE ACTION TO BAN TOBACCO ADVERTISING IN NEWSPAPERS & MAGAZINES, ON BILLBOARDS, TELEVISION & RADIO.

B.U.G.A. U.P
billboard-
utilising
graffitists
against
unhealthy
promotions

"Why don't the it for real?" "What a Sterling idea."

THIS ADVERTISING IS CRIMINAL

go for it!

THE WRITING'S ON THE BILLBOARD
Do-It-Yourself Graffiti Guide

Despite the occasional organised Offensive and Blitz campaigns, the bulk of BUGA UP graffiti is done on an ad hoc basis, whenever people can fit it in.

For most people this means painting on billboards just before catching the train to and from work, or "painting the town red" at night or on their days off.

Billboard graffiti is so simple you can organise it around just about anything. Even if you paint only one billboard per week you'll be costing the corporate pushers between $500 and $5000 per year, depending on your thoroughness. It's a sad fact, but we've learnt through long experience that money is the only language billboard advertising companies understand. Nothing will get those ads down faster than if their profits are reduced by escalating maintenance costs.

But even more important than this financial factor is the effect that the refaced ad will have on those who read it. At the very least you'll be Speaking Up for Community Health — something none of our governments seem to care much about.

So now, just to show you how easy the whole operation is, BUGA UP presents the Do-it-Yourself Graffiti Guide.

First, you'll need to buy and test your equipment. Go to a shop (big chain supermarkets are usually the cheapest) and get your spray cans. Black and chrome

ILLUST. A ILLUST. B

are the most versatile colours, but red, blue, purple and white are also effective on particular billboards. Spraycans must be shaken for at least a minute prior to use. Always test new cans as some are duds.

You then find your tobacco and alcohol billboards and work out the easiest access and departure routes. Position somebody to watch for the rare cop who may happen upon you, and to chat with passers-by. Then, Go For It!

Try to break down the power of the billboard ad by answering it, looking at the space available and the way in which the words and images lend themselves to addition, alteration or comment. We've found humour to be extremely effective in exposing the advertiser's real intentions — turning the ads message back on itself.

When you finish writing (avoiding spelling mistakes, the graffitist's curse) you sign the billboard "B.U.G.A. U.P." Bang! You're a member with full entitlement to the Fighting Fund should you need it.

If the offending billboard proves too high to reach you have a number of options open to you:

1. Get a ladder! This isn't altogether satisfactory as you look rather conspicuous and any hasty retreat is made difficult.

2. Build a spray can extension rod! Obtain a broom handle or other solid, strong but light weight pole (Illust. A, No.1). At one end cut out a wedge, half the width of the pole. Fit a flat metal bar to the remaining wood (No. 2). 30cm from this end, attach a support clamp which the can will rest on (No. 3). Fit an angle bracket on each side of the pole, 20cm from the end (No. 4). The spray can should slot between these brackets. Tie a length of plastic coated wire to the flat metal bar (No. 2) and feed it through a hole in the support clamp (No. 3) and screw eyes attached the length of the pole (No. 5). This wire when pulled, will press down

the nozzle of the spray can and paint will spray out. An optional extra is the roll-top of a deodorant bottle, fitted to a support clamp (No. 6). This will help maintain an even distance between the spray can and billboard (Illust. B). We've had enormous success with these extension systems. They're a bit difficult to use at first, but practice makes passable.

3. Construct paint bombs! Take one raw egg. With a needle drill a hole in the top of the egg, gently breaking away about ½ sq. cm of shell (Illust. C, No. 1). Insert the needle and stir up the yolk and white. Poke another hole in the same end of the egg, about 3 cm from the first hole (Illust. C, No. 2). Blow through the second hole so that the yolk and white come out the first hole (Illust. D). Have an omelette! Make up a mixture of 50% black, red, yellow, blue or fluorescent green oil-based paint and 50% thinner (eg. turps, petrol, kerosene). Alternatively, make up a solution of colour-fast dye, mixing it with a thickener such as cornflour over heat until you get a gravy-type consistency. Pour this mixture into a thin-nozzled, screw-top bottle. Seal the second hole of the egg with a pasty mixture of flour and water or candle wax (Illust. E). Pour in the paint/dye solution through the first hole (Illust. F) and seal it also. You now have a perfect-sized, semi-biodegradable missile. We've found these little beauties very effective.

One word of warning. Contrary to popular myth, the worst time to graffiti on billboards is between 10pm and 8am. During this period there are proportionately more police out on the road than at any other time, and often they haven't got anything better to do than arrest you. The majority of BUGA UP arrests (small in number compared to the number of billboards that have been refaced) have been made after midnight.

Well, there you have it,

Good Luck,
See you on the billboards.

ILLUST. C ILLUST. D ILLUST. E ILLUST. F

POSTER DESIGN TOM CIVIL
TEXT IAIN MCINTYRE
ORIGINAL SPRAY-CAN EXTENSION ROD ILLUSTRATION BY TOFU
PHOTOS & D.I.Y. GUIDE TAKEN FROM B.U.G.A. U.P. SPRING CATALOGUE 1981

CELEBRATE PEOPLE'S HISTORY!

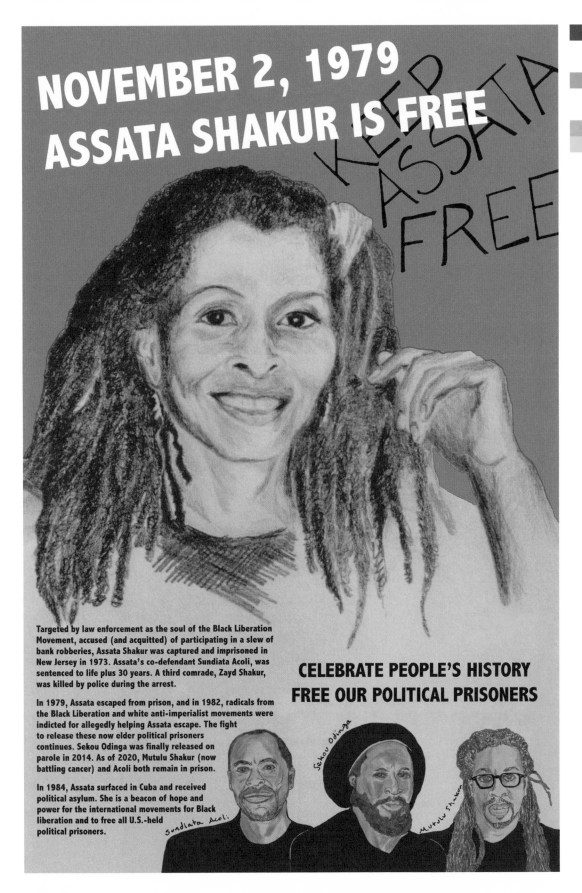

NOVEMBER 2, 1979
ASSATA SHAKUR IS FREE

KEEP ASSATA FREE

Targeted by law enforcement as the soul of the Black Liberation Movement, accused (and acquitted) of participating in a slew of bank robberies, Assata Shakur was captured and imprisoned in New Jersey in 1973. Assata's co-defendant Sundiata Acoli, was sentenced to life plus 30 years. A third comrade, Zayd Shakur, was killed by police during the arrest.

In 1979, Assata escaped from prison, and in 1982, radicals from the Black Liberation and white anti-imperialist movements were indicted for allegedly helping Assata escape. The fight to release these now elder political prisoners continues. Sekou Odinga was finally released on parole in 2014. As of 2020, Mutulu Shakur (now battling cancer) and Acoli both remain in prison.

In 1984, Assata surfaced in Cuba and received political asylum. She is a beacon of hope and power for the international movements for Black liberation and to free all U.S.-held political prisoners.

CELEBRATE PEOPLE'S HISTORY
FREE OUR POLITICAL PRISONERS

Sundiata Acoli

Sekou Odinga

Mutulu Shakur

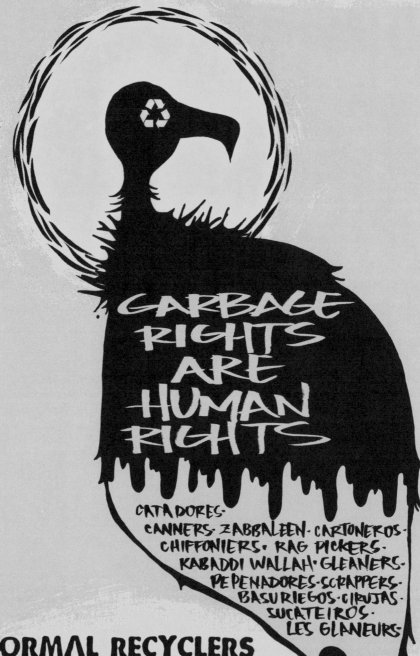

GARBAGE RIGHTS ARE HUMAN RIGHTS

CATADORES·
CANNERS· ZABBALEEN· CARTONEROS·
CHIFFONIERS· RAG PICKERS·
KABADDI WALLAH· GLEANERS·
PEPENADORES· SCRAPPERS·
BASURIEGOS· CIRUJAS·
SUCATEIROS·
LES GLANEURS·

INFORMAL RECYCLERS

Informal recyclers reuse and resell the world's garbage as a means of survival. They collect recyclables door to door, in the street, from trash cans, from landfills, and even from canals of untreated sewage. These recyclers are responsible for rerouting a significant portion of the world's waste from landfills into reuse, but they lack transportation, housing, sanitation, medical treatment, legal rights to garbage, and other basic needs. Informal recyclers typically begin and end life as social outcasts in the poorest economic sector of society. Like garbage, they are discarded and ignored. Instead of finding ways to integrate these workers into effective waste management models, many countries are making access to garbage illegal. With garbage and poverty increasing around the world, it is time to end privatized waste management and move on to inclusive recycling systems.

CELEBRATE PEOPLE'S HISTORY

AUDRE LORDE
GAMBDA ADISA

NYC, USA BORN FEBRUARY 18, 1934 - DIED NOVEMBER 17, 1992 ST. CROIX

BLACK LESBIAN
MOTHER
WARRIOR
POET

"AND WHEN WE SPEAK WE ARE AFRAID
OUR WORDS WILL NOT BE HEARD
NOR WELCOMED
BUT WHEN WE ARE SILENT
WE ARE STILL AFRAID
SO IT IS BETTER TO SPEAK
REMEMBERING
WE WERE NEVER
MEANT TO SURVIVE."
- A LITANY FOR SURVIVAL

SHE WHO MAKES HER MEANING KNOWN

ink works PRESS collective

worker owned

movement printing

union shop

green

socialist

feminist

Inkworks Press was founded in 1973 in Berkeley, CA, by movement activists who saw that "Freedom of the Press belongs only to those who own one." With an offset press inherited from a trade school for working-class and women organizers, they formed a worker-collective union shop serving a set of political points of unity. For over 35 years, Inkworks put the power of printing press in the hands of frontline communities by printing iconic posters, advocacy reports, and effective organizing materials. The collective provided infrastructure for the Bay Area's ecosystem of culture workers and movement artists to create strategic visual communications for our movements. Their legacy continues to this day.

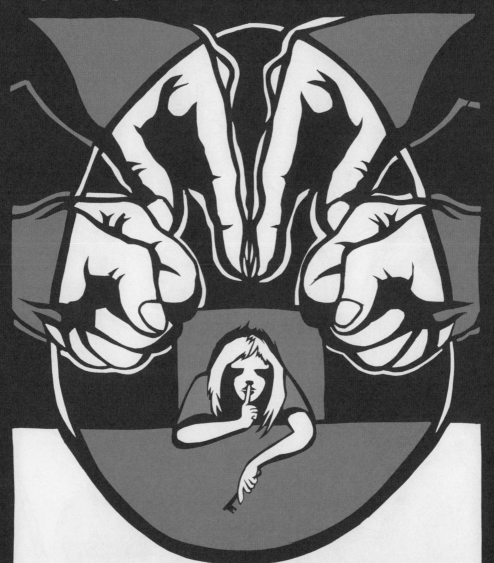

THE SILENT MAJORITY

THIS POSTER IS A CELEBRATION OF ALL THOSE WHO KEPT THEIR MOUTHS SHUT; THE PEOPLE WHO REFUSED TO SNITCH TO THE COPS, WHO RESISTED GRAND JURIES, WHO STOOD UP TO TORTURE AND KEPT SECRETS SAFE. WITHOUT THEM, ALL OUR STRUGGLES WOULD HAVE ENDED A LONG TIME AGO.

CELEBRATE PEOPLE'S HISTORY

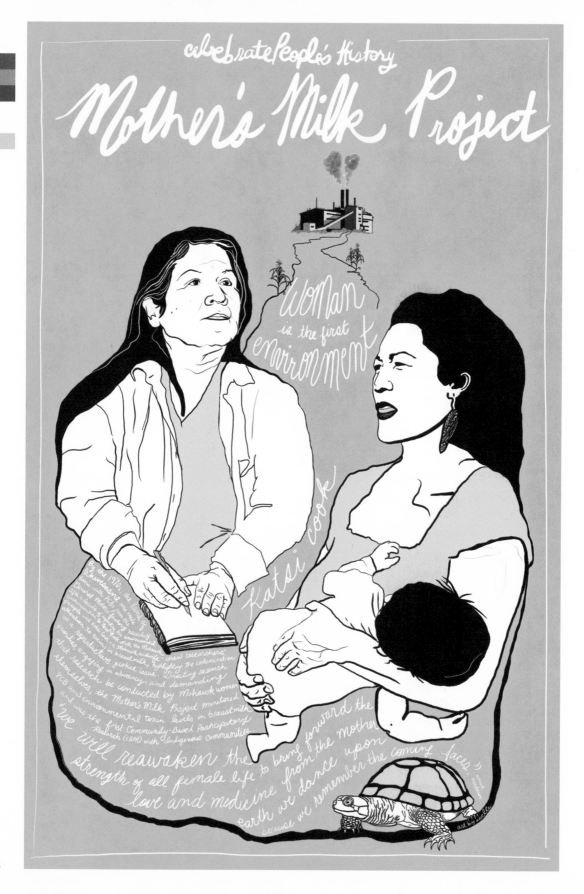

PHOOLAN DEVI

"WHAT OTHERS CALLED A CRIME, I CALLED JUSTICE"

 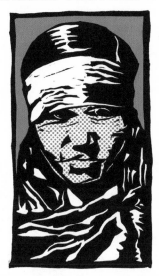

FEBRUARY 1981: A 24 YEAR OLD VILLAGE WOMAN, BORN INTO POVERTY IN INDIA, IS LABELLED 'THE BANDIT QUEEN'. SHE IS CHARGED WITH A NUMBER OF MAJOR OFFENCES INCLUDING MURDER, KIDNAP FOR RANSOM AND LOOTING VILLAGES. MOST IMPORTANTLY, SHE IS ACCUSED OF KILLING 22 HIGH-CASTE MEN IN THE VILLAGE OF BEHMAI, A MASSACRE UNDERTAKEN AS REVENGE FOR THE DEATH OF HER LOVER AND

 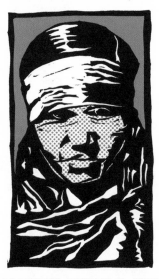 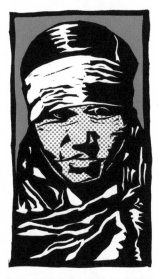

REPEATED GANG RAPE AGAINST HERSELF. THE QUESTION WAS OFTEN ASKED HOW A POOR, UNEDUCATED AND ILLITERATE WOMAN BECAME A BANDIT. BUT PHOOLAN DEVI'S LIFE, AND THE INJUSTICE SHE SUFFERED BECAUSE OF HER GENDER AND HER CLASS, ONLY MAKE US WONDER WHY OTHER LOW-CASTE WOMEN (FOR PHOOLAN'S EXPERIENCES WERE NOT IN ANY WAY UNIQUE) DID NOT ALSO BECOME BANDITS.

CELEBRATE PEOPLE'S HISTORY

Radio Venceremos

Radio Venceremos was a clandestine broadcasting unit used throughout the El Salvadoran Civil War, 1981–1992. Known as the voice of the armed guerrilla movement the Farabundo Marti National Liberation Front (FMLN), it was a critical tool for communicating directly with civil society and a powerful example of controlling the means of media production.

Radio Venceremos fue una radio difusora clandestina en El Salvador que transmitía durante la guerra civil de 1981 a 1992. Conocida como la voz del movimiento guerrillero Farabundo Marti Liberación Nacional (FMLN), fue una herramienta crítica de comunicación directa con la comunidad civil y un ejemplo poderoso de control de recursos.

CELEBRATE PEOPLE'S HISTORY

ANARCHISM | COMMUNISM | SOCIALISM
ANTI-WAR | ANTI-IMPERIALISM | SOLIDARITY
ENVIRONMENTALISM
FEMINISM | QUEER LIBERATION
HEALTH | HOUSING | EDUCATION | CULTURE
LABOR | ANTI-CAPITALISM
SLAVERY | POLICE | PRISONS | ANTI-FASCISM
RACIAL JUSTICE | NATIONAL LIBERATION | INDIGENOUS STRUGGLE

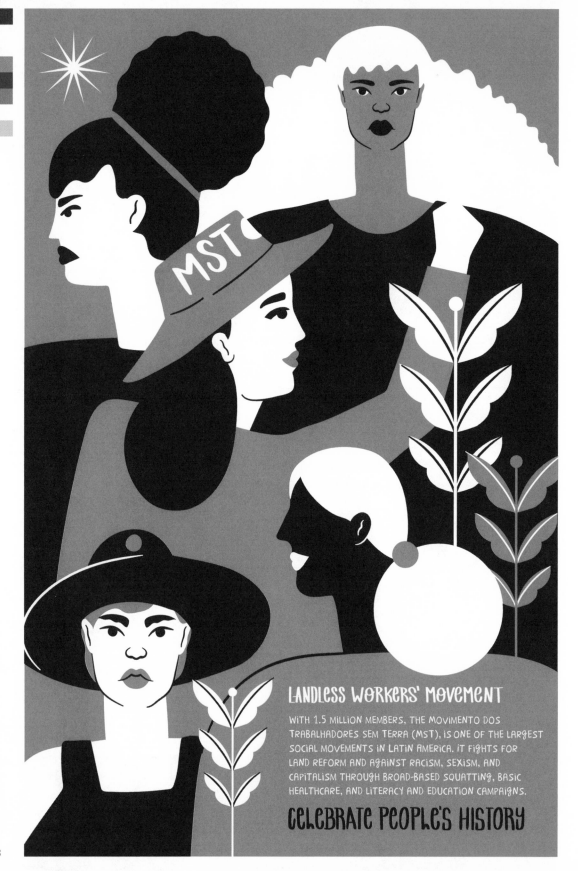

LANDLESS WORKERS' MOVEMENT

WITH 1.5 MILLION MEMBERS, THE MOVIMENTO DOS TRABALHADORES SEM TERRA (MST), IS ONE OF THE LARGEST SOCIAL MOVEMENTS IN LATIN AMERICA. IT FIGHTS FOR LAND REFORM AND AGAINST RACISM, SEXISM, AND CAPITALISM THROUGH BROAD-BASED SQUATTING, BASIC HEALTHCARE, AND LITERACY AND EDUCATION CAMPAIGNS.

CELEBRATE PEOPLE'S HISTORY

Greenham Common Women's Peace Camp 1981-2001

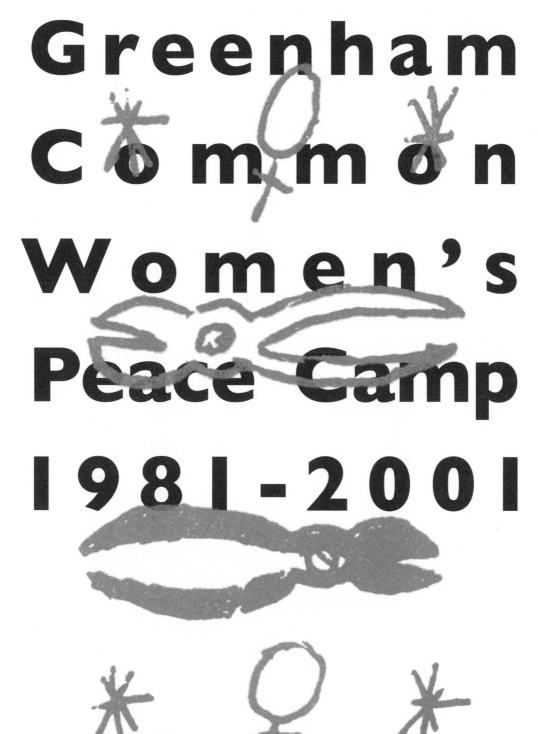

Greenham Common Women's Peace Camp was a series of protest camps established to protest US and UK nuclear weapons being placed at RAF Greenham Common in Berkshire, England. Women for Life on Earth, a Welsh peace group, marched from Wales to Greenham in September 1981 in protest against the decision of the British government to allow cruise missiles to be stored at Greenham. Realizing that the march alone was not going to garner enough attention to have the missiles removed, some began to stay on the site to continue their protest, starting with 36 women chaining themselves to the base fence. The first blockade of the base occurred in March 1982 with 250 women protesting, during which 34 arrests were made. Through various actions, evictions, and reconvenings, the camp was active for 19 years and disbanded in 2000. (The symbols above are reproduced from the February 1983 issue of the Women's Peace Camp Newsletter.)

CELEBRATE PEOPLE'S HISTORY

GREENHAM COMMON WOMEN'S PEACE CAMP GREG MIHALKO

179

SQUAMISH 5

CELEBRATE PEOPLE'S HISTORY

SQUAMISH 5 MATT GAUCK

IN 1982, FIVE ACTIVISTS FROM SQUAMISH, CANADA, DYNAMITED A HYDROELECTRIC PROJECT AS WELL AS A CRUISE MISSILE FACTORY, AMONG OTHERS. THEY HAD BECOME FRUSTRATED WITH CONVENTIONAL FORMS OF ACTIVISM & NON-VIOLENT PROTEST, SO THEY TOOK TO PROPAGANDA OF THE DEED, AND MADE A DIFFERENCE WITH DIRECT ACTION.

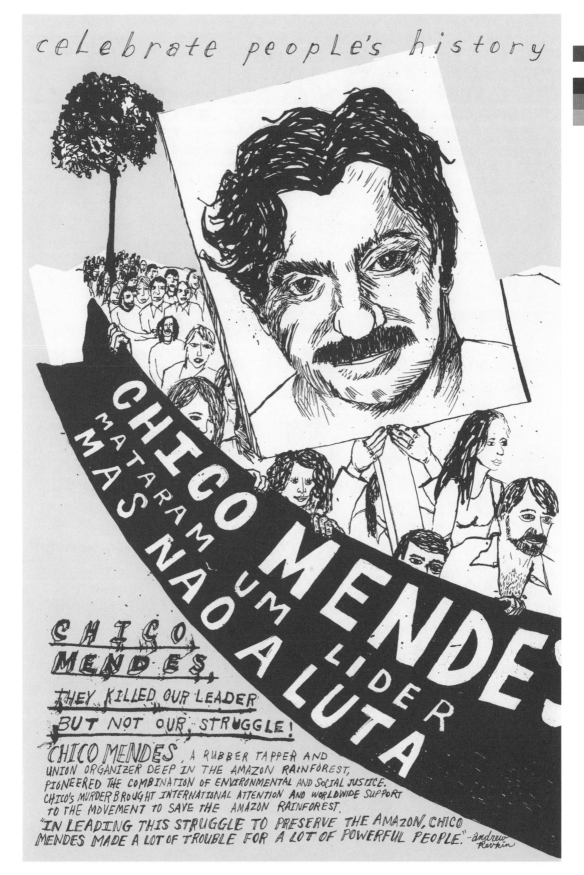

CHICO MENDES MATARAM UM LIDER MAS NÃO A LUTA

CHICO MENDES, THEY KILLED OUR LEADER BUT NOT OUR STRUGGLE!

CHICO MENDES, A RUBBER TAPPER AND UNION ORGANIZER DEEP IN THE AMAZON RAINFOREST, PIONEERED THE COMBINATION OF ENVIRONMENTAL AND SOCIAL JUSTICE. CHICO'S MURDER BROUGHT INTERNATIONAL ATTENTION AND WORLDWIDE SUPPORT TO THE MOVEMENT TO SAVE THE AMAZON RAINFOREST.

"IN LEADING THIS STRUGGLE TO PRESERVE THE AMAZON, CHICO MENDES MADE A LOT OF TROUBLE FOR A LOT OF POWERFUL PEOPLE." —andrew revkin

CHICO MENDES COLIN MATTHES

181

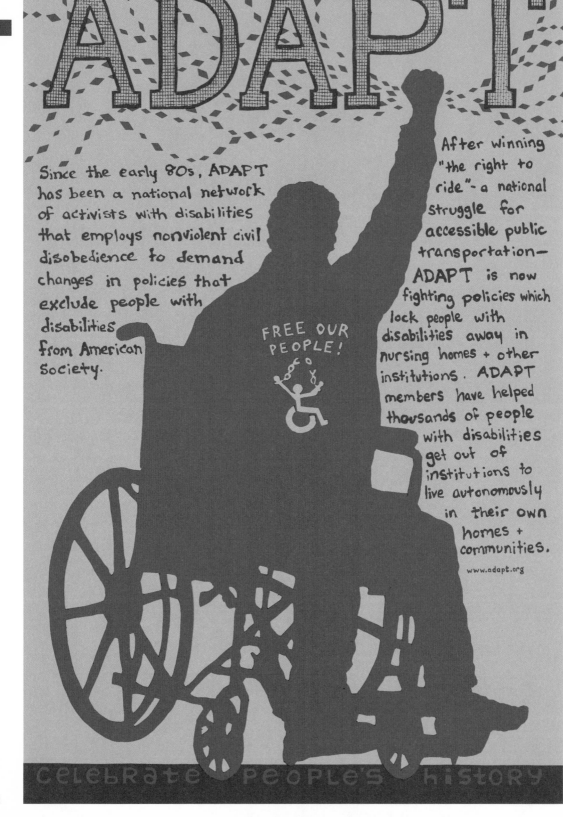

ADAPT

Since the early 80s, ADAPT has been a national network of activists with disabilities that employs nonviolent civil disobedience to demand changes in policies that exclude people with disabilities from American society.

FREE OUR PEOPLE!

After winning "the right to ride"- a national struggle for accessible public transportation— ADAPT is now fighting policies which lock people with disabilities away in nursing homes + other institutions. ADAPT members have helped thousands of people with disabilities get out of institutions to live autonomously in their own homes + communities.

www.adapt.org

CELEBRATE PEOPLE'S HISTORY

"The Great Arizona Mine Strike

1983

The towns of Clifton and Morence went on strike in opposition to large salary cuts at the Phelps Dodge Copper Corporation. The strike lasted 18 months. Due to an injunction filed by Phelps Dodge, employees were not allowed to participate in picket lines. Although there were women miners and had been since before WWII, most of the workers were men. So it was the women of the town who held the picket lines for a year and a half. This legendary strike found law abiding citizens standing up to the national guard, arrests, circling helicopters, and other violent and oppresive tactics used by Phelps Dodge. The strike came at the end of the copper industry's profitability in the U.S. At the end of the 18 months the company was mere skin and bones and had to close its U.S. facilities, leaving the community jobless, yet strangely victorious.

PEOPLE'S CLINIC

SOLIDARITY

ON STRIKE

ON STRIKE UNITED STEELWORKERS WE SUPPORT OUR HUSBANDS ON STRIKE

a heroine of the strike, Anne O'Leary- "Through the strike I learned to appreciate my culture and myself. It's astonishing even to me how we women changed. We used to just accept authority just because our leadership were authoritarian people. Now we can never take their word at face value."

celebrate people's history

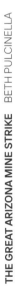

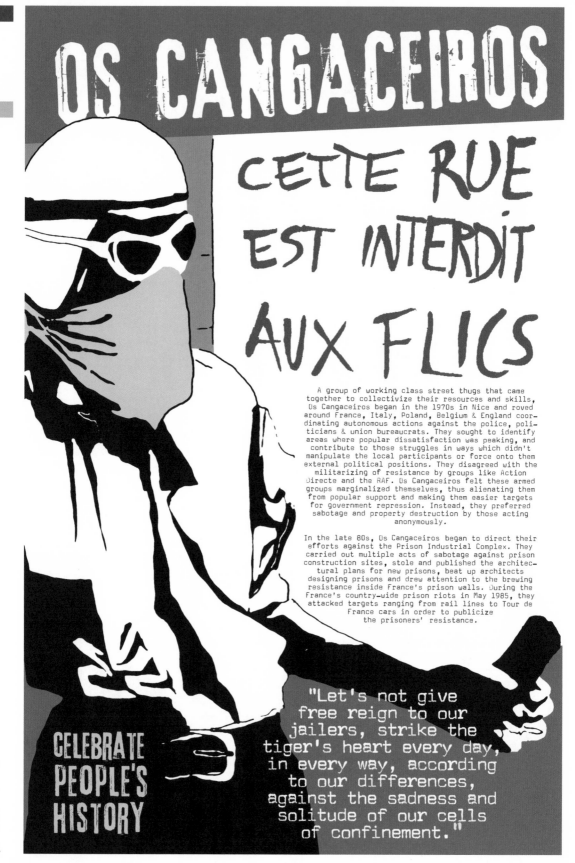

OS CANGACEIROS

CETTE RUE EST INTERDIT AUX FLICS

A group of working class street thugs that came together to collectivize their resources and skills, Os Cangaceiros began in the 1970s in Nice and roved around France, Italy, Poland, Belgium & England coordinating autonomous actions against the police, politicians & union bureaucrats. They sought to identify areas where popular dissatisfaction was peaking, and contribute to those struggles in ways which didn't manipulate the local participants or force onto them external political positions. They disagreed with the militarizing of resistance by groups like Action Directe and the RAF. Os Cangaceiros felt these armed groups marginalized themselves, thus alienating them from popular support and making them easier targets for government repression. Instead, they preferred sabotage and property destruction by those acting anonymously.

In the late 80s, Os Cangaceiros began to direct their efforts against the Prison Industrial Complex. They carried out multiple acts of sabotage against prison construction sites, stole and published the architectural plans for new prisons, beat up architects designing prisons and drew attention to the brewing resistance inside France's prison walls. During the France's country-wide prison riots in May 1985, they attacked targets ranging from rail lines to Tour de France cars in order to publicize the prisoners' resistance.

"Let's not give free reign to our jailers, strike the tiger's heart every day, in every way, according to our differences, against the sadness and solitude of our cells of confinement."

CELEBRATE PEOPLE'S HISTORY

OS CANGACEIROS RYNE ZIEMBA

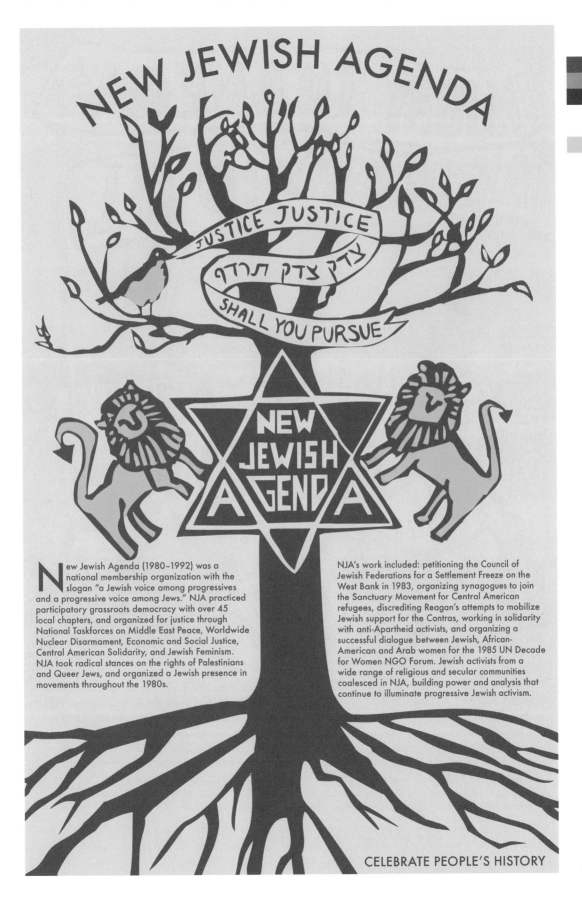

NEW JEWISH AGENDA

JUSTICE JUSTICE

צדק צדק תרדף

SHALL YOU PURSUE

NEW JEWISH AGENDA

New Jewish Agenda (1980–1992) was a national membership organization with the slogan "a Jewish voice among progressives and a progressive voice among Jews." NJA practiced participatory grassroots democracy with over 45 local chapters, and organized for justice through National Taskforces on Middle East Peace, Worldwide Nuclear Disarmament, Economic and Social Justice, Central American Solidarity, and Jewish Feminism. NJA took radical stances on the rights of Palestinians and Queer Jews, and organized a Jewish presence in movements throughout the 1980s.

NJA's work included: petitioning the Council of Jewish Federations for a Settlement Freeze on the West Bank in 1983, organizing synagogues to join the Sanctuary Movement for Central American refugees, discrediting Reagan's attempts to mobilize Jewish support for the Contras, working in solidarity with anti-Apartheid activists, and organizing a successful dialogue between Jewish, African-American and Arab women for the 1985 UN Decade for Women NGO Forum. Jewish activists from a wide range of religious and secular communities coalesced in NJA, building power and analysis that continue to illuminate progressive Jewish activism.

CELEBRATE PEOPLE'S HISTORY

NEW JEWISH AGENDA ABIGAIL MILLER AND EZRA NEPON

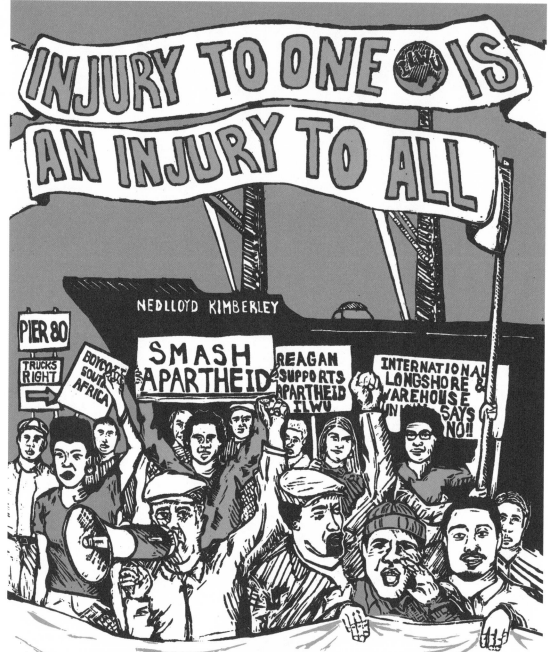

INJURY TO ONE IS AN INJURY TO ALL

NEDLLOYD KIMBERLEY

PIER 80
TRUCKS RIGHT →

BOYCOTT SOUTH AFRICA

SMASH APARTHEID

REAGAN SUPPORTS APARTHEID ILWU

INTERNATIONAL LONGSHORE & WAREHOUSE UNION SAYS NO!!

In 1984 members of the International Longshore & Warehouse Union (ILWU) refused to unload South African cargo off the Nedlloyd Kimberley in San Francisco. They did so to demonstrate their opposition to South Africa's apartheid regime. For eleven days, as thousands rallied in support, that cargo remained in the ship's hold. This action belongs to a militant tradition in the Bay Area's Local 10 that stretches back from the 1930s into the 21st Century. As the union's first president, Harry Bridges once declared: "Interfere with foreign policy of the country? Sure as Hell! That's our job, that's our privilege, that's our right, that's our duty." In 1990 while visiting Oakland, shortly after his release from prison, Nelson Mandela thanked the members of the ILWU for their support in the fight against apartheid.

CELEBRATE PEOPLE'S HISTORY

WORLD CHARTER
FOR
PROSTITUTES' RIGHTS
1985

SEX WORKERS' RIGHTS ARE HUMAN RIGHTS

I·C·P·R
INTERNATIONAL COMMITTEE
FOR PROSTITUTES RIGHTS

LAWS

1 Decriminalize all aspects of adult prostitution resulting from individual decision.

2 Decriminalize prostitution and regulate third parties according to standard business codes. It must be noted that existing standard business codes allow abuse of prostitutes. Therefore special clauses must be included to prevent the abuse and stigmatization of prostitutes (self-employed and others).

3 Enforce criminal laws against fraud, coercion, violence, child sexual abuse, child labor, rape, racism everywhere and across national boundaries, whether or not in the context of prostitution.

4 Eradicate laws that can be interpreted to deny freedom of association, or freedom to travel, to prostitutes within and between countries. Prostitutes have rights to a private life.

HUMAN RIGHTS

5 Guarantee prostitutes all human rights and civil liberties, including the freedom of speech, travel, immigration, work, marriage, and motherhood and the right to unemployment insurance, health insurance, and housing.

6 Grant asylum to anyone denied human rights on the basis of a "crime of status," be it prostitution or homosexuality.

WORKING CONDITIONS

7 There should be no law which implies systematic zoning of prostitution. Prostitutes should have the freedom to choose their place of work and residence. It is essential that prostitutes can provide their services under the conditions that are absolutely determined by themselves and no one else.

8 There should be a committee to insure the protection of the rights of the prostitutes and to whom prostitutes can address their complaints. This committee must be comprised of prostitutes and other professionals like lawyers and supporters.

9 There should be no law discriminating against prostitutes associating and working collectively in order to acquire a high degree of personal security.

HEALTH

10 All women and men should be educated to periodical health screening for sexually transmitted diseases. Since health checks have historically been used to control and stigmatize prostitutes, and since adult prostitutes are generally even more aware of sexual health than others, mandatory checks for prostitutes are unacceptable unless they are mandatory for all sexually active people.

SERVICES

11 Employment, counseling, legal, and housing services for runaway children should be funded in order to prevent child prostitution and to promote child well-being and opportunity.

12 Prostitutes must have the same social benefits as all other citizens according to the different regulations in different countries.

13 Shelters and services for working prostitutes and re-training programs for prostitutes wishing to leave the life should be funded.

TAXES

14 No special taxes should be levied on prostitutes or prostitute businesses.

15 Prostitutes should pay regular taxes on the same basis as other independent contractors and employees, and should receive the same benefits.

PUBLIC OPINION

16 Support educational programs to change social attitudes which stigmatize and discriminate against prostitutes and ex-prostitutes of any race, gender, or nationality.

17 Develop educational programs which help the public to understand that the customer plays a crucial role in the prostitution phenomenon, this role being generally ignored. The customer, like the prostitute, should not, however, be criminalized or condemned on a moral basis.

18 We are in solidarity with workers in the sex industry.

International Committee for Prostitutes' Rights (ICPR), Amsterdam 1985, Published in Pheterson, G (ed.), A Vindication of the Rights of Whores. Seattle: Seal Press, 1989. (p.40)

Organizations of prostitutes and ex-prostitutes should be supported to further implementation of the above charter.

CELEBRATE PEOPLE'S HISTORY

MOTHERS OF EAST LOS ANGELES

A group of Chicana mothers formed MELA in 1985 to fight the construction of a prison in their East L.A. neighborhood. Years of community mobilizing and candlelight vigils eventually paid off and the prison project was cancelled. MELA also successfully fought against an oil pipeline and toxic waste incinerator being built in their community. They have gone on to establish programs for scholarships, water conservation, and health education.

" The politicians thought we wouldn't fight, but we united and said, *Ya Basta*, enough, this is a dumping ground no more... The kids around here were babies when we started. Now they will fight for what they believe in because we showed them their voices count!"

Celebrate People's History!

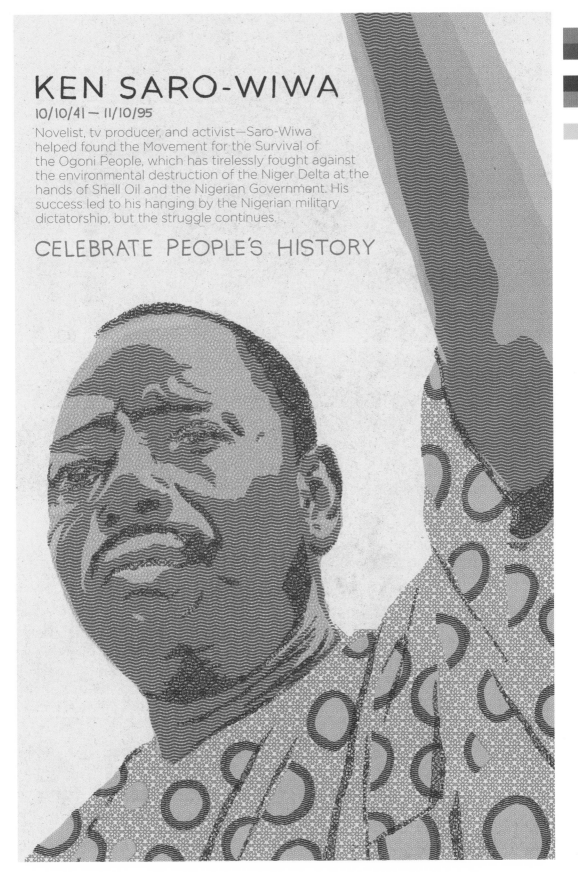

KEN SARO-WIWA

10/10/41 – 11/10/95

Novelist, tv producer, and activist—Saro-Wiwa
helped found the Movement for the Survival of
the Ogoni People, which has tirelessly fought against
the environmental destruction of the Niger Delta at the
hands of Shell Oil and the Nigerian Government. His
success led to his hanging by the Nigerian military
dictatorship, but the struggle continues.

CELEBRATE PEOPLE'S HISTORY

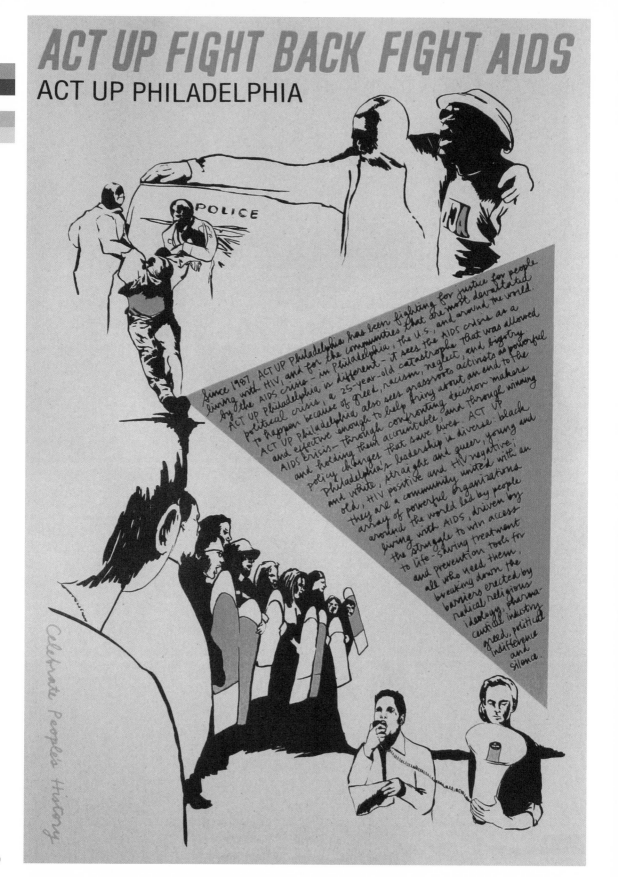

ACT UP FIGHT BACK FIGHT AIDS

ACT UP PHILADELPHIA

Since 1987 ACT UP Philadelphia has been fighting for justice for people living with HIV, and for the communities that are most devastated by the AIDS crisis in Philadelphia, the U.S. and around the world. ACT UP Philadelphia is different - it sees the AIDS crisis as a political crisis, a 25-year-old catastrophe that was allowed to happen because of greed, racism, neglect, and bigotry and effective enough to help bring about an end to the ACT UP Philadelphia also sees grassroots activists as powerful and holding them accountable, and through winning AIDS crisis - through confronting decision makers policy changes that save lives. ACT UP Philadelphia's leadership is diverse: black and white, straight and queer, young and old, HIV-positive and HIV-negative; they are a community united with an array of powerful organizations around the world led by people living with AIDS, driven by the struggle to win access to life-saving treatment and prevention tools for all who need them, breaking down the barriers erected by radical religious ideology, pharmaceutical industry greed, political indifference and silence.

Celebrate People's History

NEW YORK CITY
POLICE
RIOT
AUGUST 6
1988

CELEBRATE PEOPLE'S HISTORY

BATTLE
OF
Tompkins
Square
Park

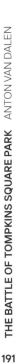

CELEBRATE PEOPLE'S HISTORY

★ 8.8.88 ★

THE DEMOCRATIC UPRISING IN BURMA

On August 8th, 1988, hundreds of thousands of workers, students, monks, mothers and children gathered in the streets all across Burma to demand an end to the brutal military dictatorship. As a response the military junta sent troops to quell the uprising and in the following weeks 10,000 people were murdered. Thousands fled to the border and into Thailand to gain refuge. Others joined rebel armies and took up arms to protect their people and fight for freedom. 8.8.88 made visible the resistance against the military and has become an enduring symbol of the Burmese struggle for democracy.

NARMADA
BACHAO ANDOLAN

In 1989, Narmada Bachao Andolan, (Save Narmada Movement) formed to protest the damming of the Narmada River, which displaced hundreds of thousands of people in India — mostly underprivileged castes and adivasi tribes.

NBA staged hunger strikes, blockaded freeways and united thousands in mass procession to the dam site. As part of the struggle, many dam-affected people pledged to refuse to leave their homes and drown with their villages.

The strength of NBA's non-violent resistance compelled the World Bank to withdraw from the Narmada Dam project. Despite the movement's considerable success, however, the Indian government continues to push for big dam development and NBA struggles to this day.

CELEBRATE PEOPLE'S HISTORY

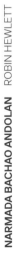

NARMADA BACHAO ANDOLAN ROBIN HEWLETT

193

JUDI BARI

1949–1997

Environmentalist, Labor Organizer, Earth First! Activist

ENVIRONMENTALISTS AND LOGGERS UNITE!

"A revolutionary ecology movement must also organize among poor and working people. With the exception of the toxics movement and the native land rights movement most U.S. environmentalists are white and privileged. This group is too invested in the system to pose it much of a threat. A revolutionary ideology in the hands of privileged people can indeed bring about some disruption and change in the system. But a revolutionary ideology in the hands of working people can bring that system to a halt. For it is the working people who have their hands on the machinery. And only by stopping the machinery of destruction can we ever hope to stop this madness."

CELEBRE LA HISTORIA POPULAR
CELEBRATE PEOPLE'S HISTORY
CELEBRER DE L'HISTOIRE DES GENS

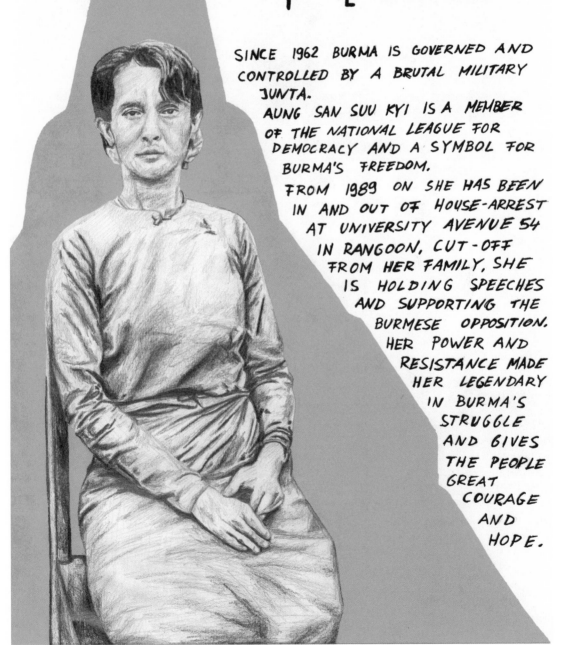

-CELEBRATE PEOPLE'S HISTORY-

AUNG SAN SUU KYI

အောင် ဆန်း စု ကြည်

SINCE 1962 BURMA IS GOVERNED AND CONTROLLED BY A BRUTAL MILITARY JUNTA.

AUNG SAN SUU KYI IS A MEMBER OF THE NATIONAL LEAGUE FOR DEMOCRACY AND A SYMBOL FOR BURMA'S FREEDOM.

FROM 1989 ON SHE HAS BEEN IN AND OUT OF HOUSE-ARREST AT UNIVERSITY AVENUE 54 IN RANGOON, CUT-OFF FROM HER FAMILY, SHE IS HOLDING SPEECHES AND SUPPORTING THE BURMESE OPPOSITION. HER POWER AND RESISTANCE MADE HER LEGENDARY IN BURMA'S STRUGGLE AND GIVES THE PEOPLE GREAT COURAGE AND HOPE.

AUNG SAN SUU KYI NICHOLAS GANZ

ANARCHISM | COMMUNISM | SOCIALISM
ANTI-WAR | ANTI-IMPERIALISM | SOLIDARITY
ENVIRONMENTALISM
FEMINISM | QUEER LIBERATION
HEALTH | HOUSING | EDUCATION | CULTURE
LABOR | ANTI-CAPITALISM
SLAVERY | POLICE | PRISONS | ANTI-FASCISM
RACIAL JUSTICE | NATIONAL LIBERATION | INDIGENOUS STRUGGLE

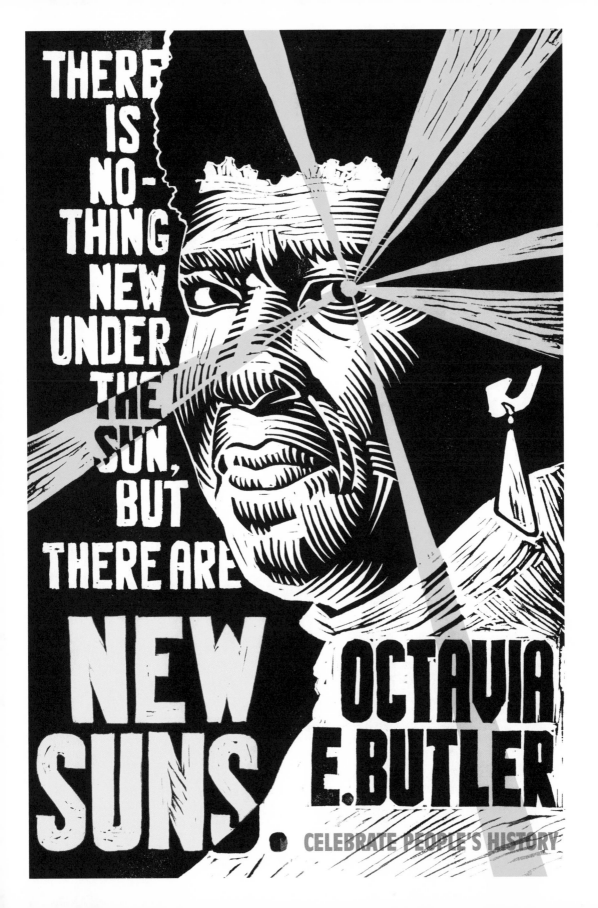

THERE IS NO-THING NEW UNDER THE SUN, BUT THERE ARE NEW SUNS.

OCTAVIA E. BUTLER

CELEBRATE PEOPLE'S HISTORY

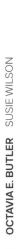

OCTAVIA E. BUTLER SUSIE WILSON

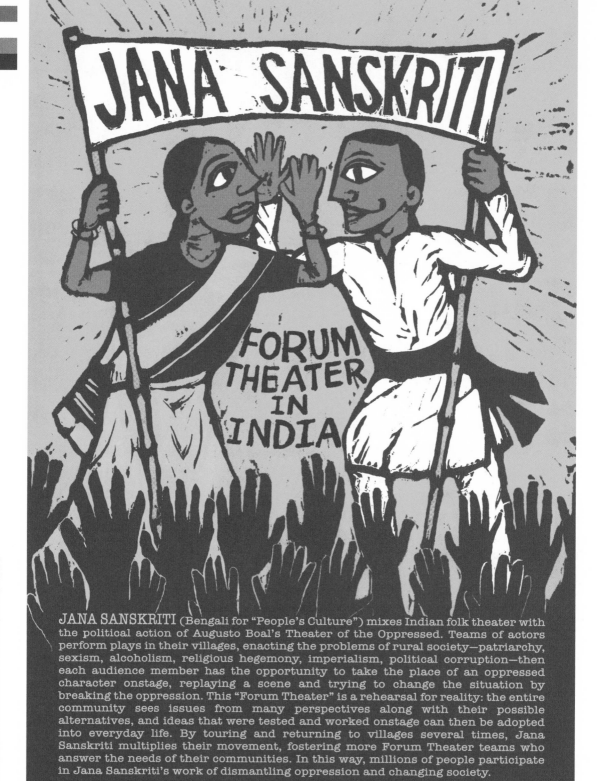

JANA SANSKRITI (Bengali for "People's Culture") mixes Indian folk theater with the political action of Augusto Boal's Theater of the Oppressed. Teams of actors perform plays in their villages, enacting the problems of rural society—patriarchy, sexism, alcoholism, religious hegemony, imperialism, political corruption—then each audience member has the opportunity to take the place of an oppressed character onstage, replaying a scene and trying to change the situation by breaking the oppression. This "Forum Theater" is a rehearsal for reality: the entire community sees issues from many perspectives along with their possible alternatives, and ideas that were tested and worked onstage can then be adopted into everyday life. By touring and returning to villages several times, Jana Sanskriti multiplies their movement, fostering more Forum Theater teams who answer the needs of their communities. In this way, millions of people participate in Jana Sanskriti's work of dismantling oppression and changing society.

CELEBRATE PEOPLE'S HISTORY

JANA SANSKRITI MORGAN FITZPATRICK ANDREWS

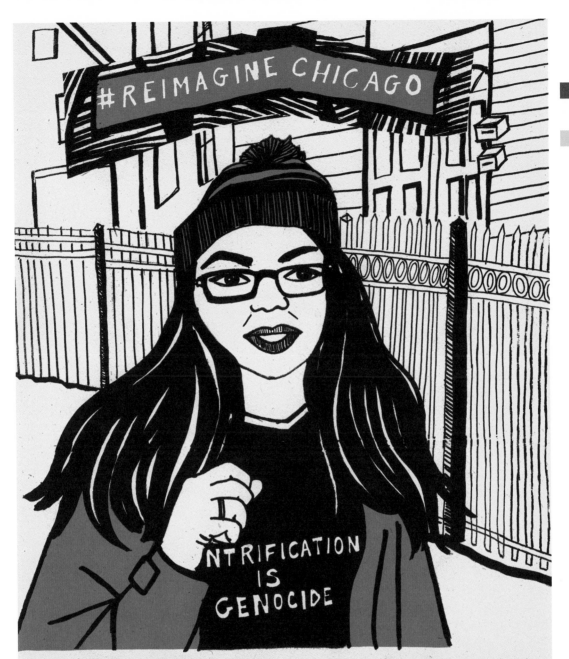

#REIMAGINE CHICAGO

NTRIFICATION IS GENOCIDE

IN THE 1960's, THE YOUNG LORDS, AN ORGANIZATION FOCUSED ON PUERTO RICAN SELF-DETERMINATION, FOUGHT AGAINST THE WHITE MIDDLE CLASS REHABBERS MOVING INTO THEIR CHICAGO NEIGHBORHOOD. 50 YEARS LATER, BLACK & LATINX RESIDENTS STILL ORGANIZE AGAINST THE PUSHOUT OF LONG TIME FAMILIES. LIKE IN 2016, WHEN COMMUNITY LEADERS WON A HUGE CAMPAIGN TO FORCE THE CITY TO REPLACE 525 PUBLIC HOUSING UNITS AT LATHROP HOMES. WHETHER IT'S WOODLAWN ON THE SOUTHSIDE, OR LOGAN SQUARE ON THE NORTHSIDE, COMMUNITY LEADERS CONTINUE TO WORK TO REIMAGINE CHICAGO.

DEVELOPMENT WITHOUT POLICIES TO PROTECT LOW INCOME RESIDENTS ACCELERATES GENTRIFICATION. THE CREATION OF THE 606 ELEVATED TRAIL HAS DONE JUST THIS. ASHLEY GALVAN RAMOS, A LEADER WITH THE LOGAN SQUARE NEIGHBORHOOD ASSOCIATION, WAS PUSHED OUT OF HER COMMUNITY. "WHEN I LOOK AT THE 606, I SEE COLONIZATION. IF WE DON'T FIGHT DISPLACEMENT, CHICAGO IS NOT GOING TO BE THE CHICAGO WE KNOW."

CELEBRATE PEOPLE'S HISTORY

REIMAGINE CHICAGO AMISHA PATEL

DELTA PRIDE

THANK YOU

SARAH WHITE

SARAH WHITE, AN AFRICAN-AMERICAN THIRTY-ONE YEAR OLD SINGLE MOTHER, ORGANIZED A HISTORIC AND SUCCESSFUL LABOR STRIKE COMPOSED OF **BLACK FEMALE CATFISH FACTORY WORKERS**. THE COMPANY, **DELTA PRIDE** WAS ACCUSED OF SEVERELY UNDERPAYING THE WORKERS, SUPPORTING UNSAFE WORKING ENVIRONMENTS, AND PUSHING THE WOMEN TO WORK UNIMAGINABLY LONG HOURS. THIS TOOK PLACE IN **THE MISSISSIPPI DELTA IN 1991.**

SARAH WHITE AND THE DELTA PRIDE STRIKE JOHN JENNINGS

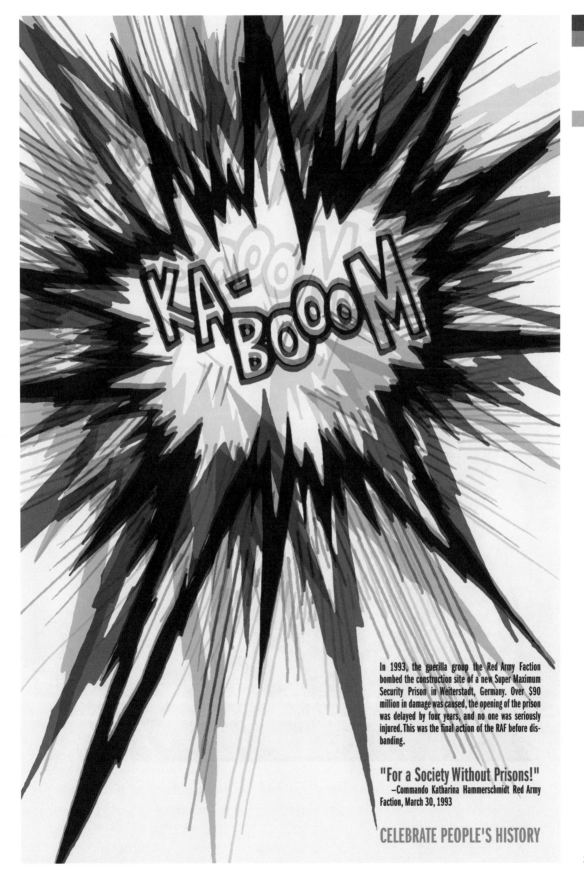

In 1993, the guerilla group the Red Army Faction bombed the construction site of a new Super Maximum Security Prison in Weiterstadt, Germany. Over $90 million in damage was caused, the opening of the prison was delayed by four years, and no one was seriously injured. This was the final action of the RAF before disbanding.

"For a Society Without Prisons!"
—Commando Katharina Hammerschmidt Red Army Faction, March 30, 1993

CELEBRATE PEOPLE'S HISTORY

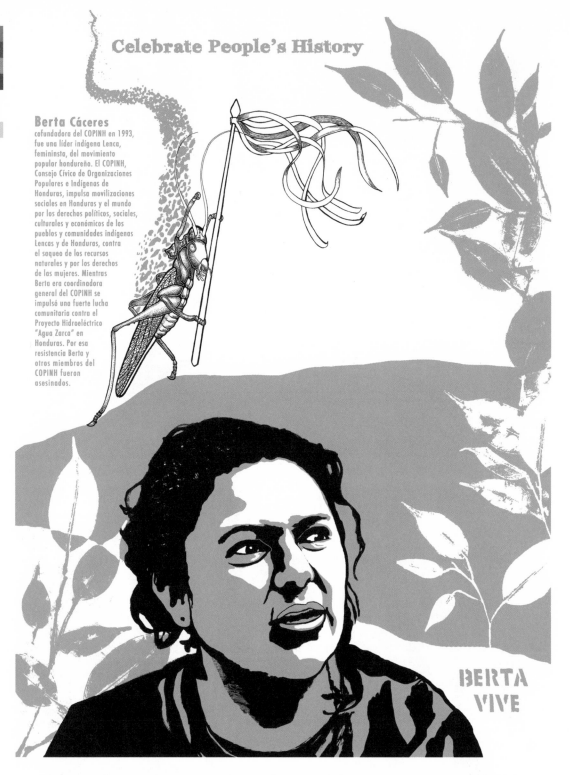

Celebrate People's History

Berta Cáceres cofundadora del COPINH en 1993, fue una líder indígena Lenca, feminista, del movimiento popular hondureño. El COPINH, Consejo Cívico de Organizaciones Populares e Indígenas de Honduras, impulsa movilizaciones sociales en Honduras y el mundo por los derechos políticos, sociales, culturales y económicos de los pueblos y comunidades indígenas Lencas y de Honduras, contra el saqueo de los recursos naturales y por los derechos de las mujeres. Mientras Berta era coordinadora general del COPINH se impulsó una fuerte lucha comunitaria contra el Proyecto Hidroeléctrico "Agua Zarca" en Honduras. Por esa resistencia Berta y otros miembros del COPINH fueron asesinados.

BERTA VIVE

No nos detengamos, que las políticas del terror no nos paralicen y continuemos luchando con alegría, con esperanza - Berta Cáceres, asesinada el 2 de marzo de 2016

ANARCHISM | COMMUNISM | SOCIALISM
ANTI-WAR | ANTI-IMPERIALISM | SOLIDARITY
ENVIRONMENTALISM
FEMINISM | QUEER LIBERATION
HEALTH | HOUSING | EDUCATION | CULTURE
LABOR | ANTI-CAPITALISM
SLAVERY | POLICE | PRISONS | ANTI-FASCISM
RACIAL JUSTICE | NATIONAL LIBERATION | INDIGENOUS STRUGGLE

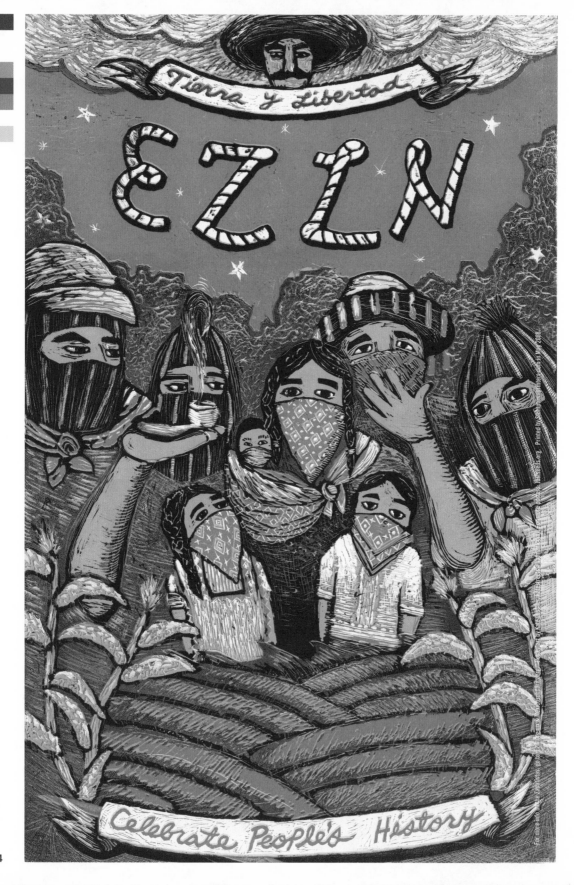

Tierra y Libertad

EZLN

Celebrate People's History

For more info on the Zapatistas, go to zmag.org · Relief print by Kate Luscher · www.katebits.org · Printed by Silkroundprinters.com in May 2008.

EZLN (EJÉRCITO ZAPATISTA DE LIBERACIÓN NACIONAL) KATE LUSCHER

THE KOREAN PEASANTS LEAGUE

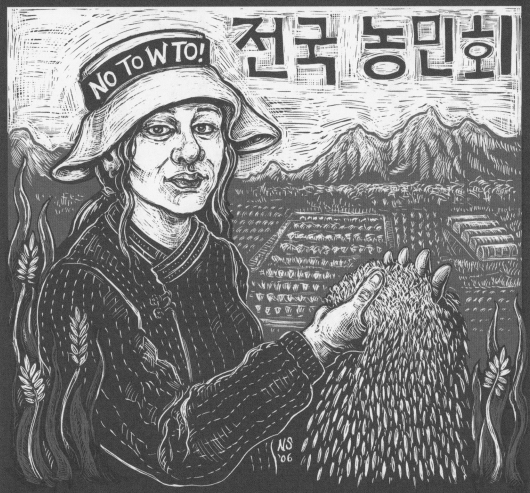

NO TO WTO!

전국 농민회

NS '06

The Korean Peasants League fights in solidarity with the indigenous farmers of the world against the destructive policies of the World Trade Organization. Since its creation, the WTO has forced developing nations like South Korea to import foreign produce such as rice and cut subsidies to their own agriculture. In consequence, hundreds of farmers have lost their land, their livelihoods and thousands of years of traditions. On September 10, 2003 world attention was focused on the Korean Peasants League when one of their most respected leaders Lee Kyung Hae took his own life during a protest at the Fifth Ministerial of the WTO in Cancun. The League continues to struggle against the neoliberal agenda of the WTO and the forces of Globalization.

한국 전국농민회는 전세계의 농민들과 함께 WTO의 파괴적이고 무책임한 협상 정책에 반대 합니다. WTO는 항상 한국과 같이 발전하는나라들에게 필요없는 곡물, 쌀 등을 억지로 수입하게하고 정부보조를 낮추는 뿐만아니라 농민들의 전통적인 삶을 없애고 있읍니다. 2003년 9월 10일 Cancun, Mexico에서의 WTO모임때 이경해 열사의 자결로 한국의 전국농민회가 세계적으로 알려졌읍니다. 전국농민회는 계속 WTO의 무모한 개방주의와 부자국가 우호적인 국제화에 대한 반대 운동을 하고있읍니다.

CELEBRATE PEOPLE'S HISTORY!

Korean Peasants League: http://ijunnong.net/

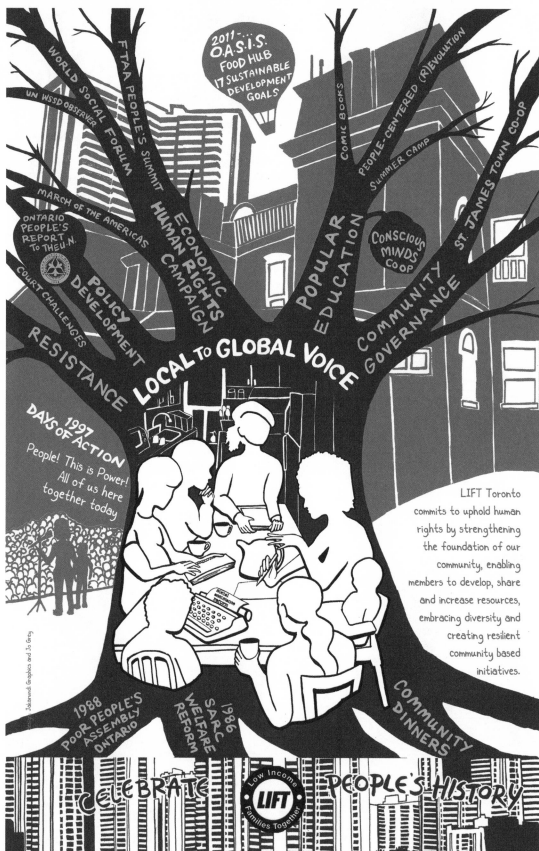

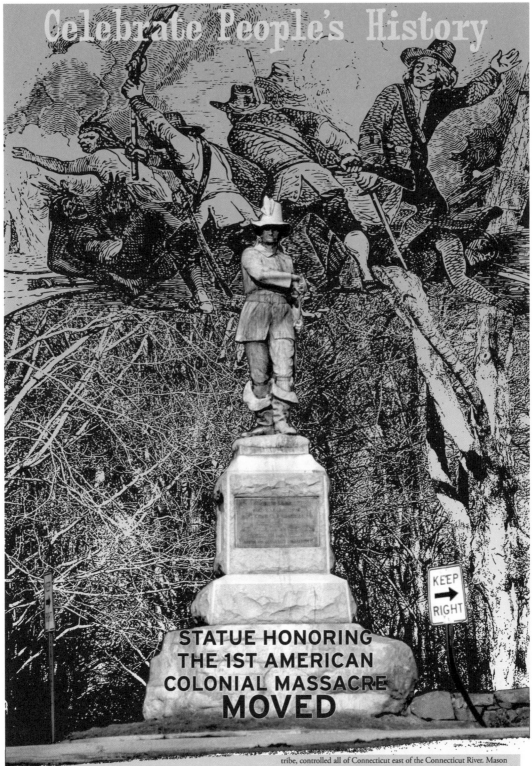

Celebrate People's History

STATUE HONORING THE 1ST AMERICAN COLONIAL MASSACRE MOVED

KEEP
→
RIGHT

The Mystic Massacre took place on May 26, 1637, when English settlers under Captain John Mason, and Narragansett and Mohegan allies set fire to a Pequot village near the Mystic River, killing any victims who attempted to escape the wooden palisade. Except for a few survivors the entire village of 600 to 700, mostly women and children, were murdered. This was done in retaliation for previous Pequot attacks. The Pequot Indians, once a powerful tribe, controlled all of Connecticut east of the Connecticut River. Mason declared that the holocaust against the Pequot was justified in the name of God. The Narragansett and Mohegan warriors who had fought alongside Mason at Mystic were horrified by the brutality of the Puritan English. This statue of John Mason was erected in 1889 on the site of the Pequot massacre. The 23–ton monument was relocated to Windsor, Connecticut, in 1996 from Mystic, after a three–year struggle by Native Americans and community groups to have it removed.

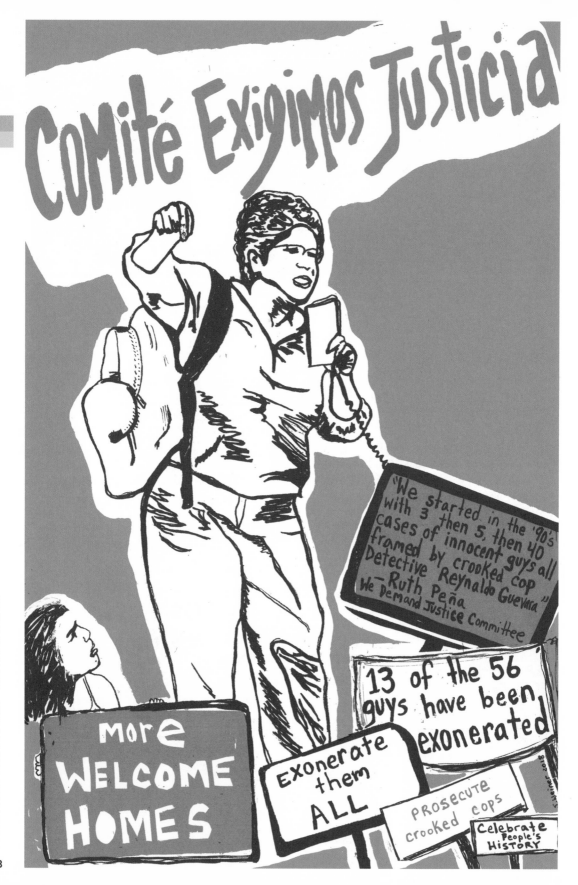

COMITÉ EXIGIMOS JUSTICIA STEPHANIE WEINER

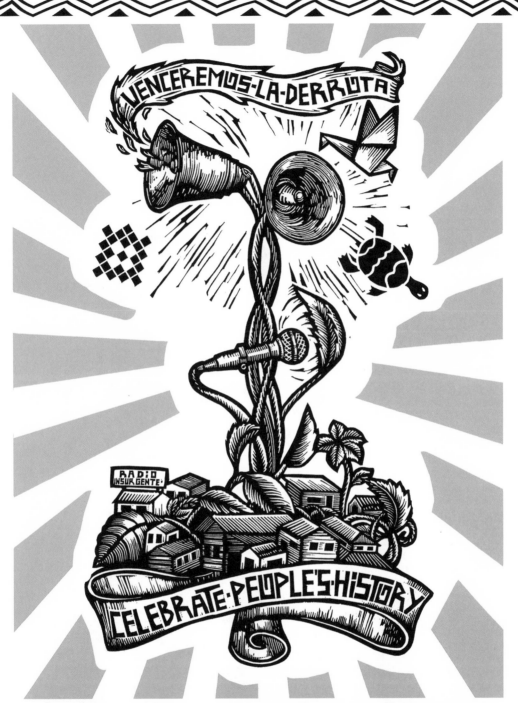

RADIOS COMUNITARIAS
FRECUENCIAS DIGNAS, LIBRES Y REBELDES
COMMUNITY RADIOS. DIGNIFIED, FREE AND REBEL FREQUENCIES

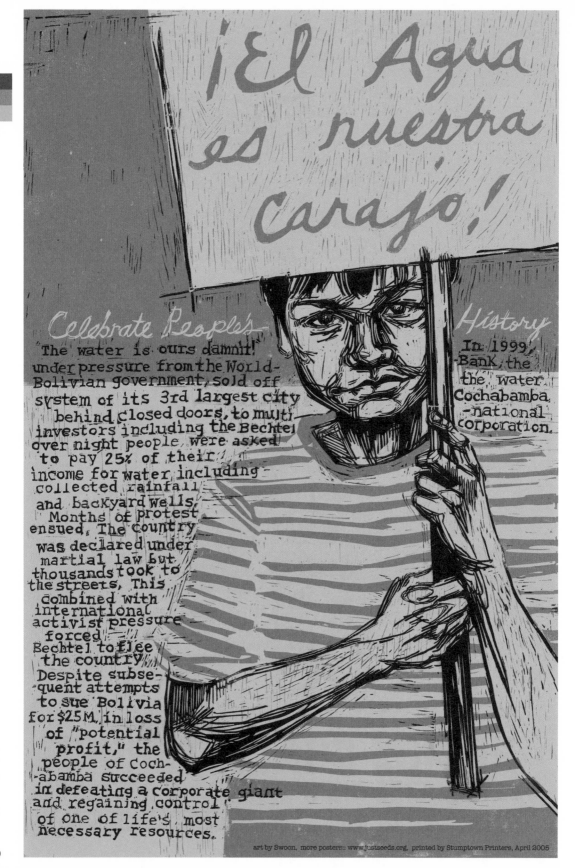

¡El Agua es nuestra carajo,!

Celebrate People's History

The water is ours damnit! Under pressure from the World-Bank, the Bolivian government, sold off the water system of its 3rd largest city Cochabamba behind closed doors, to multi-national investors including the Bechtel corporation. over night people were asked to pay 25% of their income for water including collected rainfall and backyard wells. Months of protest ensued. The country was declared under martial law but thousands took to the streets. This combined with international activist pressure forced Bechtel to flee the country. Despite subsequent attempts to sue Bolivia for $25M. in loss of "potential profit," the people of Coch-abamba succeeded in defeating a corporate giant and regaining control of one of life's most necessary resources.

art by Swoon, more posters:: www.justseeds.org, printed by Stumptown Printers, April 2005

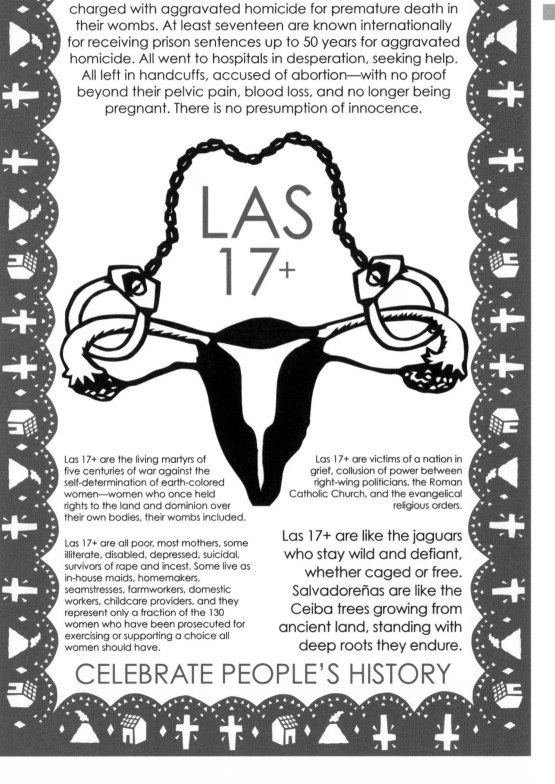

Beginning in 1999, women in El Salvador have been charged with aggravated homicide for premature death in their wombs. At least seventeen are known internationally for receiving prison sentences up to 50 years for aggravated homicide. All went to hospitals in desperation, seeking help. All left in handcuffs, accused of abortion—with no proof beyond their pelvic pain, blood loss, and no longer being pregnant. There is no presumption of innocence.

LAS 17+

Las 17+ are the living martyrs of five centuries of war against the self-determination of earth-colored women—women who once held rights to the land and dominion over their own bodies, their wombs included.

Las 17+ are all poor, most mothers, some illiterate, disabled, depressed, suicidal, survivors of rape and incest. Some live as in-house maids, homemakers, seamstresses, farmworkers, domestic workers, childcare providers, and they represent only a fraction of the 130 women who have been prosecuted for exercising or supporting a choice all women should have.

Las 17+ are victims of a nation in grief, collusion of power between right-wing politicians, the Roman Catholic Church, and the evangelical religious orders.

Las 17+ are like the jaguars who stay wild and defiant, whether caged or free. Salvadoreñas are like the Ceiba trees growing from ancient land, standing with deep roots they endure.

CELEBRATE PEOPLE'S HISTORY

LAS 17+ MINCHO VEGA

211

JI8

→ June 18th 1999
or the CARNIVAL against CAPITALISM

IN LONDON 12,000 festive, MASKED, PEOPLE STORMED the CITY of LONDON (the city's financial district!). AT MIDDAY PROTESTERS met at LIVERPOOL STREET STATION & SPLIT into five (5) different PROCESSIONS following DIFFERENT coloured FLAGS. BETWEEN 2PM & 3PM the MARCHES CONVERGED on the LIFFE (LONDON INT'L FINANCIAL FUTURES EXCHANGE). A FIRE HYDRANT was SET OFF to SYMBOLISE THE FREEING of the Walbrook river. THE LOWER ENTRANCE to the LIFFE building was BRICKED up before another group RAN in & SMASHED up THE RECEPTION AREA before TRYING to GAIN ACCESS to THE TRADING FLOOR. THE REST OF THE DAY was Spent in Running BATTLES w/ the COPS BEFORE ending Peacefully IN TRAFALGAR SQUARE...

JI8 was the FIRST in the LINE of HUGE ANTI-CAPITALIST PROTESTS such as N30 in SEATTLE, S22 in PRAGUE & the G8 protests in GENOA...

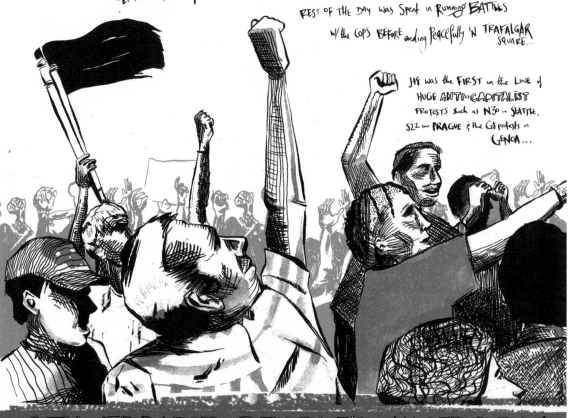

CELEBRATE PEOPLE'S HISTORY

JI8, OR THE CARNIVAL AGAINST CAPITALISM EDD BALDRY

DIRECT ACTION SHUTS DOWN
THE WORLD TRADE ORGANIZATION MEETING IN SEATTLE

NOVEMBER 30TH, 1999

CELEBRATE PEOPLE'S HISTORY

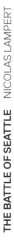

The Austin community is on Chicago's Far West Side and is anchored by a group of women who look out over their neighborhood for the sake of the children. These grandmother gatekeepers are the powerful protectors of the young. The kind-hearted benefactors of supple and uncertain lives. Their steady efforts amidst manifold risks are invisible to many, but not those that depend on them to rise up and grow. Bridging wisdoms that will not be erased, tracing (her)stories to know the meanings of today.

CELEBRATE PEOPLE'S HISTORY

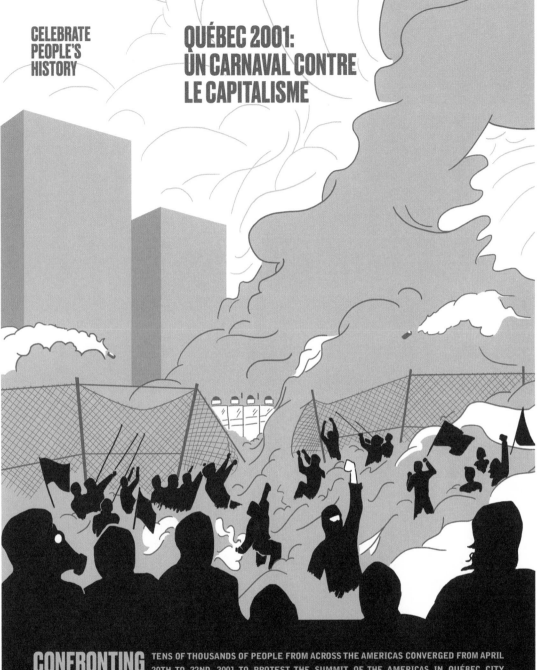

QUÉBEC 2001:
UN CARNAVAL CONTRE
LE CAPITALISME

CONFRONTING THE FTAA

TENS OF THOUSANDS OF PEOPLE FROM ACROSS THE AMERICAS CONVERGED FROM APRIL 20TH TO 22ND, 2001 TO PROTEST THE SUMMIT OF THE AMERICAS IN QUÉBEC CITY. DEMONSTRATIONS, DIRECT ACTIONS AND ACTS OF CREATIVE RESISTANCE CONFRONTED THE CLOSED-DOOR NEGOTIATIONS ON THE FREE TRADE AREA OF THE AMERICAS (FTAA) AGREEMENT, HEMISPHERIC TRADE LEGISLATION THAT MANY DUBBED "NAFTA ON STEROIDS." THE RESISTANCE IN THE STREETS ON THOSE EARLY SPRING DAYS OCCURRED AS PART OF A CONTINUUM OF ANTI-COLONIAL RESISTANCE, OVER MANY GENERATIONS, THAT LOCATED THE FTAA WITHIN A HISTORICAL TRAJECTORY OF CONQUEST, RESOURCE EXTRACTION AND COLONIAL EXPLOITATION UNDER THE SEEMINGLY BENIGN VENEER OF "FREE TRADE." PEOPLE TORE DOWN SECTIONS OF THE SECURITY FENCE SURROUNDING THE SUMMIT, DESPITE THOUSANDS OF HEAVILY ARMED POLICE WHO TARGETED THEM WITH RUBBER BULLETS AND SUBMERGED THE CITY IN CLOUDS OF TEAR GAS. THIS GRASSROOTS CONVERGENCE PROTEST WAS A CRITICAL STEP IN MOBILIZING POPULAR RESISTANCE TO THE FTAA ACROSS THE HEMISPHERE, LEADING TO THE DEFEAT OF THE AGREEMENT IN 2005, BEFORE IT WAS EVER RATIFIED.

QUÉBEC 2001: UN CARNAVAL CONTRE LE CAPITALISME KEVIN YUEN KIT LO AND STEFAN CHRISTOFF

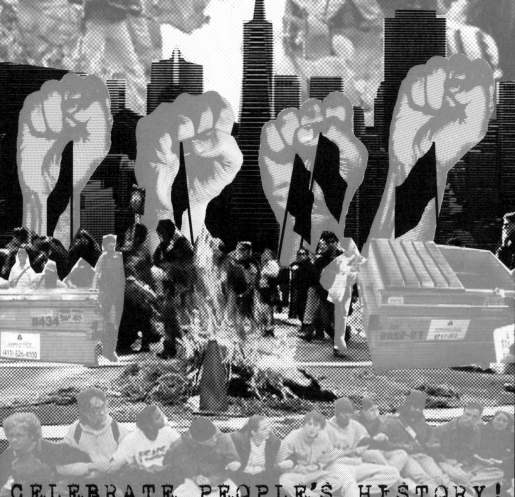

SHANNON AIRPORT PLOUGHSHARES

Are ordinary citizens powerless to stop the US-led war machine and the War in Iraq? Not according to two extraordinary acts of resistance by peace activists in Ireland. On January 29, 2003, Mary Kelly, a 51-year old nurse and mother of 4, voiced her objection to Shannon Airport being utilized as a re-fueling station for the US military by smashing the nosecone and fuel lines of a war plane with an axe. Less than a week later, the Pit Stop Ploughshares, five members of the Catholic Workers, snuck into Shannon Airport and attacked a US Navy plane with household tools, causing an estimated $2.5 million in damages. Deirdre Clancy, Nuin Dunlop, Karen Fallon, Ciaron O'Reilly & Damien Moran were arrested and spent 4 to 11 weeks in Limerick Prison each. They were tried three times and ultimately acquitted. A Dublin jury determined that their actions were reasonable considering that they were acting to save lives in Iraq and in Ireland.

CELEBRATE PEOPLE'S HISTORY

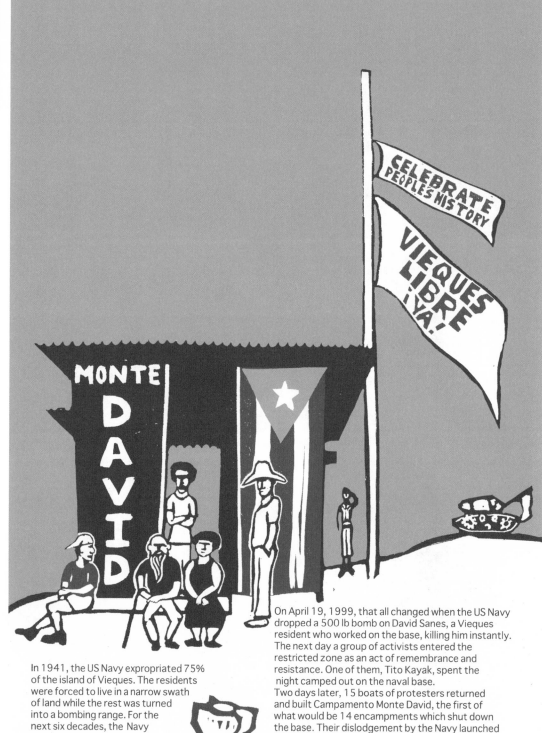

MONTE DAVID

CELEBRATE PEOPLES HISTORY

VIEQUES LIBRE ¡YA!

On April 19, 1999, that all changed when the US Navy dropped a 500 lb bomb on David Sanes, a Vieques resident who worked on the base, killing him instantly. The next day a group of activists entered the restricted zone as an act of remembrance and resistance. One of them, Tito Kayak, spent the night camped out on the naval base.

Two days later, 15 boats of protesters returned and built Campamento Monte David, the first of what would be 14 encampments which shut down the base. Their dislodgement by the Navy launched a campaign of civil disobedience in which over 1,000 were arrested and the largest political demonstration in the history of Puerto Rico was held. The Navy closed the base in 2003, but the residents are still fighting to have their island fully cleaned of the Navy's toxic remains.

In 1941, the US Navy expropriated 75% of the island of Vieques. The residents were forced to live in a narrow swath of land while the rest was turned into a bombing range. For the next six decades, the Navy launched bombs from ships, dropped napalm from planes, fired depleted uranium shells, staged mock invasions on the beaches and rented out the island to arms manufacturers to test their munitions.

ATENCO AGUANTA
EL PUEBLO SE LEVANTA
CELEBRATE PEOPLE'S HISTORY

NO WAL-MART
NO AEROPUERTO
liberan nuestros
presos politicos

San Salvador de Atenco has a long history of resistance to the central government, dating from before Mexico's Revolution of 1910. In 2001, Atenco villagers, mostly small farmers, organized the People's Front for Defense of the Land and stopped former President Vicente Fox from grabbing their farmlands for the construction of a new international airport. When they prevailed, a movement was born.

In 2006, this group spearheaded the defense of the flower vendors of nearby Texcoco, who were forcibly removed by police from the streets in order to prepare for the coming of a Wal-Mart store. Wielding their machetes, the people's resistance became a symbol of popular protest in Mexico. The resisters were targeted by the State and at least 15 prominent flower vendors and leaders of the People's Front were sentenced to a combined 500 years in maximum security prison.

Members of the People's Front and other Atenco activists are determined to fight for their people, and their freedom. Support their struggle! For more information: http://atencofpdt.blogspot.com.

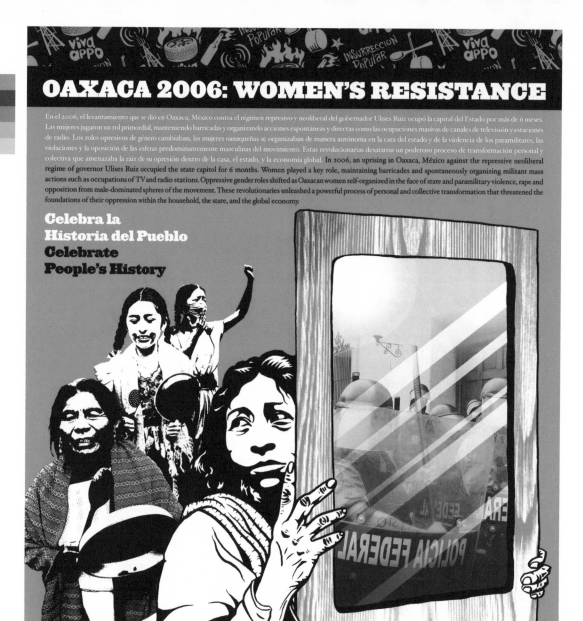

OAXACA 2006: WOMEN'S RESISTANCE

En el 2006, el levantamiento que se dió en Oaxaca, México contra el régimen represivo y neoliberal del gobernador Ulises Ruiz ocupó la capital del Estado por más de 6 meses. Las mujeres jugaron un rol primordial, manteniendo barricadas y organizando acciones espontáneas y directas como las ocupaciones masivas de canales de televisión y estaciones de radio. Los roles opresivos de género cambiaban, las mujeres oaxaqueñas se organizaban de manera autónoma en la cara del estado y de la violencia de los paramilitares, las violaciones y la oposición de las esferas predominantemente masculinas del movimiento. Estas revolucionarias desataron un poderoso proceso de transformación personal y colectiva que amenazaba la raíz de su opresión dentro de la casa, el estado, y la economía global. **In 2006, an uprising in Oaxaca, México against the repressive neoliberal regime of governor Ulises Ruiz occupied the state capitol for 6 months. Women played a key role, maintaining barricades and spontaneously organizing militant mass actions such as occupations of TV and radio stations. Oppressive gender roles shifted as Oaxacan women self-organized in the face of state and paramilitary violence, rape and opposition from male-dominated spheres of the movement. These revolutionaries unleashed a powerful process of personal and collective transformation that threatened the foundations of their oppression within the household, the state, and the global economy.**

**Celebra la
Historia del Pueblo
Celebrate
People's History**

Durante el levantamiento, las mujeres utilizaron tácticas inovadoras como cazuelas y sartenes para hacer ruido así como espejos que sostenían frente a las filas de la policía federal con la leyenda: "Somos violadores" escrito a lo largo del reflejo como respuesta a la policía y su uso de las violaciones sexuales como táctica represiva. **Women in the uprising utilized tactics such as noisy pots and pans, marches, and holding mirrors up to federal police lines with "we are rapists" written across the reflections in response to the police's use of sexual violence as a repressive tactic.**

GUERRERAS
DE LAS BARRICADAS

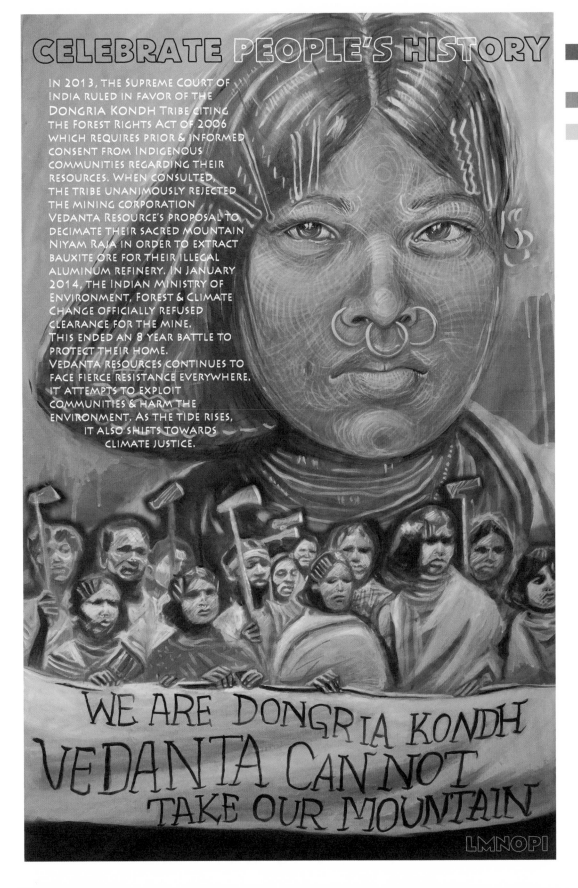

CELEBRATE PEOPLE'S HISTORY

In 2013, the Supreme Court of India ruled in favor of the Dongria Kondh Tribe citing the Forest Rights Act of 2006 which requires prior & informed consent from Indigenous communities regarding their resources. When consulted, the tribe unanimously rejected the mining corporation Vedanta Resource's proposal to decimate their sacred mountain Niyam Raja in order to extract bauxite ore for their illegal aluminum refinery. In January 2014, the Indian Ministry of Environment, Forest & Climate Change officially refused clearance for the mine. This ended an 8 year battle to protect their home. Vedanta resources continues to face fierce resistance everywhere. It attempts to exploit communities & harm the environment. As the tide rises, it also shifts towards climate justice.

WE ARE DONGRIA KONDH
VEDANTA CANNOT
TAKE OUR MOUNTAIN

LMNOPI

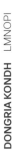

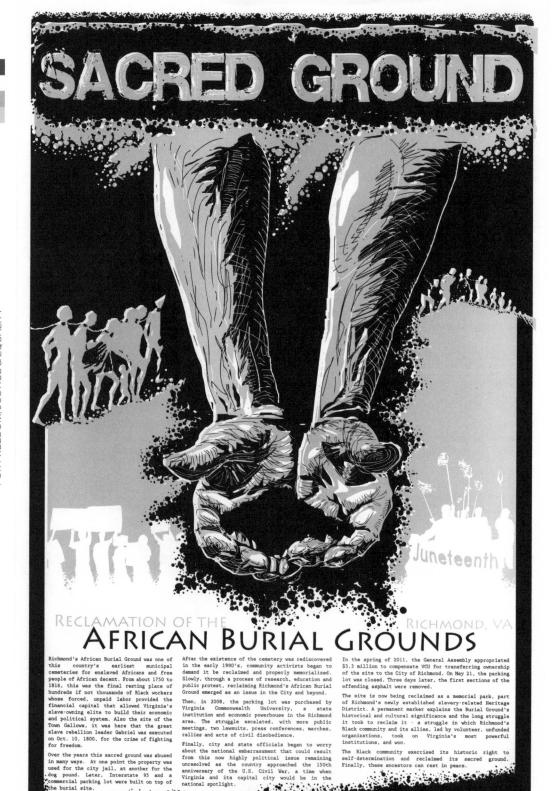

SACRED GROUND

Juneteenth

RECLAMATION OF THE
RICHMOND, VA
African Burial Grounds

Richmond's African Burial Ground was one of this country's earliest municipal cemeteries for enslaved Africans and free people of African decent. From about 1750 to 1816, this was the final resting place of hundreds if not thousands of Black workers whose forced, unpaid labor provided the financial capital that allowed Virginia's slave-owning elite to build their economic and political system. Also the site of the Town Gallows, it was here that the great slave rebellion leader Gabriel was executed on Oct. 10, 1800, for the crime of fighting for freedom.

Over the years this sacred ground was abused in many ways. At one point the property was used for the city jail, at another for the dog pound. Later, Interstate 95 and a commercial parking lot were built on top of the burial site.

After the existence of the cemetery was rediscovered in the early 1990's, community activists began to demand it be reclaimed and properly memorialized. Slowly, through a process of research, education and public protest, reclaiming Richmond's African Burial Ground emerged as an issue in the City and beyond.

Then, in 2008, the parking lot was purchased by Virginia Commonwealth University, a state institution and economic powerhouse in the Richmond area. The struggle escalated, with more public meetings, two lawsuits, press conferences, marches, rallies and acts of civil disobedience.

Finally, city and state officials began to worry about the national embarrassment that could result from this now highly political issue remaining unresolved as the country approached the 150th anniversary of the U.S. Civil War, a time when Virginia and its capital city would be in the national spotlight.

In the spring of 2011, the General Assembly appropriated $3.3 million to compensate VCU for transferring ownership of the site to the City of Richmond. On May 21, the parking lot was closed. Three days later, the first sections of the offending asphalt were removed.

The site is now being reclaimed as a memorial park, part of Richmond's newly established slavery-related Heritage District. A permanent marker explains the Burial Ground's historical and cultural significance and the long struggle it took to reclaim it - a struggle in which Richmond's Black community and its allies, led by volunteer, unfunded organizations, took on Virginia's most powerful institutions, and won.

The Black community exercised its historic right to self-determination and reclaimed its sacred ground. Finally, these ancestors can rest in peace.

INFORMATION COURTESY OF THE SACRED GROUND HISTORICAL RECLAMATION PROJECT
OF THE RICHMOND-BASED **DEFENDERS FOR FREEDOM, JUSTICE & EQUALITY**

CELEBRATE PEOPLE'S HISTORY

WAYSIDE CENTER FOR POPULAR EDUCATION · 2011

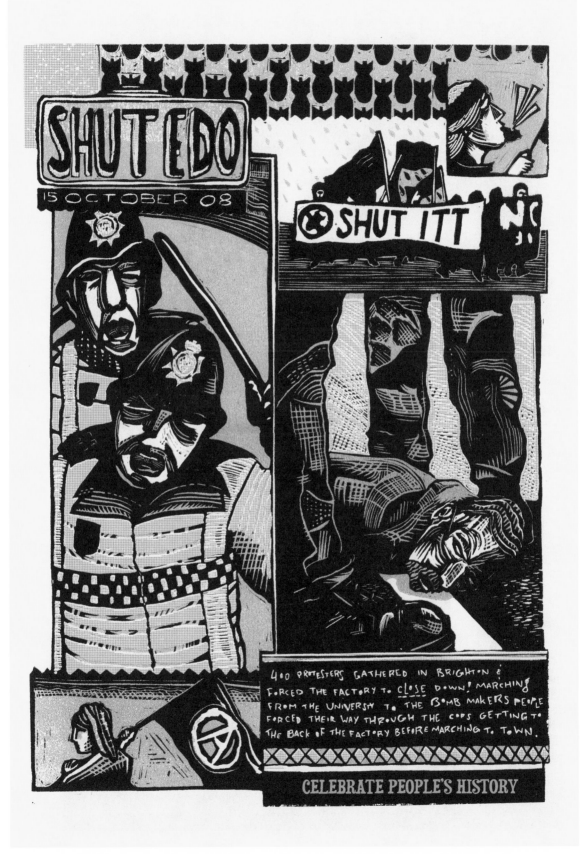

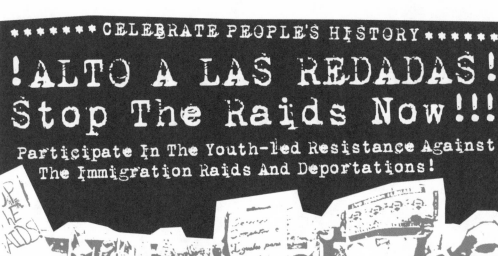

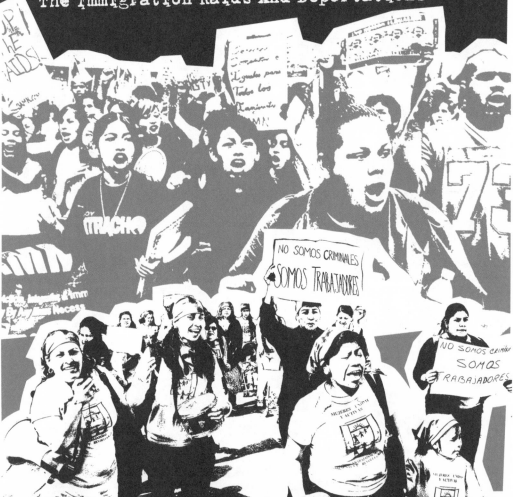

2008 marked the 40th anniversary of the mass mobilizations that were going on globally in 1968. Looking back at the various liberation struggles within the U.S. at that time, today's youth take pride in the organizing efforts of their elders—their communities that paved the way for the present youth to continue that same resistance. Youth today are inspired by the works of freedom fighters from the Black Liberation Movement, the Chicana/o Movement, the American Indian Movement, in their fight for land, education, justice, peace and self-determination. Today, youth continue organizing to keep what has been won and fight harder for their collective liberation.

Since the nationwide mobilizations of May 1st 2006, the conditions in immigrant communities have worsened. The repercussions of mobilizing have resulted in more Immigration and Customs Enforcement (I.C.E.) raids than ever before, to instill fear and to prevent people from speaking up against these injustices. In 2007 alone, 276,912 U.S. residents were deported.

On October 31st 2008 youth decided to show thier power and shut down the I.C.E. offices in San Francisco for the day. Using civil disobedience the youth demonstrated that direct action can stop the terrorization of immigrant communities if at least one day.

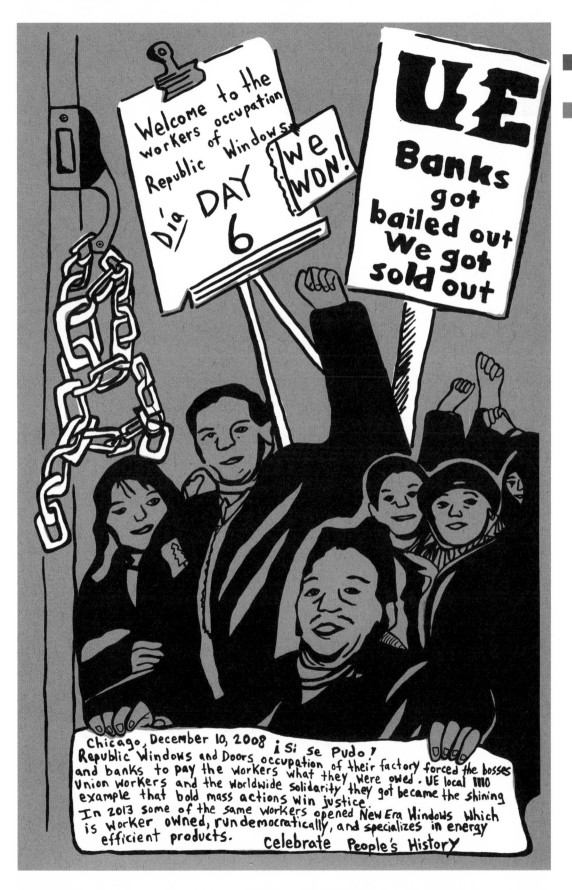

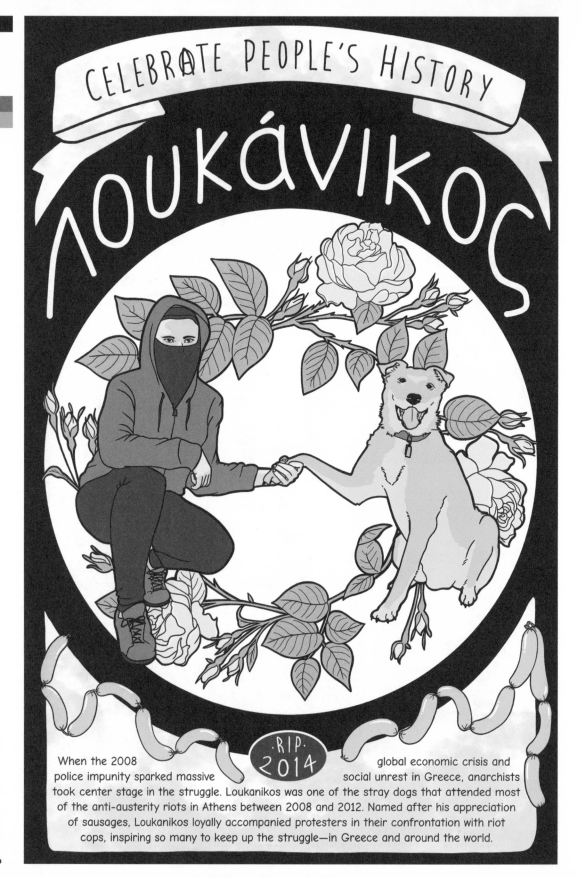

CELEBRATE PEOPLE'S HISTORY

ΛΟΥΚΆΝΙΚΟΣ

R.I.P. 2014

When the 2008 global economic crisis and police impunity sparked massive social unrest in Greece, anarchists took center stage in the struggle. Loukanikos was one of the stray dogs that attended most of the anti-austerity riots in Athens between 2008 and 2012. Named after his appreciation of sausages, Loukanikos loyally accompanied protesters in their confrontation with riot cops, inspiring so many to keep up the struggle—in Greece and around the world.

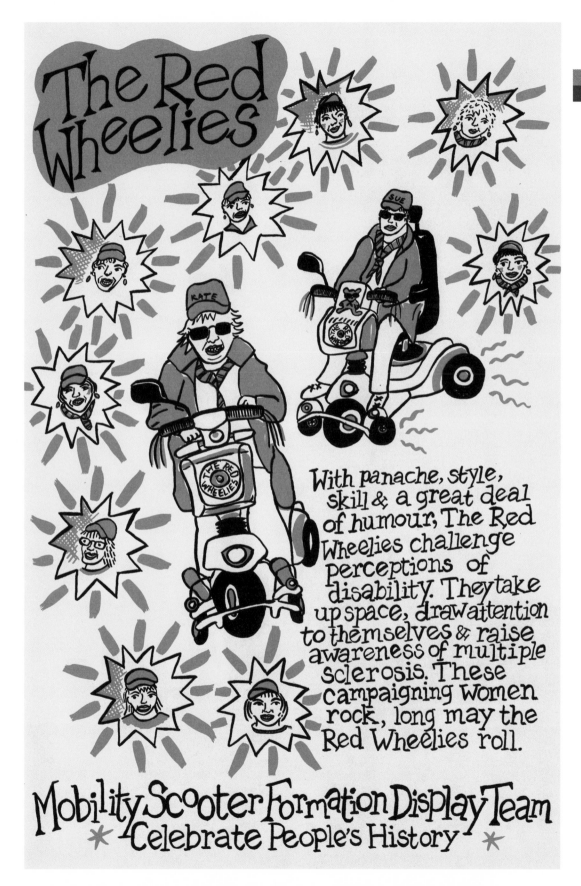

The Red Wheelies

With panache, style, skill & a great deal of humour, The Red Wheelies challenge perceptions of disability. They take up space, draw attention to themselves & raise awareness of multiple sclerosis. These campaigning women rock, long may the Red Wheelies roll.

Mobility Scooter Formation Display Team
✳ Celebrate People's History ✳

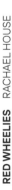

WE WILL NOT KILL FOR YOUR PROFIT.

IRAQ VETERANS AGAINST THE WAR

CALL TO RESIST THE G20

CELEBRATE PEOPLE'S HISTORY

WE WILL NOT SACRIFICE FOR YOUR PROFITS.
WE WILL NOT KILL FOR YOUR PROFITS.

was stenciled in mud by Iraq Veterans Against the War in protest of the 2009 G20 Summit in Pittsburgh. Prior to and during the Summit, IVAW members also reached out to the National Guard, encouraging them to stand down instead of protecting the leaders and bankers of the wealthiest countries in the world.

IVAW used mud to symbolize how veterans often get treated – like dirt – following military service. Because there are no clear laws against getting a sidewalk dirty, police surrounded the veterans but didn't make arrests.

One of these people was shot dead for signing a peace treaty with an illegitimate state. He has been glorified in history books as a war hero and peacekeeper. His name is Sadat. The other was shot dead for attempting to lay flowers in a public square as an act of commemoration for the thousands who lost their lives protesting social injustice. The history books will not write about her, and she will soon be forgotten. Her name is Shaimaa el-Sabbagh.

Celebrate TheRight People's History.

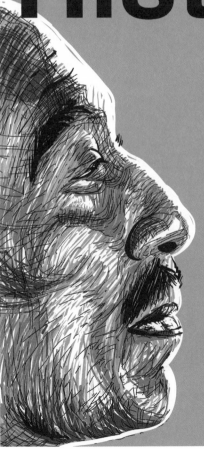

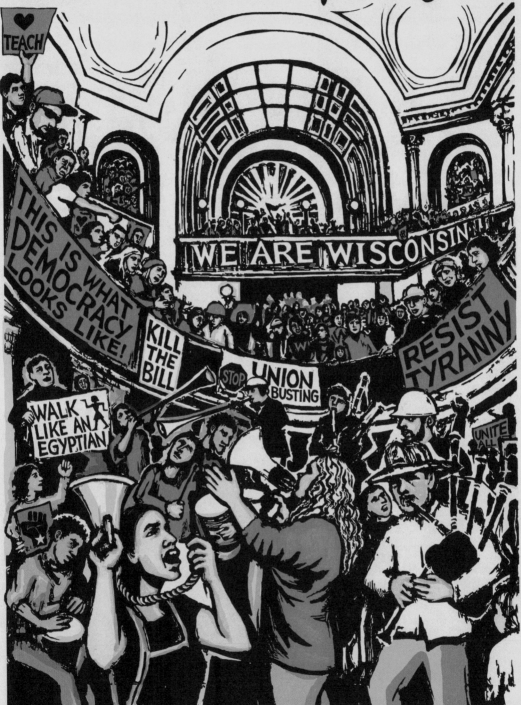

Wisconsin Workers' Uprising 2011

WE ARE WISCONSIN

Celebrate People's History

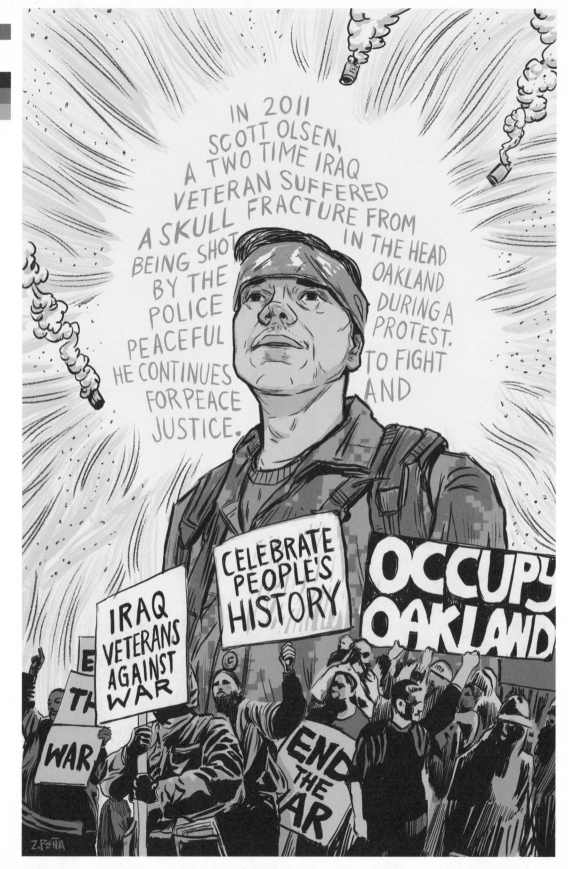

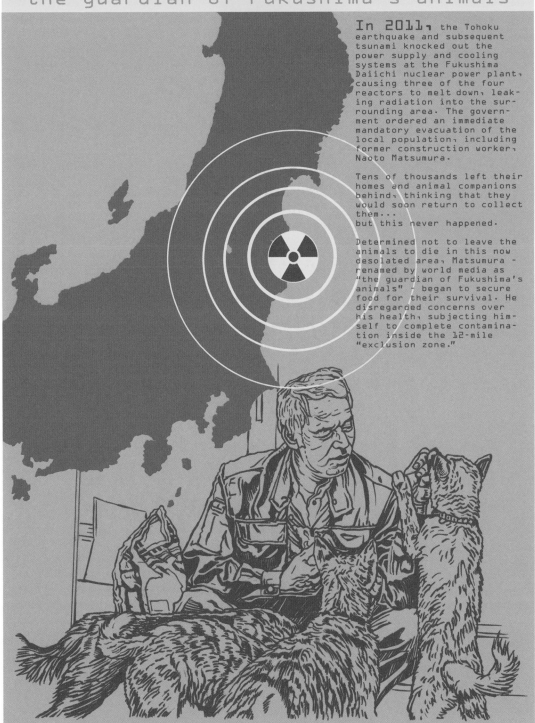

NAOTO MATSUMURA
"the guardian of Fukushima's animals"

In 2011, the Tohoku earthquake and subsequent tsunami knocked out the power supply and cooling systems at the Fukushima Daiichi nuclear power plant, causing three of the four reactors to melt down, leaking radiation into the surrounding area. The government ordered an immediate mandatory evacuation of the local population, including former construction worker, Naoto Matsumura.

Tens of thousands left their homes and animal companions behind, thinking that they would soon return to collect them...
but this never happened.

Determined not to leave the animals to die in this now desolated area, Matsumura - renamed by world media as "the guardian of Fukushima's animals" - began to secure food for their survival. He disregarded concerns over his health, subjecting himself to complete contamination inside the 12-mile "exclusion zone."

CELEBRATE PEOPLE'S HISTORY

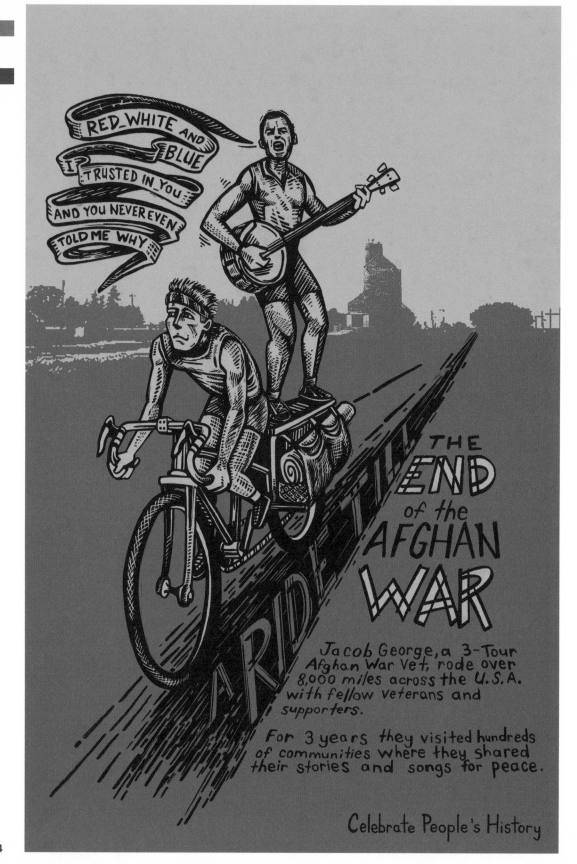

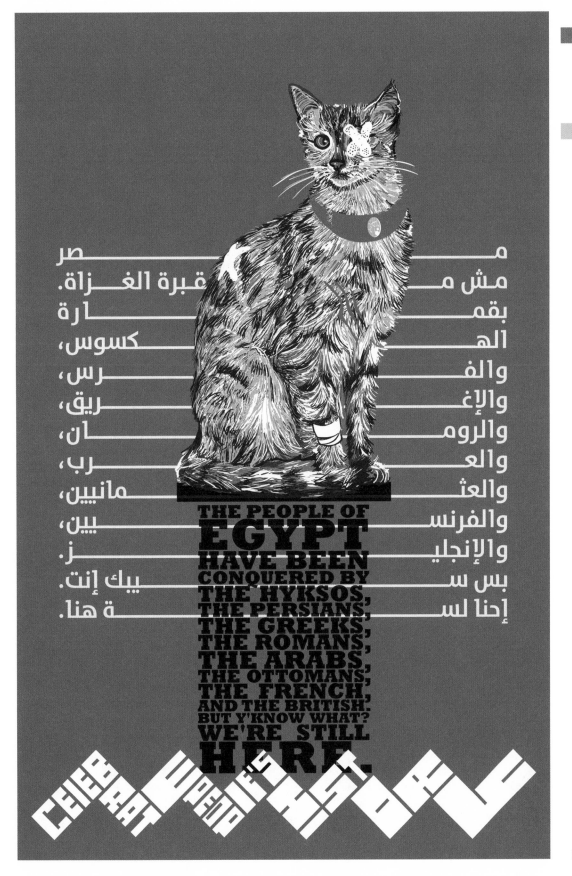

LICK YOUR ELBOW

In mid-2012, protests erupted in Khartoum in opposition to the quarter-century reign of Omar al-Bashir and his National Congress Party. Begun by female students challenging austerity and high prices, within a week it had spread, involving tens of thousands—and this in a context where all signs of dissent are brutally suppressed.

TRY AGAIN

Actions were organized under the slogan "Lick your elbow," a Sudanese saying for attempting to achieve the impossible. Marches and a general strike led to intense and bloody clashes with the police, and while the regime was not overthrown, the people of Sudan proved to themselves that they could organize and build power outside the government.

AND AGAIN
AND AGAIN
AND AGAIN
CELEBRATE PEOPLE'S HISTORY

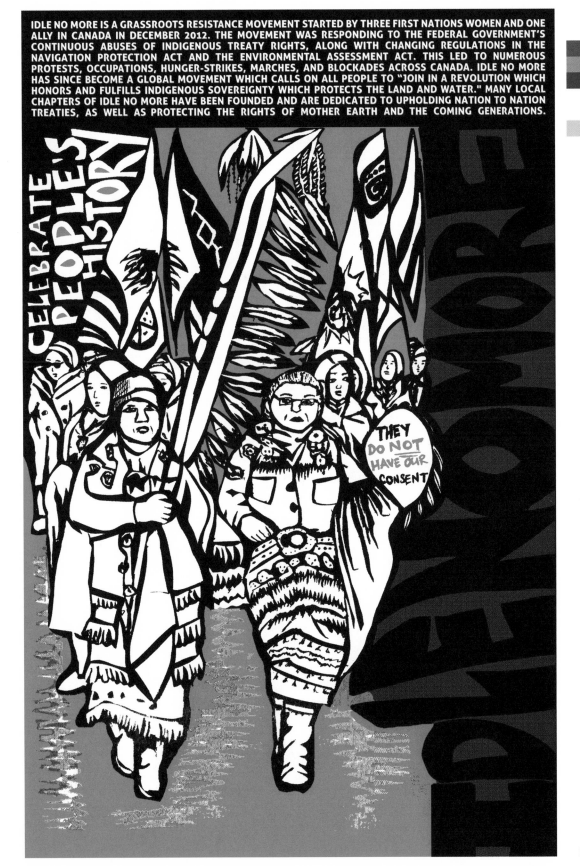

IDLE NO MORE IS A GRASSROOTS RESISTANCE MOVEMENT STARTED BY THREE FIRST NATIONS WOMEN AND ONE ALLY IN CANADA IN DECEMBER 2012. THE MOVEMENT WAS RESPONDING TO THE FEDERAL GOVERNMENT'S CONTINUOUS ABUSES OF INDIGENOUS TREATY RIGHTS, ALONG WITH CHANGING REGULATIONS IN THE NAVIGATION PROTECTION ACT AND THE ENVIRONMENTAL ASSESSMENT ACT. THIS LED TO NUMEROUS PROTESTS, OCCUPATIONS, HUNGER-STRIKES, MARCHES, AND BLOCKADES ACROSS CANADA. IDLE NO MORE HAS SINCE BECOME A GLOBAL MOVEMENT WHICH CALLS ON ALL PEOPLE TO "JOIN IN A REVOLUTION WHICH HONORS AND FULFILLS INDIGENOUS SOVEREIGNTY WHICH PROTECTS THE LAND AND WATER." MANY LOCAL CHAPTERS OF IDLE NO MORE HAVE BEEN FOUNDED AND ARE DEDICATED TO UPHOLDING NATION TO NATION TREATIES, AS WELL AS PROTECTING THE RIGHTS OF MOTHER EARTH AND THE COMING GENERATIONS.

CELEBRATE PEOPLE'S HISTORY

IDLE NO MORE

THEY DO NOT HAVE OUR CONSENT

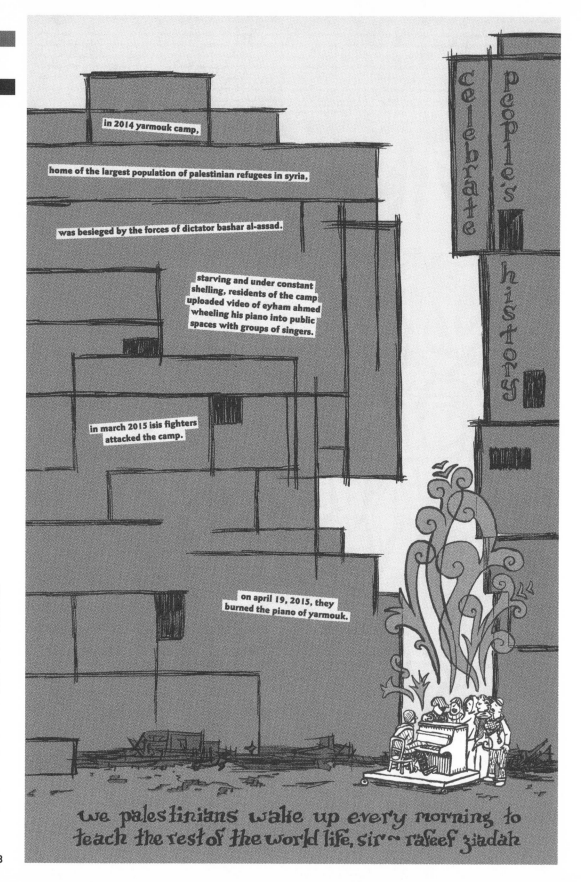

in 2014 yarmouk camp,

home of the largest population of palestinian refugees in syria,

was besieged by the forces of dictator bashar al-assad.

starving and under constant shelling, residents of the camp uploaded video of eyham ahmed wheeling his piano into public spaces with groups of singers.

in march 2015 isis fighters attacked the camp.

on april 19, 2015, they burned the piano of yarmouk.

celebrate people's history

we palestinians wake up every morning to teach the rest of the world life, sir ~ rafeef ziadah

THE PIANO PLAYER OF YARMOUK ETHAN HEITNER

SISTERS UNCUT

TAKING DIRECT ACTION FOR DOMESTIC VIOLENCE SERVICES

SAFETY IS NOT SUBJECT TO IMMIGRATION STATUS

THEY CUT WE BLEED

INTERSECTIONAL FEMINIST BRITISH DIRECT ACTION GROUP OPPOSED TO CUTS TO UK GOVT. SERVICES FOR DOMESTIC VIOLENCE VICTIMS

CELEBRATE PEOPLE'S HISTORY

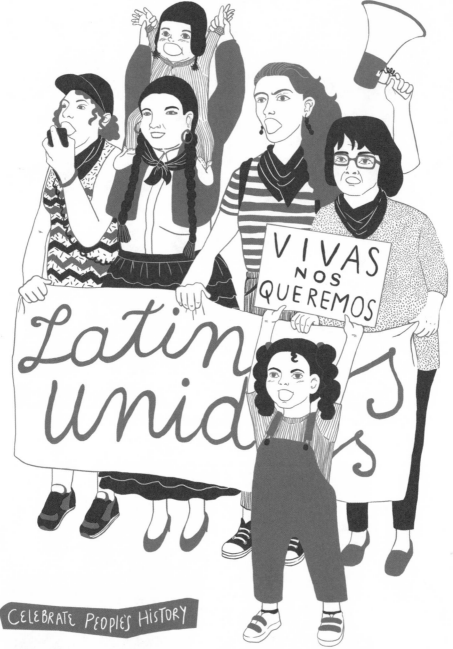

CELEBRATE PEOPLE'S HISTORY

NI UNA MENOS

Not One (Woman) Less

The movement Ni Una Menos represents one of the strongest claims of female empowerment in recent Argentinian history and has grown to become a wake up call and catalyst for women throughout Latin America. Comparable to the Me Too movement in North America, Ni Una Menos joins the fight against gender based violence, working to end femicide and deconstruct the societal forces that enable the control of, and aggression towards, women by men.

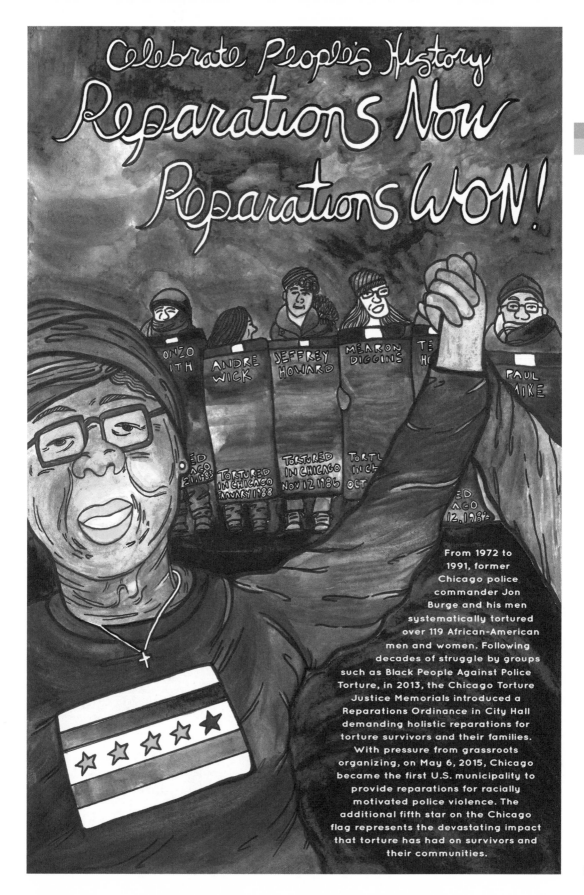

From 1972 to 1991, former Chicago police commander Jon Burge and his men systematically tortured over 119 African-American men and women. Following decades of struggle by groups such as Black People Against Police Torture, in 2013, the Chicago Torture Justice Memorials introduced a Reparations Ordinance in City Hall demanding holistic reparations for torture survivors and their families. With pressure from grassroots organizing, on May 6, 2015, Chicago became the first U.S. municipality to provide reparations for racially motivated police violence. The additional fifth star on the Chicago flag represents the devastating impact that torture has had on survivors and their communities.

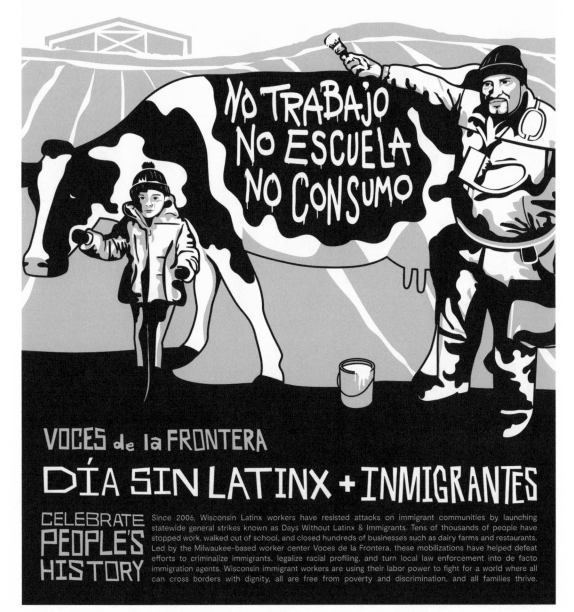

NO TRABAJO
NO ESCUELA
NO CONSUMO

VOCES de la FRONTERA
DÍA SIN LATINX + INMIGRANTES

CELEBRATE PEOPLE'S HISTORY

Since 2006, Wisconsin Latinx workers have resisted attacks on immigrant communities by launching statewide general strikes known as Days Without Latinx & Immigrants. Tens of thousands of people have stopped work, walked out of school, and closed hundreds of businesses such as dairy farms and restaurants. Led by the Milwaukee-based worker center Voces de la Frontera, these mobilizations have helped defeat efforts to criminalize immigrants, legalize racial profiling, and turn local law enforcement into de facto immigration agents. Wisconsin immigrant workers are using their labor power to fight for a world where all can cross borders with dignity, all are free from poverty and discrimination, and all families thrive.

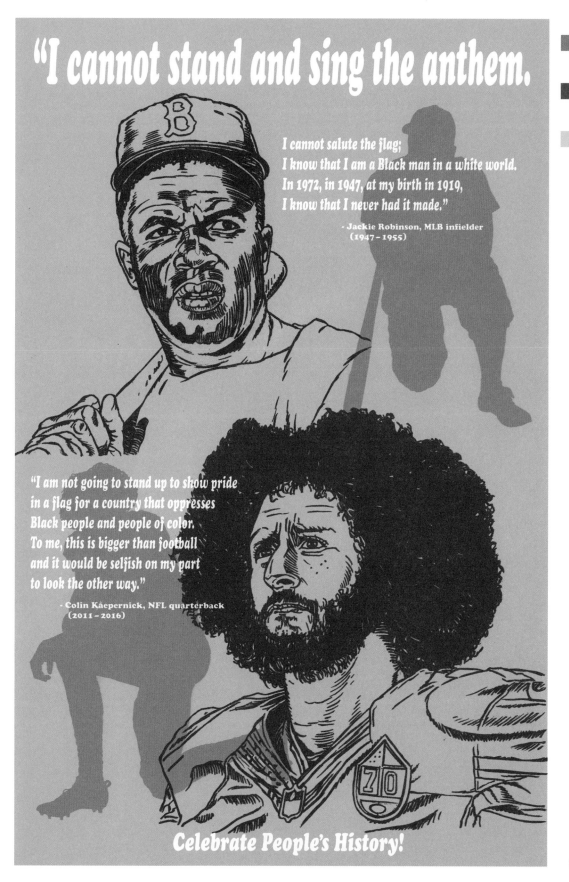

"**I cannot stand and sing the anthem.**

I cannot salute the flag;
I know that I am a Black man in a white world.
In 1972, in 1947, at my birth in 1919,
I know that I never had it made."

- Jackie Robinson, MLB infielder
(1947 – 1955)

"I am not going to stand up to show pride
in a flag for a country that oppresses
Black people and people of color.
To me, this is bigger than football
and it would be selfish on my part
to look the other way."

- Colin Kaepernick, NFL quarterback
(2011 – 2016)

Celebrate People's History!

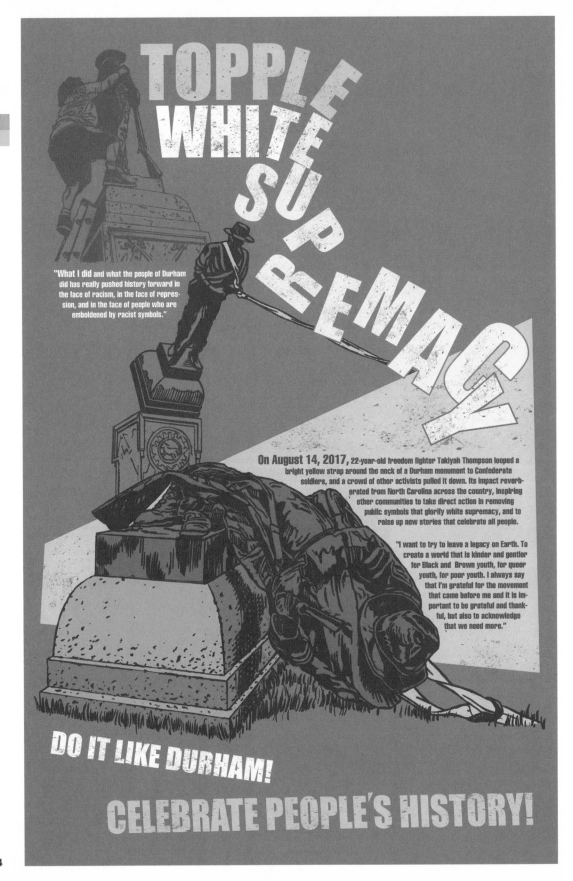

TOPPLING WHITE SUPREMACY IN DURHAM BRETT COLLEY

CELEBRATE PEOPLE'S HISTORY

In the first week of July 2018, volunteers planted a record 66 million trees during the annual National Festival of Tree Planting, or Van Mahotsav. This tradition was begun in 1950 by then Minister of Agriculture Kanaiyalal Meneklal Munshi, and the goal is for each person in India to plant at least one tree each year as part of a broader campaign to combat global climate change.

VAN MAHOTSAV HELEN PEÑA

Artist Biographies

A3BC (76)
A3BC is a woodblock print collective based in Irregular Rhythm Asylum, an infoshop in Tokyo. @a3bcollective

LEILA ABDELRAZAQ (155)
Leila Abdelrazaq is a Chicago-born Palestinian artist and organizer living in Detroit. She is the author and illustrator of the graphic novels *Baddawi* and *The Opening*. lalaleila.com

ALFONSO ACEVES (148)
Alfonso Aceves is a self-taught artist born and raised in Boyle Heights, CA, and one part of Kalli Arte Collective. "Through our work we will share our stories." @kalliarte

SHIVA ADDANKI (159)
Shiva Addanki is an artist, musician, and researcher based in Brooklyn.

MORGAN FITZPATRICK ANDREWS (198)
Morgan FitzPatrick Andrews teaches movement, performance, and politics at Goddard College, Tufts University, and with Philadelphia Theatre of the Oppressed.

TOMIE ARAI (122)
Tomie Arai is a public artist who was born and raised in New York. She collaborates with local communities to create visual narratives that give meaning to the spaces we live in.

JANET ATTARD (63)
In a world of computer-generated images, Janet Attard continues (since 1995) to cut and individually print bicycle stencils by hand. Her work is displayed in books and group shows around the world.

FIONA AVOCADO (151)
Fiona Avocado is an artist and educator who is curious about print media, fiber arts, and personal narratives. She currently lives in Athens, OH. fionavocado.com

EDD BALDRY (212, 223)
Edd Baldry is a designer based in Bristol, England. He goes running a lot.

JESUS BARRAZA (224)
Jesus Barraza is an interdisciplinary artist and cofounder of Dignidad Rebelde, a graphic arts collaboration that produces prints and multimedia projects.

BRANDON BAUER (135, 164)
Brandon Bauer is a multimedia artist and arts educator based in Wisconsin. He uses art as a space for critical and ethical inquiry. brandonbauer.org

DAN BERGER (116)
Dan Berger is a writer and professor based in Seattle. He is the author or editor of several books on US social movements. @dnbrgr

SUSAN SIMENSKY BIETILA (230)
Susan Simensky Bietila has been making activist art since the late 1960s. She is a water protector, working with Voces de los Artistas and doing graphic nonfiction with *World War 3 Illustrated* magazine.

BLANCO (186)
Blanco is a street artist and anthropologist based in Brooklyn.

ERIC "EROK" BOERER (61)
Eric "Erok" Boerer has spent most of his adult life working toward the bicycle revolution and transportation equity in his adopted hometown of Pittsburgh.

NEDRA BONDS (127)
NedRa Bonds is an American quilter, educator, and activist born and raised in the Quindaro neighborhood in Kansas City, KS.

FRANK BRANNON (44)
Frank Brannon is a book artist and educator who has researched the history of the *Cherokee Phoenix* newspaper and developed a Cherokee language–based letterpress studio with the Oconaluftee Institute of Cultural Arts. frank-brannon.squarespace.com

ELI BROWN (106, 109)
Eli Brown is an artist and organizer based in Boston. theelimachine.net

EMILY BRYMER (140)
Emily Brymer is a cartoonist, illustrator, and graphic designer from Newark, DE. emilybrymer.com

DAVE BUCHEN (218)
Dave Buchen lives in Puerto Rico, where he makes theater with Theater Oobleck and El Teatro Bárbaro, and plays music with La Banda Municipal de Makula Barun.

KEVIN CAPLICKI (176)
Kevin Caplicki is an artist (@justseeds), farmer (@woodthrushfarm), social movement archivist (@interferencearchive) living in New York.

CHRISTOPHER CARDINALE (67, 234)
Christopher Cardinale is a muralist, graphic novelist, and teaching artist who collaborates with communities and organizations in New York City creating art that addresses social justice issues. christophercardinale.com

JENNIFER CARTWRIGHT (182, 188)
Jennifer Cartwright has worked as a community organizer on issues ranging from immigrants' rights to homelessness to ending the death penalty.

MELANIE CERVANTES (219)
Melanie Cervantes creates visual art that is inspired by her communities' desire for radical social transformation. She is cofounder of the graphic arts collaboration Dignidad Rebelde.

DUSTIN CHANG (205)
Dustin Chang was born in South Korea and immigrated to the US in 1990. He is an artist, filmmaker, and writer.

STEFAN CHRISTOFF (215)
Stefan Christoff is a media maker, musician, and community organizer based in Montréal. @spirodon

TOM CIVIL (168)
Tom Civil is an artist, muralist, community art facilitator, and printmaker based in Melbourne. He is the cofounder of Breakdown Press and is a member of Everfresh Studio. tomcivil.com

PETER COLE (73, 186)
Peter Cole is a history professor at Western Illinois University. His books include *Dockworker Power: Race and Activism in Durban and San Francisco* among others.

BRETT COLLEY (233, 243, 244)
Brett Colley is an artist living and working in West Michigan, where he teaches at Grand Valley State University. brettcolley.com

JULIO CORDOVA (128)
Julio Cordova is an artist born and raised in Milwaukee. He is committed to both his community and social justice.

MARK CORT (38)
Mark Cort is a freelance designer and illustrator. He works for reduced cost with local small businesses and start-ups, and he especially enjoys projects that empower social justice movements.

BOBBY CORTEZ (119)
Bobby Cortez lives in San Francisco and benefits daily from the work of Dolores Huerta and all others like her.

CRISIS STUDIO (80)
Crisis Studio is based in Ypsilanti, MI. bycrisis.com

LARRY CYR (47)
Larry Cyr's stencils are informed by his background in graphic design and photojournalism. In 2006 he served as an infantryman in Iraq.

COURTNEY DAILEY (190)
Courtney Dailey is a curator, designer, and artist based in Portland. She and is currently serving as board chair of the Portland Institute for Contemporary Art.

JARED DAVIDSON (68)
Jared Davidson is an archivist and labor historian based in Wellington, Aotearoa (New Zealand). jared-davidson.com

KATE DECICCIO (50)
Kate DeCiccio is an artist, educator, and cultural organizer based in Oakland.

DESIGN ACTION COLLECTIVE (172)
Design Action Collective is a worker-owned cooperative and union shop. Beginning in 2002, we have grown to be a diverse, multilingual, eleven-person shop that is majority people of color, women, and trans folks. designaction.org

ROCKY DOBEY (161)
Rocky Dobey has been installing street art in Toronto and other Canadian cities for over forty years. His most recent art is etched copper plaques bolted to street posts. rockydobey.wordpress.com

LINDSAY DRAWS (96, 100)
Lindsay Draws is an artist working with paper, clay, wood, and wool in East London. @andsomeplyers

ERIC DROOKER (32)
Eric Drooker is a painter and graphic novelist. He's the award-winning author of *Flood! A Novel in Pictures*, and *Blood Song: A Silent Ballad*. His paintings appear on covers of the *New Yorker*, and hang in numerous collections.

JIM DUIGNAN (214)
Jim Duignan is an artist and educator in Chicago. jimduignan.com

ALEC DUNN (74)
Alec Dunn is a printer and illustrator living in Portland. He coedits *Signal: A Journal of International Political Graphics & Culture.*

ALEXANDER DWINELL (153)
Alexander Dwinell is Brooklyn-based artist, publisher, and editor. Exhibitions include ABC No Rio, Temporary Agency, and Carriage Trade.

MOLLY FAIR (169)
Molly Fair is a multidisciplinary artist whose work explores the possibilities of radical social transformation through collective action. She is a member of Justseeds Artists' Cooperative.

EDIE FAKE (124)
Edie Fake is an artist living in the High Desert of California.

ADAM FANUCCI (59)
Adam Fanucci's love for animals, his wife, vegan donuts, and krav maga is only rivaled by his genuine disdain for authoritarian institutions. Stay gold.

KAREN FIORITO (162)
Karen Fiorito's artwork has been exhibited internationally and featured in publications such as *Art in America*, *Hyperallergic*, and *Art Forum*.

THE FRIENDLY FIRE COLLECTIVE (174, 216)
The Friendly Fire Collective was an SF Bay Area group that provided radical popular education capable of breaking out of current confines of "the fringe" and reaching new audiences and movements.

NOELLE FRIES (174)
Noelle Fries is a queer facilitator, advocate, and researcher based in Lenape Territory, also known as Brooklyn.

DARRELL GANE-MCCALLA (52)
Darrell Gane-McCalla is an artist committed to radical social change, and an elementary school art teacher in Massachusetts.

NICHOLAS GANZ (99, 192, 195)
Nicholas Ganz is an artist, photographer, and author from Berlin. nicholasganz.de

GANZEER (229, 235)
Ganzeer is an exiled Egyptian artist, designer, and storyteller. He has lived in Cairo, New York, Los Angeles, Denver, and Houston, where he is now based. ganzeer.com

CHEYENNE GARRISON (108)
Cheyenne Garrison is a freelance graphic designer based in Kansas City, MO.

MATT GAUCK (180)
Matt Gauck is an illustrator, screenprinter, and vegan goofball living in a tiny town in North Carolina. veganpatches.com

EMI GENNIS (62)
Emi Gennis makes comics about dead people. She is an associate professor of comics and narrative practice at the Columbus College of Art & Design. emigennis.com

SHANNON GERARD (115)
Shannon Gerard's work spans writing, drawing, crocheting, printmaking, and large-scale installations. Her work emphasizes the materials and ethos of independent publishing as social-political engagements.

JOHN GERKEN (144)
John Gerken lives in New Orleans, plays in the band Why Are We Building Such a Big Ship?, and is the author of the long-running zine *I Hate This Part of Texas*.

SHAWN GILHEENEY (71)
Shawn Gilheeney is a painter and printmaker from Providence, RI, and the founder of Providence Painted Signs.

KYLE GOEN (138)
Kyle Goen is an artist and visionary organizer in New York City. His work intentionally blurs the lines between art and activism. kylegoen.net

GRABIEL GRÁFICA (209)
Grabiel Gráfica is a printmaker from Michoacán, Mexico. @grabiel_grafica

JO GREY (206)
Jo Grey is a longtime eco-activist, human rights defender, and organizer in Toronto. She founded LIFT, Low Income Families Together, in 1986. lift.to

LANA GROVE (58)
Lana Grove is a Native artist based in Lawrence, KS.

RYAN HAYES (228)
Ryan Hayes is a cultural worker based in Toronto. He is a member of the Design Justice Network. ryanhay.es

ART HAZELWOOD (33, 90)
Art Hazelwood teaches printmaking at the San Francisco Art Institute, where he works on behalf of recently unionized adjunct faculty. arthazelwood.com

ETHAN HEITNER (238)
Ethan Heitner is a cartoonist living and working in New York City. freedomfunnies.tumblr.com

ROBIN HEWLETT (193)
Robin Hewlett is a certified nurse–midwife living in Cuenca, Ecuador.

RACHAEL HOUSE (227, 239)
Rachael House is a UK-based multidisciplinary queer feminist artist. She makes events, objects, performances, drawings, and zines. @rachaellhouse

RUSSELL HOWZE (38)
Russell Howze has been documenting, making, teaching, and writing and speaking about street art for twenty-five years. His main project continues to be the Stencil Archive. stencilarchive.org

SANYA HYLAND (153)
Sanya Hyland is an illustrator and letterpress printer living in Mexico City. sanyahyland.com

JOHN ISAACSON (163)
John Isaacson is the author of *Do-It-Yourself Screenprinting*. He teaches junior high English in Goleta, CA.

JAKARUNDI GRAPHICS (206)
Jakarundi Graphics is a Toronto-based studio for screenprinting, block printing, and illustration. jakarundigraphics.art

JAMAA AL-YAD (120)
Jamaa Al-Yad is an artists' collective based in Beirut, Greater Syria, that focuses on cultural manifestations based in the local, vernacular, indigenous, and popular. Their work ideologically reflects nonhierarchical models of collaboration, cooperation, and communality. jamaalyad.org

JOHN JENNINGS (48, 91, 107, 200)
John Jennings is a professor of media and cultural studies at the University of California, Riverside. Jennings's recent projects include the graphic novel adaptations of Octavia Butler's novels *Kindred* and *Parable of the Sower*.

SABRINA JONES (112)
Sabrina Jones created her first comics for *World War 3 Illustrated* and contributes to this day. Her most recent graphic novel is *Our Lady of Birth Control: A Cartoonist's Encounter with Margaret Sanger*.

KILL JOY (34)
Kill Joy's work is grounded in honoring the earth and seeking environmental justice. Her work is an interpretation of world mythology and a study of ancient symbols. @kill.joy.mall

ARTHUR KATRINA (171)
Arthur Katrina (they/them) is a printmaker, zine maker, and tattooist based in Brooklyn. mbdx.life

AMOS PAUL KENNEDY (105)
Amos Paul Kennedy is a descendant of the enslaved kidnapped peoples of the African continent, and runs a printing press.

SAM AND KATAH KERSON (40)
Sam and Katah Kerson run Dragon Dance Theatre, based at their print workshop in Quebec.

KLUTCH (170)
Klutch, best known as the cranky old punk responsible for the worldwide vinyl record–painting movement, has been creating visual mischief for over three decades.

MARA KOMOSKA (167)
Mara Komoska is an educator and activist who has been volunteering with the Co-Madres since 2008 in both El Salvador and Brooklyn.

NICOLAS LAMPERT (70, 78, 194, 213, 217)
Nicolas Lampert is based in Milwaukee and works with the Justseeds Artists' Cooperative and the Art Build Workers. He is the author of *A People's Art History of the United States*. nicolaslampert.org

CHRIS LEE (85)
Chris Lee is a graphic designer and educator based in Brooklyn and Buffalo, NY. He is an assistant professor in the Undergraduate Communications Design department at the Pratt Institute.

ALI CAT. LEEDS (57)
Ali Cat. Leeds is an artist and printmaker based in Portland. entangledroots.com

DAVID LESTER (84)
David Lester is the guitarist in the underground rock duo Mecca Normal and illustrator of *1919: A Graphic History of the Winnipeg General Strike*. davidlesterartmusicdesign.wordpress.com

RICARDO LEVINS MORALES (131)
Ricardo Levins Morales is a Puerto Rican people's artist in Minneapolis. He has long been active in movements for labor, environmental, and racial justice.

ROBERT LIU-TRUJILLO (130)
Robert Liu-Trujillo is a father, a husband, an artist, and an author based in Oakland. robdontstop.com

LMNOPI (221)
The artist behind the moniker LMNOPI was raised during the back to the land movement of the 1970s in the Adirondack Mountains. She is an activist who uses her artistic skills to amplify messages emanating from within movements for social, economic, racial, and climate justice. lmnopi.com

KEVIN YUEN KIT LO (215)
Kevin Yuen Kit Lo has been working in graphic design since 2001. His experience bridges art direction, and graphic and interactive design at leading agencies, to creating campaigns and visuals for front-line social justice movements and grassroots community-organizing work. lokidesign.net

DAMON LOCKS (37)
Chicagoan Damon Locks is a visual artist, educator, and vocalist/musician. He performs in the Exploding Star Orchestra, the Eternals, and Black Monument Ensemble.

DAVE LOEWENSTEIN (81)
Dave Loewenstein is a muralist, printmaker, and arts organizer based in Lawrence, KS. His prints, which focus on social justice issues, are exhibited internationally and are in the permanent collections of many cultural institutions. daveloewenstein.com

FLAVIA LÓPEZ-CZISCHKE (240)
Flavia López-Czischke is a Latin American researcher and designer based in Toronto. flavialopez.com

ASHLEY LUKASHEVSKY (147)
Ashley Lukashevsky uses illustration and visual art as a tool to strengthen social movements for racial, immigrant, and climate justice, mental health, and queer and trans liberation. ashleylukashevsky.com

KATE LUSCHER (204)
Kate Luscher has been a printmaker and tattoo artist, and is currently a health-care worker.

JOSH MACPHEE
(41, 79, 95, 104, 111, 125, 143, 158, 189, 201, 236)
Josh MacPhee is a designer, artist, and archivist. He is a founding member of the Justseeds Artists' Cooperative and cofounder of Interference Archive. justseeds.org

NICOLE MARROQUIN (132, 152)
Nicole Marroquin is an interdisciplinary artist, researcher, and teacher educator whose current research looks at Chicago school uprisings between 1967 and 1974. nicolemarroquin.com

FERNANDO MARTÍ (141)
Fernando Martí is a housing activist, community architect, poet, and printmaker from Ecuador. He has been involved in San Francisco's struggles for housing and ecological justice and the reclamation of the commons. justseeds.org/artist/fernandomarti/

ALICIA MARTINSON (110)
Alicia Martinson is a Brooklyn-based artist, teacher, and organizer of community public-art projects.

COLIN MATTHES (117, 181)
Colin Matthes makes graphics, instructional drawings, and solar-powered remote-control demolition derbies. colinmatthes.com

MAZATL (64)
Mazatl lives in Mexico City, where he part takes in several collectives seeking social, political, and environmental justice. His art is inspired by the work individuals and collectives do to shake off the noose around our necks. graficamazatl.com

MAC MCGILL (39)
Mac McGill is an illustrator and comic artist whose work has appeared in dozens of publications across the globe. He is a native New Yorker living in the East Village. macmcgill.com

IAIN MCINTYRE (168)
Iain McIntyre is an author and community radio presenter from Melbourne who has written various books on radical history and (un)popular culture. pmpress.org/blog/authors-artists-comrades/iain-mcintyre/

SARA BETH MEISTER (72)
Sara Beth Meister is a professional Waldorf educator.

GREG MIHALKO (179)
Greg Mihalko is a multi-disciplinary designer, artist, and activist living in Brooklyn, NY. He is a founder of Partner & Partners, a worker-owned design practice in New York City focusing on print, exhibition, interactive, and identity work. partnerandpartners.com

ABIGAIL MILLER (185)
Abigail Miller is a designer and artist based in Brooklyn. abigailsmiller.com

DYLAN AT MINER (36, 53, 93)
Dylan AT Miner is an artist, activist, and scholar. He is director of American Indian and Indigenous Studies, as well as associate professor in the Residential College in the Arts and Humanities, at Michigan State University. dylanminer.com

CLAUDE MOLLER (136, 137)
Claude Moller is an artist and community organizer who cut his first stencil in 1985 to protest America's bloating war spending. He makes street art for housing justice groups and fantasizes about anti-yuppie lynch mobs.

JAMES DAVID MORGAN (133)
James David Morgan is a cofounding member of the Groundswell Collective, a loose affiliation of critical cultural producers who work at the intersection of art and activism.

MARC MOSCATO (77)
Marc Moscato is the proprietor of Buffalo Bike Tours in Buffalo, NY, where he leads daily history and food tours of the city on two wheels. His career in public history spans working for Road Scholar, Know Your City, Everybody's Bike Tours, and Microcosm Publishing.

CARRIE MOYER (154)
Carrie Moyer is an artist and writer. Her work has been exhibited widely, in both the US and Europe. carriemoyer.com

UN MUNDO FELIZ (98, 101)
Un Mundo Feliz is a Spanish design project directed by Sonia Díaz and Gabriel Martínez. They aim to create and catalog reusable design elements in order to formulate common vocabulary for visual activism.

KEISUKE NARITA (82)
Keisuke Narita runs the Irregular Rhythm Asylum infoshop in Tokyo. He is also a member of the A3BC. ira.tokyo

MARC NELSON (73)
Marc Nelson's paintings and drawings have been featured in exhibitions and collections across the US. He and his wife live and work in Kewanee, IL.

EZRA NEPON (185)
Ezra Nepon is a writer and archives nerd based in Philadelphia. ezraberkleynepon.com.

JON ORLANDO (228)
Jon Orlando is an artist activist who uses photography to deepen our collective sense of humanity. jonorlandophoto.com

CAROLINE PAQUITA-KERN (146)
Caroline Paquita-Kern is an artist, publisher, and Womxnimal based in Brooklyn. carolinepaquita.com

AMISHA PATEL (199)
Amisha Patel is a queer desi labor and community organizer, parent, and lover of art that connects to movements.

ROGER PEET (56, 166, 173)
Roger Peet is an artist, muralist, writer, and printmaker in Portland. justseeds.org/artist/rogerpeet/

BARUCHA PELLER (220)
Barucha Peller is a writer, photographer, and organizer. Her writing on the Oaxaca Uprising focuses on the subversion of gender relations in the creation of the Oaxaca Commune, and is based off interviews she conducted on the barricades.

HELEN PEÑA (245)
Helen Peña is a designer and photographer who is inspired by nature and creates art to defend it. helenpena.com

ZEKE PEÑA (232)
Zeke Peña makes comics and illustrations as an accessible way to remix history and explore complex issues. He lives and works in El Paso. zpvisual.com

ANDRÉ PEREZ (126)
André Perez is a Latinx transgender filmmaker, educator, and community organizer. From founding the Transgender Oral History Project to directing *America in Transition*, his work centers collaborative storytelling with people of color. andrealanperez.com

GILDA POSADA (237)
Gilda Posada is a Xicana cultural worker from Southeast Los Angeles. She received her BA in Chicana/o studies at UC Davis, and her MFA in social practice and MA in visual and critical studies from California College of the Arts.

BETH PULCINELLA (183)
Beth Pulcinella is committed to building community arts infrastructure, using her creative energy and skills to move resources, and unpacking the oppressive educational model that is a cornerstone of our society.

PETE RAILAND (60, 89)
Pete Railand is a founding member of Justseeds Artists' Cooperative, printmaker, educator, bike rider, self-taught musician, and stay-at-home dad. He currently lives in Milwaukee.

DEAN RANK (77)
Dean Rank is a designer and illustrator living in Oakland.

REDEYE (82)
Redeye is an illustrator based in Tokyo.

AARON RENIER (42)
Aaron Renier is an educator, activist, and cartoonist living in Green Bay. His webcomic, *Unchained Melanie*, is updated rarely.

ALLY REEVES (165)
Ally Reeves is an artist from Tennessee who now lives and works in Pittsburgh. Reeves's work addresses issues of information-sharing, empowerment, and alternative economies.

BLAKE RILEY (119)
Blake Riley lives in San Francisco and benefits daily from the work of Dolores Huerta and all others like her.

CRISTY C. ROAD (92)
Cristy C. Road is a Cuban American artist, writer, and musician who's been supplying creativity for punk rock, publishing, and social justice movements since she was a teenager in Miami. croadcore.org

NICOLE RODRIGUES (157)
Nicole Rodrigues is a teaching artist, illustrator, and screenprinter based in Philadelphia who makes shirts and comics. nikkirodrigues.com

CAMILA ROSA (178)
Camila Rosa is a Brazilian illustrator focused on translating women from an alternative perspective, featuring Latin American traits in a women's liberation atmosphere. camilarosa.net

BEN RUBIN (66)
Ben Rubin teaches at Malcolm X College in Chicago.

ERIK RUIN (35, 88, 134)
Erik Ruin is a Michigan-raised, Philadelphia-based printmaker, shadow puppeteer, and paper-cut artist. His work oscillates between the poles of apocalyptic anxieties and utopian yearnings, with an emphasis on empathy, transcendence, and obsessive detail. erikruin.info

JOSHUA KAHN RUSSELL (116, 139)
Joshua Kahn Russell is a social movement facilitator, organizer, and strategist who has trained thousands of activists across the globe. He is the executive director of the Wildfire Project. wildfireproject.org

AARON SAMSEL (222)
Aaron Samsel is an artist/activist turned labor lawyer/ dad from Takoma Park, MD.

JOS SANCES (207)
Jos Sances has made his living as a printmaker and muralist for more than forty-five years. He is the founder of Alliance Graphics and cofounded Mission Gráfica in the Bay Area. The Library of Congress has acquired 495 of his prints.

FRED SASAKI (77)
Fred Sasaki is the art director for *Poetry* magazine and exhibitions cocurator for the Poetry Foundation. He publishes *Sasaki Family Zines* with his closest kin and collaborates with Homeroom Chicago, Prison + Neighborhood Art Project, and Revolving Door Arts.

JENNY SCHMID (69)
Jenny Schmid grew up in Seattle and lives in Minneapolis, where she runs bikini press international. Represented by Davidson Galleries, her prints are in collections including the Minneapolis Institute of Arts, the Detroit Institute of Arts, and the Library of Congress. jennyschmid.com

NICOLE SCHULMAN (167, 205)
Nicole Schulman was born and raised in New York City by a couple of Jews from the Bronx. She is known for her comics, posters, album covers, and illustrations, which have appeared in the *New York Times*, the *Progressive*, *New Politics*, and *World War 3 Illustrated*.

SCOUT (97)
Scout is an artist and train conductor based in mighty Chatham, NY. scoutpines.com

DEVIKA SEN (187)
Devika Sen is a graphic designer with a background in printmaking. She is an owner of Partner & Partners, a worker-owned, multidisciplinary design practice in New York City. partnerandpartners.com

T.L. SIMONS (220)
T.L. Simons is a designer and illustrator of games, maps, logos, books, and other printed matter. tlsimons.com

SHAUN SLIFER (43, 51, 72)
Shaun Slifer is an artist, writer, scrimshander, self-taught historian, and museum professional based in Pittsburgh. Shaun regularly works in collaboration with other artists, nonartists, and in collectively structured groups. sslifer.com

FRED SOCHARD (55)
Fred Sochard is an illustrator in the world of press and publishing. His inspiration stems from outsider and popular art, stories about rebels and pirates, and tales from all over the word. fredsochard.com

BISHAKH SOM (49)
Bishakh Som is an artist from Brooklyn. Her work has been in the *New Yorker* and various queer comics anthologies. She is the author of *Apsara Engine* and *Spellbound: A Graphic Memoir*. bishakh.com

MIRIAM KLEIN STAHL (102, 104, 175)
Miriam Klein Stahl is an educator, artist, activist, mom, and illustrator of the Rad Women book series. She is based in Berkeley. miriamkleinstahl.com

CHRIS STAIN (83)
By adapting images from photographs and working with spray paint, stencils, and paper to create interior/exterior works, Chris Stain seeks to convey an authentic contemporary document that illustrates the triumph of the human spirit as experienced by those in underrepresented environments. chrisstain.com

JEFF STARK (160)
Jeff Stark is an artist and teacher in Brooklyn. jeffstark.org

MEREDITH STERN (94, 121, 145)
Meredith Stern is a Justseeds member living in Providence, RI. Her most recent project is a series of prints and booklets of the thirty articles of the Universal Declaration of Human Rights.

TAYLOR CASS STEVENSON (170)
Taylor Cass Stevenson is interested in reuse as a tool for social integration and economic development, and is compelled by people around the world who survive from garbage or who, similar to garbage, are rejected by society.

SWOON (210)
Swoon (Caledonia Curry) is a Brooklyn-based artist and is widely known as the first woman to gain large-scale recognition in the male-dominated world of street art. swoonstudio.org

MIKE TAYLOR (118)
Mike Taylor makes paintings, prints, books, and music between St. Augustine, FL, and New York City.

CHIP THOMAS (46)
Chip Thomas has lived and worked as a primary-care physician on the Navajo Nation since 1987. He sees his public art practice as an extension of his medical work in that both attempt to achieve wellness in the individual and within the community. jetsonorama.net

APRILLE THURHEIMER (75)
Aprille Thurheimer is a printmaker living in Seattle.

MARY TREMONTE (115)
Mary Tremonte is an artist, educator, and DJ based in Pittsburgh. A member of Justseeds Artists' Cooperative, she works with printmaking in the expanded field, including printstallation, interactive silkscreen printing in public space, and wearable artist multiples.

MONICA TRINIDAD (241)
Monica Trinidad is an artist and organizer based in Chicago. She is the cofounder of Brown and Proud Press, For the People Artists Collective, the People's Response Team, and the *Lit Review* podcast. monicatrinidad.com

ANTON VAN DALEN (191)
Anton Van Dalen was born in 1938 in Amstelveen, Netherlands. He currently lives in New York's East Village.

MINCHO VEGA (211)
Mincho Vega (Ben Rojas) is a Brooklyn-based visual artist, art educator, father, and husband. Mincho, who is of Salvadoran descent, left the Bay Area and moved to New York in 2004.

THE VIRGINIA DEFENDERS FOR FREEDOM, JUSTICE & EQUALITY (222)
The Virginia Defenders for Freedom, Justice & Equality is an organization of Virginia residents working for the survival of our communities through education and social justice projects.

VOCES DE LA FRONTERA (242)
Voces de la Frontera is an immigrant rights organization based in Wisconsin. vdlf.org

STEPHANIE WEINER (208, 225)
Stephanie Weiner is an artist and longtime activist based in Chicago. revolutionarylemonadestand.com

EIAN WEISSMAN (113)
Eian Weissman is an illustrator and writer living in Philadelphia.

JOSIAH WERNING (242)
Josiah Werning is a designer from Milwaukee now based in Brooklyn.

BOFF WHALLEY (175)
Boff Whalley is a musician, writer, and mountain runner. He coordinates an anarchist choir and owns the petrol cap from the Beatles' original *Magical Mystery Tour* bus. boffwhalley.com

WATIE WHITE (214)
Watie White is a painter, printmaker, and public artist based in Omaha. He has degrees and has won awards, but mostly works every day.

LAURA WHITEHORN (169)
Laura Whitehorn is formerly incarcerated. She cofounded Release Aging People in Prison and edited *The War Before* by the late Black Panther Safiya Bukhari. rappcampaign.com

SUSIE WILSON (197)
Susie Wilson is a multimedia illustrator, printmaker, and comic artist. A graduate of Emily Carr University in Vancouver, she is interested in all of the ways the world may or may not end in the near future.

CHRISTINE WONG YAP (87)
Christine Wong Yap is a project-based artist who explores psychological wellbeing via social practice, hand lettering, printmaking, and more. She is based in Queens, NY, with roots in the SF Bay Area. christinewongyap.com

SOPHIE YANOW (150)
Sophie Yanow is a cartoonist and the author of *War of Streets and Houses* and *The Contradictions*. sophieyanow.com

BEC YOUNG (114, 129)
Bec Young is a visual artist based in Detroit who seeks to inspire—and draw inspiration from—movements for justice and ecological wellness.

RYNE ZIEMBA (184)
In the tenth grade, a friend gave Ryne Ziemba a copy of *The ABC of Anarchism*, which changed his life. Through writing, visual art, music, and film, he brings a noncompromised political edge to pop culture.

ZOLA (226)
Zola is a street artist and community organizer living in Montreal. Her work focuses on Indigenous solidarity, feminism, and anti-capitalism.

Acknowledgments

The Celebrate People's History posters were as much Liz Goss's brainchild as they were my own. Without her early collaboration, support, and guidance, they wouldn't exist. Other early advocates of the project include Michael Staudenmaier, Sara Brodzinsky, Darrell from the A-Zone, and everyone at C&D Printshop (Don, Janeen, Christian, Vic, Anton). Claude Moller, Ben Rubin, Shaun Slifer, and Daniel Tucker all get awards for running around with me at night putting these things up. Dara Greenwald spent years literally living among boxes of posters and never once complained about it (well, maybe once or twice . . .). And all my comrades in Justseeds Artists' Cooperative have been amazingly supportive—in designing images, repping the project, and selling posters while tabling across North America. Shaun and Cat at Justseeds HQ have spent hours carrying and stacking boxes of posters, inventorying them, and packing them in envelopes to head out to thankful new owners. They're the backbone that gets tens of thousands of posters into people's hands.

Alec Dunn, Roger Peet, Darrell Gane-McCalla, John Gerken, Meredith Stern, and Erik Ruin all believed in and invested in the project early on, sending me my first unsolicited poster designs and really helping to convert the project into a group endeavor. Now over two hundred artists and writers have gotten involved in the project. I can't thank any of you enough for taking part in this experiment. Rebecca Gilbert and Eric and Brian Bagdonas from Stumptown Printers are true heroes. When C&D closed, they were a fledgling worker-owned and worker-run printshop, and they not only took on the printing but were always amazingly supportive of the project. From 2003 through 2018, they printed 112 different posters(!), some of them multiple times. I miss them greatly, and the loss of their shop has been a big blow to the project. Thankfully Ross and Ranil from Community Printers have stepped in to take over poster printing, and I'm excited to put the project in their capable hands.

Amy Scholder had the vision to see how impressive the posters would look collected in a book and did so much to support the first edition of this publication, which was released in 2010. Drew Stevens designed it; Elizabeth Koke and Jisu Kim from the Feminist Press did an immense amount of work to get it into people's hands; and now I need to thank Jamia Wilson, Lauren Rosemary Hook, Nick Whitney, and Jisu and Drew (again!) for helping craft and guide this new edition. I'm honored that both Charlene Carruthers and Rebecca Solnit thought the project worthy enough to write their fabulous forewords. Lindsay Caplan, Alec Dunn, and Monica Johnson helped immensely in editing my introduction. Finally, none of this could have happened without the support of Monica Johnson, and the inspiration of Asa Michigan. They keep me going.